Friends of the
Houston Public Library

DAUGHTER OF DESTINY

JUSTIFICATION FOR BAC PUBLICATIONS

<u>Daughter Of Destiny</u> is a splendid example of why this sole proprietorship was registered with the Texas Comptroller 11-01-92 as a book publisher. That purpose was to put on the market deserving works that the large, well-known publishing houses will not even consider.

It seems indelibly clear to this publisher that there are those of the publishing conglomerate (I do not say all) who are primarily interested in working with "celebrities" and other pursuits which will fill the financial coffer, regardless of its character.

Yet there are still those of us who do not agree with that philosophy. Admittedly, money and material things have their place, but not first or exclusive place! As <u>Daughter Of Destiny</u> confirms, top priorities of life (really) are honoring God, service to mankind and development of character.

We of the BAC mold not only refrain from writing and publishing for money alone, but we do so to spend money (our own as self-publishers), feeling it is a good investment for now and eternity.

BAC Publications (Bill & Ann Carraway) reiterates that it exists for and seeks the worthy, unknown writer who has a story to tell or a literary contribution to make to the glory of God, the honoring of truth and the edification of humankind.

<div style="text-align:right">The Publisher</div>

DAUGHTER OF DESTINY

MEMOIRS OF A
BOWIE COUNTY, TEXAS
FARM GIRL

CARLENE (MAXWELL) HOWELL

BAC PUBLICATIONS
PO Box 963
Winnsboro, TX 75494

Copyright © 1995
by Carlene (Maxwell) Howell

All Rights Reserved

Biblical Quotations
All Biblical quotations in this book are taken from the King James Version.

Designer/Illustrator
The hardcover design and the jacket design and illustration are the work of Marsha Spilmann, MRS Productions, 3236 Indiana Avenue, Kenner, LA 70065. She also did the final proofreading.

Library of Congress Card Number
(202) 707-6345

International Standard Book Number
0-9633855-1-8

Manufactured by BookCrafters, Chelsea, MI of camera ready copy furnished by publisher.

Published by
BAC Publications
Winnsboro, TX 75494

Printed in
the United States
of America

CONTENTS

FRONT MATTER
Contents
Foreword
Dedication
Acknowledgments
Preface
Introduction
Photograph Identification

CHAPTER 1 - Childhood 01

CHAPTER 2 - Growing Up 11

CHAPTER 3 - Farm Life 25

CHAPTER 4 - Public School Days 39

CHAPTER 5 - College 55

CHAPTER 6 - Career 71

CHAPTER 7 - Married Life 81

CHAPTER 8 - Malcolm Goes To War 89

CHAPTER 9 - Life And Death 103

CHAPTER 10 - Picking Up The Pieces 119

CHAPTER 11 - Divorce 135

CHAPTER 12 - A Man And A Mule 149

CHAPTER 13 - Sleep, Little Mama 163

CHAPTER 14 - Papa Joins Mama 171

CHAPTER 15 - Dogs In My Life 185

CHAPTER 16 - A Wedding And A Trip 193

CHAPTER 17 - Retirement 203

CHAPTER 18 - On The Road Again 215

CHAPTER 19 - Life With Loyd 227

CHAPTER 20 - Serenity 241

BACK MATTER
Pictorial Directory 259
Order Form 267

FOREWORD

Through the tidal wave of change that marked the experience of the 20th century, Carlene (Maxwell) Howell has expressed with admirable honesty and elegance the timeless values born in the heart of Texas.

From the simple pleasures of life on a Bowie County farm to the complicated trials of alcoholism and divorce, <u>Daughter Of Destiny</u> is a story of faith, hope and triumph. Carlene Howell takes us on a remarkable journey through school, marriage and parenthood and tells us the lessons she learned on the way.

Through it all, Carlene teaches us the importance of family and children and of the need to work together to pass on a better life to our children and grandchildren.

<div style="text-align:right">
Ann W. Richards

Governor of Texas

1990 - 1994
</div>

DEDICATION

To my **parents** who gave me life and an early sense of values through their precepts and example.

To my **son** and his **descendants** who are my link to the future.

To all those **family members** and **friends**, without whose encouragement DAUGHTER OF DESTINY might never have become a reality.

ACKNOWLEDGMENTS

I wish to thank **John Fooks**, my mentor who helped me realize I had a story to tell.

I thank **Carlene Dacus** for transforming my many pages of longhand to readable type for the typesetter.

My deepest appreciation to **Dr. Kenneth Howard** for research on my Howard ancestors.

I am grateful for **Bill Carraway's** directions along an uncharted path.

I am indebted to **Marsha Spilmann** for her excellent work in designing and illustrating the book's hardcover and jacket and proofreading.

And last, but by no means least, "Orchids to you," **Ann W. Richards**, Texas Governor from 1991 to 1995, for graciously consenting to write this work's foreword.

PREFACE

My Family Heritage

My heritage includes people from East Texas and the red-clay hills of Georgia, South Carolina and perhaps many other states.

Mama's grandfather was Peter Howard, born in 1812 in South Carolina. He married Clarissa Grogan circa 1830. He and one of his sons fought in the Civil War on the Confederate side. Mama's father (Peter's son) was Richard Wilson Howard, born August 25, 1852 in Dawsonville, Georgia. He married Sarah Elizabeth Harden in Georgia near 1874. Richard Wilson had a twin sister, Loucinda, who died young and there were many other brothers and sisters. **Mama, Roxie Jane Howard,** was born April 13, 1880 in Georgia and was the third of eleven children born to Richard Wilson and Sarah Elizabeth Howard. One boy died in early childhood but ten children lived to maturity, married, and had families. They are Peter Doyle, then Jefferson Otis, Roxie Jane, Sally Emmoline, Lou Anna, Cora Rebecca, Arthur Lewis, Roy Jackson, Laura Catherine and Grady Allison.

Sarah Elizabeth died in 1904 after the family moved to Texas in 1900. She is buried in the cemetery at Wards Creek of Western Bowie County, Texas. After her death, Richard Wilson married George Ann Treadway, a widow from Cass County, Texas. The year was 1907. Seven children were born to this union: Bessie, Homer, Lorene, Estelle, a son who died in infancy, Vernon and Richard Wilson, Jr.

Papa's grandfather was Samuel Walker, born (date unknown) in the Republic of Texas probably in what is now Bowie or Red River County. He married Jane Poer, born February 25, 1826 in Madison County of the State of Tennessee. Samuel died about 1860, probably in Angelina County, Texas. Jane died at Dalby Springs, Bowie County, Texas and is buried in the Wards Creek Cemetery. My grandfather, James Richmond Walker was born to Samuel and Jane Walker on December 23, 1857 at Dalby Springs. He was married in 1880 to Hettie Kight who was born in Georgia in 1856. **James Luther Walker**, my father, was born to James R. and Hettie Walker September 23, 1882 at Dalby Springs. Papa was the oldest child in a large family, but only four children (Papa, then Samuel, Olevia and Ofelia) were granted the privilege of living to rear families of their own.

Granpa Walker was a farmer and for the last few years of his life, a country doctor in the little town of Dalby Springs. I wish I could have known him, but he died young, many years before I was born. Papa said he was a good physician and never failed to respond when he was needed somewhere to attend the sick. Many times his patients could not pay in money so he took what was offered. He delivered babies and treated all sorts of illnesses for which he might be paid with a watch, a clock, a quilt or whatever the patient could afford. Papa carried a big pocket watch that Grandpa had taken in on medical debts. I remember a mantel clock in our home that struck on the hour and half-hour that had been acquired by Grandpa the same way. He traveled by buggy or on horseback and it was Papa's job to take care of the horse when Grandpa returned home, no matter when

that might be. Papa would unharness or unsaddle the horse, rubbing down and feeding him the corn or oats that were kept on hand for that purpose.

Grandpa died before Mama's family came on the scene. Grandma Walker was not well and Papa felt that he was left with a heavy responsibility. From what he told us, when he met Mama, it was not a very romantic courtship. She was a strong, healthy young woman, attractive and two and one-half years his senior. She was the answer to his prayers for help! Respect and caring turned into love and they were married October 20, 1901. Mertie Irene, my oldest sister, was born July 31, 1902. A stillborn baby boy arrived three years later. Corrie Iva joined the family May 2, 1908 and Luther Leon made his debut January 25, 1910. When Leon was one and one-half years old, my parents cleared some land on a 50 acre tract which Papa had inherited and built a house. Here Calvin Offard was born September of 1911, but he lived only a few months. Four years later I was added, the baby of the family.

PSALM 16:6

"The lines are fallen unto me in pleasant places; Yea, I have a goodly heritage."

INTRODUCTION

My first thought in writing my memoirs was to let my son and grandsons know what life was like as I grew up and something about my forebears. As I pondered over the many unusual circumstances I had experienced, and how God had seen me through, I knew it had to be more than the history of one East Texas farm girl. I came to feel that somehow I must make it a witness for my Lord and Savior and his wonderful guidance and keeping power.

As I looked back I could see His hand on my life and I know He so destined that I would be at a certain place at a certain time in order to be of service to my fellow-man and to Him.

It is with this in mind that I tell my life's story. May you, the reader, learn from God's provision for me to depend upon his love and power for your eternal salvation and his keeping care from day to day.

PSALM 119:105

"Thy word is a lamp unto me feet, and a light unto my path."

PHOTOGRAPH IDENTIFICATION

Author and Playmate 261

Neighbor, Author's Mother
and Author 261

Author's Parents 262

Family Photo at Farmhouse 262

Carlene and Malcolm Maxwell 263

Robert Maxwell, Author's
Adopted Son, and Old Fellow 263

The Robert Maxwell Family 264

Leon and Enois Walker 264

Author Counseling a Student 265

Loyd and Carlene Howell 265

CHAPTER 1

CHILDHOOD

I was born at home on Thursday, December 23, 1915, in the Wards Creek community of Western Bowie County, Texas. Dr. Dendy, from the closest town of DeKalb, delivered me, a 12-pounder. For years I had a feeling that, upon my birth, Mama decided I would be her last. My name came about this way: Miss Gladys Crockett, a school teacher, was boarding with us and suggested that I be named Carlene. Since I was born on the birthday of Mama's youngest sister, Laura, she desired that name for her newborn so I became Laura Carlene.

The Bible says, "... and who knoweth whether thou art come to the kingdom for such a time as this?" (Esther 4:14) Mordecai was instructing his niece, Esther, the queen of Persia, that she was born at this time to play a prominent role in the saving of her people, the captive Israelites, from slaughter. Sometimes, as I look back on my life, I feel that I, too, as God ordained, was born at a certain time and place to a particular set of parents for a special purpose.

One of my earliest childhood memories is that of sitting in my highchair at the table during our meals. Much to Papa's annoyance, I would slip my barefoot inside one of his boots, while he was wearing it, with

DAUGHTER OF DESTINY

the resultant scolding being no deterrence. I was drawn to those boots as if they were magnets!

Another recollection is that of being vaccinated for smallpox. When I was two-and-a-half years old, an epidemic of the disease hit our community. The doctor came to our house and vaccinated the entire family. Mine didn't take even after two tries, so the doctor left medicine and equipment for Papa to try to vaccinate me. The third effort was successful. (I called it "**doctornated**" because of the doctor's trips to our home for that purpose.) My older sisters told me that my father promised me a tricycle if I wouldn't cry. They said I passed the test but the tricycle never materialized. After I was grown and in my first year of school teaching, I reminded Papa of his not having fulfilled his promise. Soon I received a watch as a peace offering.

In the late fall of 1919, when I was almost four years old, Papa decided we would move to Compton, which was in the State of California. He knew a man, from our community who had moved there, and who had reported that work was plentiful with good wages. Mama accepted Papa's decision. In fact, she almost always did. We made the trip by train. My sisters informed me of my being the pet of the passengers on our car. When they asked my age, I said, "Four in December," which so amused them that they asked it often just to have me perform. I enjoyed the excitement of my first train ride and the attention I received so much, that I was not overly happy when it came to an end.

CHILDHOOD

Papa bought a house situated on two lots, one of which was a corner lot facing east. There were two huge palm trees in the front yard with lots of flowers and an artesian well on the north side of the house. An outdoor toilet was in the backyard and a barn and large barnyard to the south. It was a modest house in a pleasant setting and we soon felt at home there.

Papa went to work at a pickling plant after we were settled in our new home. Later, he worked as a shipbuilder in the nearby shipyards. He also participated in the construction of the Goodyear Rubber Plant in Southgate. During spring and summer he worked for George Webb Dairy irrigating sugar beets, grown to feed the dairy herd. Irene was hired by the Bishop Candy Company and delighted me by bringing samples home. I played at home while Leon and Iva attended school. During the summer months even Mama worked pulling fresh corn. Although she had never worked outside the home before, Mama had done this kind of work on our farm in Texas and felt confident doing it. Her pay was five dollars per day, with free transportation to and from work. Good pay for a woman in those days.

Upon settling in our new home, we found a church to attend, the First Baptist Church of Compton. It was bigger than the one in Texas we had attended, but the people were loving and friendly. We soon felt right at home. I remember one time Papa had to work late one Wednesday evening so the rest of the family went on to the weekly prayer meeting. Shortly after the service began, Papa appeared, wearing the

same clothes he had worked in that day, much to Mama's embarrassment. But Brother Rossier, the pastor, publicly commended my father for his faithfulness. In Sunday School I learned my first song:

> "Jesus loves me this I know,
> for the Bible tells me so.
> Little ones to Him belong,
> they are weak but He is strong.
>
> Yes, Jesus loves me,
> Yes, Jesus loves me.
> Yes, Jesus loves me,
> The Bible tells me so."

I thank God for Christian teaching and training.

One terrifying thing happened while we lived in Compton that we had never experienced before - an earthquake! I was playing in the yard and so was Leon. I heard dishes rattling and other strange noises. I couldn't imagine what was happening. By the time I ran into the house, it was all over. Leon later said, "I had to dance to stand still."

I recall we owned two animals while living there. We had a goat who played solitaire see-saw on a two-wheeled cart. He would jump up on the cart, moving toward one end. As that end started toward the ground, he would quickly move toward the other end of the cart. He was usually successful in keeping the ends from bumping the ground as he ran back and forth in his frolicking.

We also had a large and very intelligent pig. If he could find a piece of paper, he would grab it in his mouth and chase the chickens round and round the barnyard until they all escaped, shaken but unharmed, into the barn or chicken house. One day this pig got into the toilet and managed to fasten the door on the inside. When we finally found him, we had trouble getting the door open. We discovered he had desecrated our little outhouse, necessitating a thorough scrubbing before we could use it again.

How could I ever forget a little neighboring girl by the name of Mary Anna King! We often played together both at her house and mine. She had a bad habit of biting and I had been taught not to do that. One day she bit me hard enough to leave teeth marks, making me cry. Papa called us into the house to ask the problem. When he saw the evidence on my skin, he got his tooth forceps (passed on to him from his dad) and told Mary to open her mouth. He acted as though he was about to pull her teeth. Her eyes widened as she truly believed he was serious. He let her go but told her if she continued to bite people he would have to extract her teeth. It worked! She never bit me again.

Back To Texas

After living in Compton for almost a year, Papa decided we should move back to our Texas home. For some time he had received letters from family and friends telling of problems at our place we'd left behind. The renters in charge were not caring for the

property in a worthy manner. The house was not in good repair, fences were being neglected, so Papa felt he must return to get things in order.

He put the Compton place on the market as soon as he convinced Mama it was the thing to do. The house and lots cost us $1200 and were sold for $2500. Not a bad profit, so we thought. However, after we'd been back in Texas a few months, oil was discovered on Signal Hill in Long Beach and the property we formerly owned jumped in value to $25,000!

We set about packing for the long trip back to Texas. When the preparations were nearly finalized, Papa suddenly announced we should stay a while longer. Mama stood firmly, saying, "It's too late to change your mind, Luther, we're packed and ready to go and we're going!"

A railroad car was chartered to ship our household goods while we traveled by car. The trip home was quite eventful - some events good, some bad. Our car was a grotesque Chalmer touring make, mustard color with a black top. The trip took 18 days, driving on mostly unpaved and narrow roads. Believe it or not, Papa still got a ticket for speeding! He was driving 42 miles per hour in a 40-mph zone.

We had not traveled far when we entered the Mojave Desert. If there had been no recent sandstorm, we made pretty good time. If sand covered the road, "the old man of the desert," who lived about midway through it, would take a team of horses or mules with

CHILDHOOD

a scoop to move the sand. Slabs of wood were the road's only pavement. We finally cleared the desert, only to encounter the mountains. Coming over the Rocky Mountains scared me and almost made a nervous wreck of Mama. She would say, "Luther, slow down! There's a curve up ahead and no place to pass if we meet another car." Places, here and there, were cut out of the mountains' sides enabling cars to get by. When going around dangerous curves, road signs admonished drivers to sound their horn to let others know they were approaching. Looking out one side of the car would find us staring straight down for hundreds of feet. I would close my eyes and snuggle up against Mama. I just knew Papa was too close to the edge!

Looking out the other side of the car we saw just the opposite - straight up hundreds of feet. At times the road was so steep the car barely made the incline. While on the decline, there was a chance of the brakes failing and our plunging over the side of the mountain to our death. Signs on huge flat-sided boulders reminded us: "Slow! Sharp Curve Ahead" "Dangerous Steep Decline -- Reduce Speed" "In God We Trust" "Jesus Saves" "Prepare To Meet Thy God" Whew! It was scary!

On our trip home we had various types of sleeping accommodations. Sometimes at night we stayed in private homes, other times in hotels. One time we checked into a hotel and housed the Chalmer in the hotel's garage. Next morning we had breakfast in the hotel's restaurant. Our parents ordered for us all and

DAUGHTER OF DESTINY

we waited to be served. Our wait was a long one, causing Papa to be very annoyed with the delay. Calling the waiter over to our table, Papa said, "Just cancel our order. We're leaving!" The waiter summoned the owner, who demanded that we pay for the meal. "I will not," was the indignant reply. "We've waited nearly an hour and we'll just eat somewhere else." The proprietor held up our car keys and said, "Pay up or you don't drive your car out of our garage." Papa reluctantly took his seat, we ate breakfast, and went on our way.

There were some places in New Mexico and Texas where we were able to camp out under the stars. Mama cooked on an open fire and after supper, we bedded down in the car or on the ground. In spite of the coyotes yelping and other night noises, sleep did come.

Some roads were so muddy that the car got stuck. When this happened, Papa would step on the gas, unleashing all the power of the motor in an effort to extricate us. Sometimes we could get the car out of the mud if we all piled out and pushed. Other times, the powerful motor was just too much for the back axle and it would break. Then we had to stay in the nearest town while waiting for a new axle to arrive and be installed.

Upon our arriving home in Texas, Papa's fears were substantiated. Tools were broken or lost, harness for the horses was in ill repair, screens were gone from windows and doors, fences were down and livestock

was neglected and hungry. The furniture shipped to the DeKalb railroad station was hauled to the house with our parents doing the major part of putting things back into the order to which we were accustomed. Irene, Iva, and Leon did their part, also, and soon it began to feel like home again. And about that time I could say, "It's December and I'm five years old."

PROVERBS 22:6

"Train up a child in the way he should go: and when he is old, he will not depart from it."

CHAPTER 2

GROWING UP

When I was quite young I remember sitting on Mama's lap and coaxing her to sing to me. One little song went like this:

> "Rabbit in the goober patch,
> Toodle-ah, Toodle-ah, Toodle-ah.
> Rabbit in the goober patch,
> Toodle-ah, Toodle all the day."

I'm sure there were other little ditties she sang to me but this one stuck in my memory. I could just see that little rabbit hopping around in that peanut field. This activity helped pass the time as I waited for Irene, Iva and Leon to come home from school. I would watch eagerly for them so I could run to meet them. Just maybe they had something left from their lunch for me! I think they sometimes saved a treat for me so I wouldn't be disappointed.

At about age six, I wanted curls instead of that straight hairdo with bangs I'd always worn. I had watched Iva and Irene primping and curling their hair with curling irons. Mama came to my aid. She devised a way for me to have curls! She cut strong cloth strings about 30 to 36 inches long. She dampened my hair, picked out a small length of it and tied

the string around it near the scalp so that the string was divided about one-third and two-thirds. The hair was rolled around the shorter section of the string. Then the longer part of the string was wrapped tightly around the hair going the same direction. The two ends of the string were then tied securely at the end of what was to become a long hanging curl.

This was repeated until all the hair was rolled and encased. I had to wear those dangling, weighty things until my hair was dry. When the strings were removed, I could hardly wait to look in the mirror to see the transformation. It did make a difference. After a few months the routine was abandoned because it was too time-consuming and uncomfortable. Then I was back to "Buster Brown" haircuts with bangs and no more "Shirley Temple" curls (an unknown character then).

Eager To Learn

I was a curious child and very anxious to learn to read and numbers fascinated me. My family, patiently answering my questions, taught me to read, spell, write and do simple arithmetic. The law in Texas at that time required that a child be seven years old on or before September first to enter school. That meant that I was almost eight years old (December birthday) before I could start to school.

The day I entered, Mama asked the teacher to place me in the second grade (skipping primer and first grade) because of what I had learned at home.

GROWING UP

"Give her a chance, but if she can't do as well as the other second graders, I'll be willing for you to place her where she can do the work," Mama said to the teacher. She agreed and since I could do what the other second graders could, I stayed in second grade. Schools had only eleven grades after primer so I was able to graduate in ten years.

Miss Ava Pinkham was my teacher that year and she gave all those students who had perfect attendance a prize. Mine was a folding comb. My, what a treasure! The comb part folded into the green celluloid case. This was before plastic. It was on a beaded chain so I could wear it around my neck. I was so proud of it, I kept it for years.

The fall that I started to school Iva and Irene got an apartment in Texarkana. Irene would keep house for the two of them while Iva attended Texas High School. She had gone as high as Wards Creek taught and by continuing at Texas High, she could finish at an accredited school.

They had been in Texarkana only a month when Irene married Floyd Gibson. Iva stayed with them only a short time; then took a room with a family friend. She stayed with several families until her graduation in 1926.

With Iva and Irene away from home, Leon and I did the chores. Iva visited home during the summers of 1924, '25, and '26. She came home to stay until Christmas Day of '26 when she married Burl Powell.

DAUGHTER OF DESTINY

Iva and Burl moved to California in January of 1927 where they established their home and reared their two daughters, Gloria and Darlene.

For my first nine years of schooling, I attended Wards Creek, a country school of five teachers. The classrooms were heated by wood stoves encircled by a big black metal jacket. There were no janitors so each teacher was responsible for stoking his or her own stove. Some female teachers called on a male teacher or one of the larger boys to lend her a hand.

Of course in those early years we did not have a cafeteria so we carried our lunch in a pail, wrapped in a newspaper or in a paper sack (these were not plentiful). Lunch consisted of some sort of meat and biscuits left from breakfast, a piece of fruit if we had it, and a sugar pie. Now that was a treat! Mama would save a small piece of biscuit dough, roll it out and splash dabs of butter and sugar - with vanilla or cinnamon - on one-half of the rolled out dough. She then folded the plain dough half over this and sealed the edges. Then she fried this in butter. The heat made the sugar and butter melt together into a gooey delicacy. Yum! Yum! Good! I might swap a piece of fruit or a biscuit and sausage for a bologna sandwich with a classmate, but never did I swap my sugar pie!

The school day was made up of classes before and after recess, followed by lunch. After lunch there were classes before and after recess. Then it was dismissal and time to go home. When the bell rang in the mornings and after recess or lunch, we had to get

GROWING UP

in line and march in without any semblance of disorder. Just before the last class of the day, someone would ask for permission to bring in wood for the next day's fire while another would request the privilege of dusting the erasers. These activities were rewards the teacher usually passed around because everyone liked to go outside when he could.

During recesses and noon outside, small girls played hopscotch or "house." Boys played "pee-wee" marbles. They were not supposed to play "keeps" (keeping all marbles they knocked from the ring) but by the end of the day some boys' tobacco sacks were full of marbles while others were almost empty. Next day someone else was lucky. Incidentally, the mothers of these young men soon had to patch the knees of their overalls!

As we grew older, we played "Red Rover," "Crack the Whip" and baseball. I remember we drank cool water from a sparkling spring down under a hill. It was under that hill where I learned about Santa Claus and from where babies came. After I discovered there was no Saint Nicholas, I mentioned it to my mom - much to my regret. While visiting Irene and Floyd, I overheard Irene telling Mama about a pretty doll she could get for Santa to bring me. Mama's words burned in my ears, "Don't bother; she already knows about Santa. He won't be bringing things any more." A doll for Christmas would have been so wonderful! Ordinarily I found an apple, an orange, raisins and candy in my stocking I had hung faithfully from the mantel! Me and my big mouth!

DAUGHTER OF DESTINY

After the walk home from school, I looked forward to a snack. The warming closet of the cookstove was the first place I looked. Sure enough, there were baked sweet potatoes or parched peanuts, still nice and warm. Sometimes there might be molasses cookies or leftover meat and bread. There was always plenty of milk to go with the goodies.

Chores To Be Done

I had to change clothes right away because there were chores to be done. I learned this very early and was assigned to bring in kindling and wood for the kitchen stove and fireplace. During the winter, Papa got up each morning before everyone else, started the fire in the fireplace where he had "banked" the coals with ashes the night before. Then he would take a shovel of hot coals to the cookstove in the kitchen. It was mandatory that I have the kindling and wood awaiting his reach.

After each meal I had to feed the table scraps to the cats and dogs. The food for the cats had to be carried to the barn, for which there was a good reason! Papa always said, "Do it this way because..." In this case, it was so the cats would stay at the barn to catch mice and rats. I learned early if I didn't have a good reason I didn't ask permission to do something. "Just for fun" didn't cut it with Papa. Mama would always say, "Ask Luther." They both believed in "Spare the rod; Spoil the child" and Papa was definitely head of the house! No meal was eaten at our table until Papa asked the blessing. The food would-

n't have tasted right without it. He never varied in what he prayed; it was always the same. I still vividly remember his very words:

> "Gracious Lord, forgive our sins.
> Give us thankful hearts for these
> and all other blessings. Amen."

We were taught the difference between right and wrong as presented in the Bible and saw it practiced by both parents.

Sundays

Sundays did not excuse us from our usual chores, but of course we did not work in the fields. Cows had to be milked, food cooked, beds made, animals fed and barnyard cleaned. Then, dressed in our best, we went to Sunday School and church. There was Sunday School each Lord's Day and once each month our pastor filled the pulpit on Saturday night. He usually stayed overnight with one of the members or drove his buggy home after services, only to return Sunday morning to preach again. After having lunch with a family of the church, he would visit until it was time for night services.

His salary was sort of hit or miss with no set amount. Once he mentioned that he received only twelve dollars and a gallon of syrup for a year's service. That's pitiful! Brother George Pinkham was pastor for many of those early years and he, also, was the recipient of such remuneration.

DAUGHTER OF DESTINY

My Conversion Experience

We usually had a summer revival lasting a week or ten days. It was in the summer of 1928 when I accepted Christ as my Savior, was baptized in a stock pool, and became a member of the Wards Creek Baptist Church. I was twelve years old and had been concerned about the decision I knew I needed to make. I will never forget Pearlie Shafer who was sitting by me at one of the services. She saw I was crying when the invitation was given and urged me to go to the front for prayer. I was **saved** at the altar the moment I asked for forgiveness and welcomed Christ into my heart. I can truly say this was the greatest decision of my life! Without the Lord to help me, I surely could not have made it through the troubled times ahead.

Our Sunday Games

During the afternoon on Sundays, the young people of the community would get together and play town ball. This game was like baseball except there was only one base besides home plate. The bat and ball were handmade: the bat from a limb or board whittled down on one end to form the handle. The ball was made by wrapping string around a small hard rubber ball. The string usually came from raveling out cotton knitted socks.

Another childhood pastime was the "Flying Jenny"! The older boys would center a long stiff pole on a big stump. Then a hole was bored through the middle

of the pole and into the center of the stump. A long bolt or iron rod was run through the hole in the pole and into the stump. Then boards were nailed near each end of the pole for seats and we were ready for a spin. This was great fun and was our version of the "Merry-go-round"!

We always had reading material and were encouraged to read. Mom subscribed to the "Comfort" magazine and we also received the "Semi-weekly Farm News." I liked, particularly, some regular features of the "Comfort" magazine and eagerly awaited its being in our mailbox each month. There was "Aunt Het" with her wise observations, "Ham Bones," a black witty philosopher and the "Uncle Wiggly" stories. Mama read these to me until I could read them for myself. Of course we read the Bible and our Sunday School lessons regularly.

My parents took us to church even when we had to walk and I learned by their example and teaching to reverence God, His Holy Word and His Church.

A New House

In the summer of 1925, Papa decided to build a new house for us. Rev. Jim Phillips, a Methodist minister and longtime family friend, was consulted in reference to building it.

"Luther, have you considered building your house of brick instead of all wood?" he asked. "No, I hadn't," Papa replied. "Could I afford such a house?"

DAUGHTER OF DESTINY

After doing some calculations, they found it would not be out of reach. Papa had enjoyed two or three good crop years so he had money in the bank. Upon investigating, he found he could get the two thousand dollars that he lacked from the Federal Land Bank in Houston. The payments, about seventy dollars each June and December, sounded within our ability to pay so the decision was made. My! My! a brick house was almost unheard of in small towns and not to be found anywhere in the country, as far out as we lived. Word soon spread that the Walkers were building a new brick house!

Iva drew the plans and we moved our furniture into the big old all-purpose building on our property. Our nights were spent with Uncle Sam, Papa's brother, who lived across the field from us. With our personal items now stored or at Uncle Sam's, life was somewhat hectic but we managed.

Most of the lumber from our former house was saved and used in the new one. Bricks were shipped from Texarkana to Bassett by train, then hauled by wagon to the building site. The weather, too, was cooperative and we moved into our partially completed house in December of 1925. Much of the inside work was to be done after occupancy. The house had a large front porch (on the east) extending around and halfway back on the south, a porch on the northwest corner and another on the southwest corner.

Under the southwest porch, Papa and Leon dug a cellar where a Delco light system was installed. Here

GROWING UP

also was the pump for running water. We were really going to be uptown! A brick house, running water and electric lights! However, we later learned we had a problem with the cellar. It collected water when it rained! Since it was not concreted or sealed, water seeped in after a rain. All we could do was bail it out. This happened many times during rainy weather, but I guess having running water in the house and lights to see better was worth the difficulties. The kitchen cabinets and bathroom fixtures, which were to be completed after we moved in, remained on the list "to be done later."

The house had a living room, dining room, kitchen, and three bedrooms, long hall and a bathroom (unfinished until many years later). Also all that room in porches! The upstairs (attic) was floored and used for storage. It was like an oven in summer! No insulation anywhere! One fireplace and the kitchen stove furnished heat in winter and open windows gave fresh air in summers. That was my home in my **growing up** years.

A Musical Family

We always had a pump organ or piano in our home - a pump organ in pre-California days and a piano that we bought in California and shipped back to Texas. Iva was most talented at playing. We all sang in church and around the piano at home.

After Irene and Iva were grown and gone from home, I went to singing schools in summers held at church,

DAUGHTER OF DESTINY

where we attended. Some music teacher would come for a seven-day school where we learned the rudiments of music. This training led to my being able to play the piano for Sunday School and church and to sing in quartets and church choirs later.

My parents loved to sing. I can still see Papa in church as we stood to sing the old church hymns like "Come Thou Fount Of Every Blessing." Standing straight and proud, he would rock heel to toe as he sang with all his heart. Mama had a clear sweet voice that everyone seemed to enjoy.

Once we had an evening of music in our home. All the neighbors who could play musical instruments, e. g. fiddles, guitars, harmonicas, etc. and those who loved to sing or hear music attended and the house was full. I was sitting at the piano playing chords for a guitarist (my cousin) and fiddler (neighbor boy). Upon finishing a number I turned around just in time to see a man, Harvey Tutt, ask my cousin for his guitar. Tutt had a reputation for drinking and making trouble in the community. Papa had noticed him when he came in the front door and was watching his every move.

Harvey, taking the guitar, raised it over his head to hit a man standing just inside the front door. Papa lunged forward, grabbed the guitar before it could hit the intruder's target, as men at the door put the aggressor on the floor. People yelled and ran out the back doors. Some found themselves in the unfinished bathroom at the end of the hall. When Papa was able

to see if Mama was all right, she was! She was sitting calmly in her chair by the fireplace not the least bit excited! Since the troublemaker was unmistakably "under the influence", someone volunteered to take him home. Then calm settled upon the group, we finished our "Musical" and all left for home.

The next day the man who had caused the commotion came to where papa was plowing in the field, just south of the house, and apologized. He asked Papa to convey his regrets to Mama also.

"I just had too much to drink and an old grudge caused me to do what I did," he said.

Papa replied, "I forgive you, Harvey, but don't ever let it happen again." I don't remember our ever hosting another evening of music!

PSALM 119:65

"Thou hast dealt well with thy servant, O Lord, according unto thy word."

CHAPTER 3

FARM LIFE

Being a farmer was not just a matter of choosing a vocation and following it; it was an inherited unique way of life thrust upon one who was born into it. Such was my case. Papa owned 187 1/2 acres of land which fitted four categories: cultivated, pasture, meadow, and timber. The work was hard the days long, especially during growing season. But there were benefits, too. It gave us fresh milk, vegetables, exercise and fresh air plus being surrounded by living, growing things - making us partners with God and nature.

During the long growing season we never caught up - at least on Papa's farm! "Do this while you're resting!" "Do that on your way here or there." He and Mama never ran out of chores.

In the spring, plowing and planting had to be done. Terraces, which Papa had laid off and built, had to be rebuilt. Heavy rains sometimes caused them to break and let the hillside topsoil wash down.

Loads of barnyard fertilizer were hauled to the fields from the rail bins where Papa had very carefully piled it from the barn and cow lots daily since the preceding spring. He was a good steward of the earth

and rightly so for it gave us our living. It was our duty, however, to replenish it with needed nutrients.

Plowing with a turning plow, Papa or Leon would turn under the fertilizer, then make rows or beds for seeds. Each kind of seed was then planted in due season. Papa usually borrowed enough money in the early spring to buy commercial fertilizer and other essentials. He then paid it back when something was harvested and sold later in the year. How much was "enough"? It was usually no more than one hundred dollars. Interest on the money was a straight ten percent on the face of the note, regardless of its being paid in full in a few months or longer. That was a high rate of interest for those years!

Sometimes the bank would require collateral, which was a mortgage on the crop or on real estate. Severe weather could wipe out a crop. Since papa had dealt with DeKalb Bank for many years and had a good record, he was able to borrow on his signature alone. The money was deposited in the bank and no one but Papa could write a check on it. This he did as frugally as a miser!

Mama and I, following Papa's tilling and preparing the soil of the garden, opened the rows and planted the seeds at the proper times. Our vegetables in the garden consisted of onions, cabbage, English peas, Irish potatoes, radishes, green beans, speckled butter beans, greens, beets, carrots and tomatoes. The sage plants were perennial and lived from year to year. The leaves were picked, washed and dried; then they

FARM LIFE

were crushed to be used in sausage and chicken or turkey dressing.

A bed of rich soil was prepared sometime in early spring for sweet potatoes to be buried on their sides. They furnished plants to be set out later. These plants were called "slips" and came up from the eyes on the buried potatoes. When they were grown to five or more inches tall, they were carefully pulled from the bed and set out in rows.

We raised almost everything on the farm: food for the table and feed for the livestock. Cotton was a cash crop, requiring a rather long growing season. It was harvested in late fall and was the final hope of paying back the bank loan.

As soon as I was old enough, I helped with all the work in the fields and assisted Mama, too. Sheep-shearing was a task usually done once a year in May or June. We would herd the sheep into the horse stalls so we could catch them easily. I donned a pair of Papa's or Leon's overalls, went into the stall, picked out a sheep, straddled him and, grasping both hands in his wool, walked him to the shearing table. Soon he was at the mercy of me and my shears or scissors.

Beginning in the middle of his belly, I sheared to the middle of his back. I removed the shorn wool, rolling it inside out. Rolling him over, I performed the same process on the other side. Sheep are docile animals and if the shears nicked a bit of skin, they did not re-

DAUGHTER OF DESTINY

act in any way. The wool was packed into tow sacks and shipped to Sears Roebuck or other wool markets.

As we sheared the sheep, Papa made this observation: "Have you noticed the oil in the wool is very much like the oil of the human skin. It is healing to the nicks in the sheep's skin and it's healing to our own skin if we have a scratch or other break therein." "Furthermore," he added, "it is water-soluble; washes right off without soap. Someone should put this in a bottle and sell it. He could make millions!" Years later someone did put it in a bottle and called it lanolin. Even today it is used in many skin products, cosmetics, and other uses. A country farmer discovered that years earlier - my Papa! But he wasn't a scientist and did not receive any credit for his discovery.

Besides the sheep, we had the usual farm animals and fowls: horses, cows, goats, chickens, geese and turkeys. Goats were useful on the farm. They ate new growth sprouting up around stumps where the land was cleared for cultivation. They were also good for fresh meat for the table. The kid was hung up by his hind legs, his throat cut to let him bleed. Then he was skinned, gutted and cut up. Lots of fresh cold water was used throughout the process to keep the meat from being strong. The hind quarters made tasty steaks. Other parts were made into roasts or barbecue cuts. Whatever way Mama cooked it, we were pleased. This was the good side of raising goats. The bad side I remember was how pesky they could

FARM LIFE

be about getting out of the pasture where we put them. Most of our fences were made of rails, laid in a zigzag fashion. If one end of a rail accidentally fell to the ground, a goat would find it, walk up to the other end and survey the situation (I do believe he chuckled to himself at the prospect of outwitting us humans). Then he would jump to the other side. Soon others would follow unless we hurried to prevent it by replacing the rail. If we were not successful the chase would be on whether there was one or more than one. It was my job to get them back in the right pasture and that was quite a chore!

Having sheep and goats on the same farm could prove a problem if they were in the same pasture. Ole' Billy and the lead ram each wanted to prove he was "king of the hill." When this happened and we heard "bumps" at regular intervals, I had to take a stick and separate them. They fought differently. The ram would back up a certain distance and then run toward the head goat. Ole' Billy would rear up on his hind legs and come down at the precise moment of the ram's arrival, making a loud clatter when their heads hit! Billy had horns whose base was harder than the ram's head. If we didn't get them separated, soon the ram's head began to bleed. He'd shake his head, retreat and return for more. I never understood just how Ole' Billy could time his rearing up and coming down so as to make perfect contact with the ram. Sheep ate weeds from the pastures and meadows. They ate grass, too, so from time to time I had to move them from one pasture to another. Otherwise grass would be eaten down to the roots.

DAUGHTER OF DESTINY

Lambing time either came in late December or early January. If the weather was cold and rainy we had to move the ewes into dry sheds. If she had her lamb before we got the ewe inside, the newborn could die from exposure. If it was able to nurse quickly after birth, the little lamb was safe and soon frisking about its mother. Sometimes a ewe would have twins and as they grew, it was fun to watch them. As they were nursing they would hunch and lift mother ewe off the ground! Simple pleasures of the farm.

We raised geese to eat grass in the cotton field and to furnish feathers for beds and pillows. On goose-picking day we herded the geese into an enclosure so they could be caught easily. Mama sat on a chair or stool while holding the goose or gander on her lap. The feet were securely held in her left hand with the back, neck and head under her left arm while plucking feathers from the underside with her right hand. If she relaxed her left arm and the goose's beak nipped it, she would have a blue spot for several days. Soon her sack was filled with feathers and another feather bed or pillow was in the making for our comfort and joy.

Horses and mules were necessary to pull the plows, wagon or slide; sometimes we rode them. The slide was used anytime we had to go to the fields or meadow a mile or so from the house. Papa built the slide, using two-by-eight inch runners with boards nailed across. The slide was about four-by-six feet with a chain across the front where the mule was hitched to pull it.

FARM LIFE

When I was about 13 years of age, I was plowing "Old Joe" a small, mouse-colored mule. As I approached the end of the row, suddenly he bounded across the field, dragging the V-harrow and me behind him. We bounced across a few rows and he left me in a ditch full of prickly berry vines. When I got up, I checked my moving parts to see that I was not hurt. I then saw my mule running across the field, bouncing the harrow behind him. I yelled for Papa to catch him! As soon as "Old Joe" was under control and I had retrieved my shoe from the briar patch, I continued my plowing. I later learned what had caused my mule to go wild! It was a hired hand dressed in a white shirt and black hat, driving a team of horses up the nearby hill.

We had cows for milk and beef. I was so proud of myself for learning to milk at an early age. I soon found out it pays to just stay ignorant about such things! However, as I learned to do certain things, they became my responsibility. And milking cows is a most distasteful job if it is one's regular assignment. In winter there were sometimes icicles hanging on the cow's long winter hair. I had to hold the milk bucket under the cow to keep water from running into the pail when it rained. Regardless of rain, sleet or snow, the milking had to be done morning and night.

If a fly lit on the cow, she swished her tail and this could be very painful (when it was in your face). In fall, our cows grazed in the fields where crops had been gathered and cocklebur plants allowed to grow

DAUGHTER OF DESTINY

in abundance. Somehow her tail would collect about a quart or more of these, making it a lethal weapon when swished across my face! A most distasteful job indeed! It was certainly an epochal day when the electric milking machine was invented.

A wintertime chore that I always dreaded was hog killing day and the subsequent days of curing the meat. After the hog had been penned and fed grain for a week or two, we waited for a clear, cold day when our neighbor, Mr. Dan Elkins, was available to help us, especially if we were handling more than one.

Papa dug a slanting hole in the ground for the scalding barrel and it was inserted. The wash pot was filled with water and heated to the boiling point; then the hot water was transferred to the barrel with enough cold water to make the temperature "just right" for the task at hand. Meanwhile, Leon had shot the hog with a .22 rifle, and Papa did the sticking of the jugular vein to bleed him. Then the carcass was lowered into the barrel of hot water headfirst. This was turned and moved about till the hair would slip.

The men eased the dead hog out onto slabs or planks covering the ground and his back end was lowered into the barrel. When they were sure all the hair could be scraped off the body, it was eased out onto the slabs or planks on the ground and scraped clean. He was then washed and made ready to hang. A gambling stick (we called it) with pointed ends would

FARM LIFE

be used by the workers to spread his hind legs and hang him on a horizontal pole already in place. The pointed ends of the gambling stick were inserted under the tendons of the hog's ankles, allowing him to swing in the air with his nose about six to ten inches from the ground.

Then the fun began for the men! Papa took a sharp butcher knife and starting at the hog's anus, he cut around it and tied it off. He then began splitting him down the middle of his belly. He eased the knife downward, being careful not to cut his innards. Soon Leon and the neighbor held a tub underneath to catch the intestines. Once these were out, the tub was set on a table so Mama and I could cut the fat from them.

This to me was the most dreaded part! We had to be so careful not to cut the entrails. The fat was extracted, cooled, cut into small pieces, washed and cooked in the freshly cleansed wash pot. The fat had to be stirred regularly and the fire adjusted so that the grease did not burn. When cooked, the grease was put into buckets and was our supply of lard for cooking and frying. The cracklings were well-drained and used for crackling corn bread or to make lye soap. Of course there was other fat from the hog which received the cutting, cooking, and straining process.

The liver, lights (lungs) and heart remained attached to the trachea (wind pipe) and hung up to bleed some more. These were used to make hash, except the liver, which was often fried.

DAUGHTER OF DESTINY

When the carcass was washed down and clean inside and out, it was moved to a table where it was cut up. The feet were severed, the head was cut off and divided into upper and lower parts. The lower part was cut in half and these were jowls. The upper half was split in two with an axe and the brains scooped out. We usually had brains and eggs for breakfast the next day. Quite tasty!

The rest of the carcass was divided into hams, shoulder squares, side meat (middlings) with the ribs removed. The meat from the front legs was usually cut into pieces and ground with other scraps into sausage. The hams, jowls, shoulder squares and middlings were sprinkled with coarse salt and left spread out overnight on the processing table. The salt drew the water out of the meat. Afterwards, the meat was washed and hung on the ceiling joists in the smokehouse to be smoked. The fire for smoking was made in a shallow hole in the center of the smokehouse with short pieces of hickory wood being laid on the low fire. My job was to see that the fire never flamed too high. If it did, a few ashes and another piece of hickory were laid on top to make it smoke and send that sweet smelling smoke around the hanging meat.

This went on until the meat had dried and had been smoked to a golden brown. After this, the meat was taken down and put into the big wooden meat box for specific treatment: a layer of meat, then a layer of coarse salt. This process was done over and over until all of the meat had been conscientiously treated

FARM LIFE

with the formula. Then the heavy lid came down on the box until we were ready for some cured meat.

Another dreaded chore was wash day. Of course the old black iron wash pot, tubs, etc. had to be carried to the wash place, some 200 yards in front of and across the road from the house because that was where the water was. We had a well just behind the house and it furnished water for the stock and to clean animals killed for food. However, it contained so much minerals that we couldn't even wash dishes in it. Soap would curdle and detergent had not come on the scene in those early days of this century.

Fire around the water-filled wash pot soon had the water boiling for the tubs sitting nearby on a makeshift bench (made of planks across sawhorses). The hot water from the pot combined with the cold water from the well made a suitable mixture for the tubs and rub board awaiting the white clothes. More water from the well was added to the pot as we took some out for the tub with the rub board. We used lye soap which we had made from old lard, cracklings and scrap fat.

After we had rubbed the white clothes, we wrung them out by hand and put them into the pot to boil; then we rubbed the colored clothes and had them ready for the pot after the white ones had been boiled and thoroughly punched with the punching stick. Tub number two was filled with cold water and the white clothes were lifted with the punching stick, drained and dumped into the cold water. The colored

clothes were wrung out of the tub and put into the pot to be boiled and punched. Of course the boiling pot by this time needed more cut up lye soap and even some lye. Water was replenished from the well as needed.

While the colored clothes boiled, they were punched again and again. (That stick was our early version of the modern washing machine agitator.) Tub number one was then emptied of soapy, dirty water, cleaned and filled with freshly-drawn cold water. A stick of bluing was swished around in this to help keep the white clothes really white. After rinsing the white clothes through two tubs of water, they were then hand wrung, hung on a nearby barbed wire fence and left to dry. In winter they would sometimes freeze as we hung them out.

The overalls had an extra step: Taking them from the boiling pot, we dumped them on the "battling block" and the punching stick became a "battling stick." The battling block was about three feet high, cut from a two foot thick tree. The stick was used to beat these hot overalls fresh from the pot on that block.

After this treatment, the overalls and other colored clothes (these didn't usually have the "battle" treatment) followed the same rinsing procedure as the whites had received. You can see why it was called wash day. It was a full day's work by the time we took them off the fence after they dried. Ironing was a must, but took another day or most of one. My brother, Leon, wore white shirts exclusively on all dress-up

occasions so the ironing was regular. I used two smoothing irons, heated on the wood stove, in the fireplace or on a fire built outside, depending on the season of the year and time of day. Woe was I if I got a smudge of soot or ashes on his shirts!

Somehow I lived through all those years of milking, plowing, helping with hoeing, gardening, washing, hog killing, sheep shearing, dealing with goats, herding geese, chasing "Old Joe" and came out a strong and healthy girl, confident that (with God's help) I could do anything anyone else could do.

PSALM 27:1

"The Lord is my light and my salvation; whom shall I fear? The Lord is the strength of my life; of whom shall I be afraid?"

CHAPTER 4

PUBLIC SCHOOL DAYS

While I was in the eighth grade at Wards Creek School, word came from Iva and Burl that their daughter, Gloria, was very sick and in the hospital. News from them for some time was very disturbing as Gloria, hardly two years old, seemed to grow worse. The doctors were having trouble diagnosing her problem.

Finally Papa could stand it no longer so he bought a bus ticket for Compton, California. I don't know exactly what he thought he could do but he certainly couldn't do anything if he stayed in Texas, some 1800 miles away. He wanted to evaluate the situation for himself. Few of the crops were gathered so Leon was left in charge of finishing the harvesting.

Papa stayed for several weeks, scolding some young doctors for their "seeming" neglect of his granddaughter. The physicians finally determined that she had acrodynia, a disorder of the digestive system. When she showed signs of improvement, Papa returned to Texas.

Upon his arrival home, Papa noticed a drastic change in Mama. Her knees shook and she could do nothing about it. Hand trembling developed a type of

DAUGHTER OF DESTINY

pill-rolling motion in which her thumbs would rub back and forth across the tips of her fingers. We learned later that she had Parkinson's disease with no known cure. We desperately read everything we could find concerning this malady and had her treated daily for a month by an osteopathic physician. He admitted that he could only give her temporary relief so we reconciled ourselves to a bleak future for her.

As time went by, Mama's joints began to stiffen, her body pitched forward, causing her to walk haltingly on the balls of her feet. I had to take on more of the cooking and housework plus my outside chores.

Backfire

I remember an incident that happened in the spring of my last year in Wards Creek School. I was in the ninth grade and Miss Mary R. Moore was my homeroom teacher. She taught all our subjects except algebra, which was taught by Ennis Harden. Some of the students did not like Miss Moore because she worked us pretty hard and was a strict disciplinarian.

Since we had no spring holidays, the days began to be long and hot. Some of the boys made plans (with us girls agreeing) that we should give ourselves a half-day holiday soon by not coming back inside the classroom after lunch one day. We planned to take our lunch and have a picnic in the woods.

On the set day, Miss Moore's birthday, the morning classes crept by slowly. Our winks and grins permeat-

PUBLIC SCHOOL DAYS

ed the room by us scheming scholars with our teacher suspecting nothing. At noon by one's, two's and three's we drifted from the playground, the spring or from the outdoor toilets to the appointed place in the woods. We ate our lunch and played until the time for school to be out. We thought we had played a good joke on Miss Moore!

When we came to school the next morning, she did not scold us but greeted us as usual. Then the bomb fell! She calmly announced, "I have a special assignment for you." I don't remember exactly what each of the others was told to do but I recall mine quite well. We all were to memorize "Thanatopsis" by William Cullen Bryant and also read and report on a book of Miss Moore's choosing. My book was one for boys, "Tom Brown's School Days"! We could not be promoted to the tenth grade unless we complied.

I was the only one of the group who came back to school the next day - or any of the days remaining! Mama and Papa agreed with Miss Moore completely.

For the remaining three weeks of school (we had only a seven-month school year) I had a ball. Quickly I memorized the poem about death, read the Tom Brown book and made my report. Since I was the only one in class, my lessons were completed early and I could do as I wished the rest of the day (in the classroom of course).

By the end of the school year, Miss Moore and I had developed a close and enduring friendship. She even

DAUGHTER OF DESTINY

combed and styled my hair one day! The Bible states, "... and be sure your sin will find you out." (Numbers 32:23) When I was the victim of a student-trick in later years of teaching school, I thought back to the day of the Wards Creek School incident.

Also through the years I have heard speakers recite these last lines from "Thanatopsis":

> "So live that when thy summons comes to join that innumerable caravan which moves to that mysterious realm, where each shall take his abode in the silent halls of death; thou go not like the quarry slave at night, scourged to his dungeon, but sustained and soothed by an unfaltering trust, approach thy grave like one who wraps the draperies of his couch about him and lies down to pleasant dreams."

I never hear them that I don't think of our birthday trick that backfired!

By the time the 1931 school year rolled around, two adjoining communities, Siloam and Sand Hill, had consolidated and built a school, Cross Roads, where all grades would be taught. Since I had finished the highest grade taught at Wards Creek (ninth), I wanted so much to attend that new school. Some of the other students in my grade wanted to go there too. Cross Roads would have a bus or two to bring in the students. Papa began talking to the trustees of Wards

PUBLIC SCHOOL DAYS

Creek about the bus picking up the high school students. They were against it because they reasoned that if this were permitted, the younger children would want to go there also to the detriment of the Wards Creek school's future.

Therefore, the Cross Roads bus was allowed to come barely inside the Wards Creek district and had to turn around there. The turning point was at the home of Grover and Lona Johnson, some 2.8 miles from our house. I was determined to go to that school and had the full support of my parents. I knew not how I could do it but Mom always said, "Where there's a will; there's a way." I furnished the will!

By this time Mama had become more disabled but she never complained and encouraged me with "God will provide." The bus was scheduled to reach the Johnson place at 7:00 a.m. and I must be there to catch it. We estimated the time it would take me to walk the distance plus time allowed for milking, helping get breakfast, dress and fix my lunch. So Papa got me up at 5:00 a.m. I would bound out of bed, put the biscuits in the oven, place meat or sausage in the pan for frying and then head for the milking stool. Meantime Mama could turn the meat and watch the biscuits so that nothing burned. After milking the cows, I prepared my lunch, dressed and set out for my bus stop destination. Rain or shine, sleet or snow I was on my way by 6:15 each morning. I followed the same path through the woods I had used in going to Wards Creek but continued beyond for two miles. I was soon walking it alone because my

girl friends, who were also my neighbors, started out walking with me, but soon found it a bit too difficult and discontinued. I admit there were a few instances when the going really got rough, but I made it.

One morning, in particular, it was raining when I left home so I wore boots and Leon's slicker. I also carried an umbrella. About the time I reached the public road, the rain became a downpour. Going down a muddy hill (roads were not paved), I had to move gingerly as the lightning flashed. The hill was longer that morning than it had ever been! Arriving at the Johnson house, I poured the water from my boots, put on stockings and shoes (I'd carried them under my slicker with my books) and went right on to school. It was on days like this that I didn't have the best of feelings toward the trustees who would not permit the bus to come closer to my house.

On another morning the snow was falling thickly and the ground was covered. I made it just fine but I learned later that Papa had followed me through the woods because he thought the deep snow might have obliterated the path and I might get lost.

My senior year, Estel Duncan from a different district, boarded with his sister and brother-in-law, who lived on my school path through the woods, so he could attend Cross Roads High School. It was wonderful to have someone to walk with me. He was practicing for track so lots of mornings when I hollered outside the house, "Come on, Estel. Time to go!" He would answer, "Just a minute; gotta sop a bit

more syrup (or gravy as the case might be). I'll catch up with you." Soon I would hear footsteps and then he was by my side. A special bond of friendship developed as we walked to school each day. He became sort of like a brother. Other students joined us on the public road, making the going easier.

In my new school we had a different teacher for each subject. I met and had classes with boys and girls who had gone previously to the separate Siloam and Sand Hill schools. I took part in volleyball, basketball and baseball.

We organized a pep squad and chose royal blue and gold as our school colors. We selected blue overalls and gold shirts as our Pep Squad uniforms. When our sponsor shopped for sateen in those colors, no royal blue was to be found so she bought purple. We each made our own suits. I believe our Home Economics teacher helped us cut them out at school. We looked rather loud (our uniforms of purple and gold sateen) and shouted loudly as we cheered our boys to victory!

A Rumble Seat Ride

I didn't do much dating. I did "claim" Alexander May (better known as Mike May), who would bring J. K. Jackson for Rosa Shafer, my girl friend. She often came home with me from church on Sunday. Her parents did not allow her to go with boys yet so she would meet J. K. at my house. The four of us would hop in Mike's topless Model "T" Ford and ride around for awhile. Our farthest distance was normal-

DAUGHTER OF DESTINY

ly to the Dalby Springs pool or to the Sulphur River Bridge on Highway 67 just west of Bassett. If we were fortunate enough to have film for the "Box Brownie" camera, we would take pictures.

Once, while spending the night with Stella and Susie Powell, Mike (May) and his older brother, Lawrence, were to take us to a forty-two party at a home about two miles northwest of Wards Creek. Stella and Sue lived about the same distance southeast of Wards Creek. The boys came in Lawrence's car, a coupe with a "rumble seat". Instead of a trunk whose lid opened from the back, the "rumble seat" lifted the opposite way. There was a cushioned seat and the lid made a padded back. This was nice in spring or fall but this particular night was in winter and it was cold!

Mike and I were assigned the "rumble seat" while Stella and Sue sat with Lawrence in the front seat. We had not gone far toward the forty-two party when we had a flat tire. Having no spare tire, the boys had to patch the inner tube. While they were getting the patching kit out and making ready for the repair, we girls crawled out and looked for pieces of wood up and down each side of the road. The boys helped get a fire started, then returned to their flat-fixing. No houses were nearby where we could go and stay warm but we probably would not have gone if there had been. We needed to keep the fire going so Mike and Lawrence could warm themselves. Because of the cold and darkness, the tire-patching took twice as long as usual so we decided it would be best to forget

PUBLIC SCHOOL DAYS

the forty-two party, turn around, go back to the Powell home and call it a night! This we did in part. Heading home, we had gone no farther than a hundred yards when the same tire went flat again. The guys had failed to get the tube completely encased in the tire and it pinched another hole. Same process repeated. However, we finally got to the Powell house and the boys went home. We had a fruitless venture that night and I could never recommend a rumble seat ride on a cold night.

Another unusual teenage event that is burned in my memory was when a young man, visiting in the community with his cousin, Myrtis Foster, wanted to escort me to Sunday night church services. While walking home from church that Sunday, Papa and the other adult neighbors walked ahead while we young folks lagged behind. Jack Stewart, the visiting fellow, asked if he could accompany me to church that night. I replied, "I'd like to if my parents will let me. What are the plans?" I knew he was on his way home with Bill Cooper, another young man in the group, who had a car and lived near me. "Bill will pick you up and bring you to Myrtis' home where I'll be and we'll go to church from there," he replied. Bill was well-known by my parents and was well-respected in the community so I felt they would agree to my going with them. I told Jack so.

Late that afternoon after I had explained to Mama our plans and asked her permission, she said, "I think it will be all right for you to go, but since your father is also to be considered in this matter, you must ask

DAUGHTER OF DESTINY

Luther." I ran to the lot gate when it was about time to go and called out to Papa who was in the corn crib shucking corn. I didn't want to face him because he would take up a lot of time asking questions and I was in a hurry. So I said, "I'm going to church with Bill Cooper and some friends." He seldom said an outright "yes" and when he didn't say "no" I felt it was okay for me to go and besides, we always went to church.

Soon Bill and I were at Myrtis' house. While the boys ate supper with her parents, Myrtis and I had to do a bit of primping. In just a few minutes a car drove up and there was a knock at the front door. Myrtis went to the door and came back to say, "Carlene, it's your dad and he said come right now." Oh, miserable me!

I went obediently, telling Myrtis to tell Jack that I was sorry. How embarrassing it was for me, a senior in high school, to have Papa come after me and not be able to go to church with Jack.

"We're going home," Papa said as I went out the front door. We approached the car and I saw that it was Mr. Shafer, a friend who lived about halfway between Myrtis' home and ours, who brought Papa to get me. I thought to myself, "As strict as Mr. Shafer is with his girls, I guess he enjoyed bringing Papa to get me."

Nothing else was said until we arrived at Mr. Shafer's house, where we got out of the car to walk the rest of the way home, which was about one-and-a-third miles

PUBLIC SCHOOL DAYS

away. Papa told me I should have come to the barn and talked to him face-to-face. "But Papa, it was time for Bill to pick me up. And since I'd be with him, Myrtis and Jack, I thought you wouldn't mind. You met Jack coming home from church this morning. And besides, we were going to church. You know I would have been safe." I was afraid to say more.

Mama told me that she and Leon had tried to keep him from coming for me. The next day I had to stay home from school and pick "scrappy" cotton, just a few bolls here and there, scattered over a wide area. When I went back to school on Tuesday, I just knew every member of my classes could see my abashment when they asked why I had missed school the day before and, to be truthful, I had to tell them that I was made to pick cotton. It took a while for my hurt and anger toward Papa to subside because I felt that he had really mistreated me.

Social Fun

I was not a very popular girl socially and felt a little bit inferior or timid in this area of my teenage years. Papa was very strict so I didn't have very many "beaus." I did get to go to an occasional play party, though, when Papa was sure I had a safe way there and back. At these parties we played "Snap," "Pleased or Displeased" and "Old Joe Clark."

In the game of Snap, a boy and girl were chosen to stand in the middle of the room, holding hands. A boy was chosen as "It." As he circled the couple hold-

DAUGHTER OF DESTINY

ing hands, this boy called on one girl from the crowd to catch him if she could. When caught, he would replace the boy holding hands and that boy would sit down. The girl who had been the chooser called on a boy to catch her. When caught, she would replace the original girl, who sat down. This went on till someone suggested another game. In "Pleased or Displeased" we held hands and formed a circle and the person chosen to be "It" would ask someone if he or she were pleased or displeased. This person would usually say, "Displeased." "It" would reply, "And what would it take to please you?" Then the displeased person would say, "I want Tom to get on his knees and propose to Mary" (or some other action). This would bring on the laughter. Some of the requests were quite ridiculous but always clean fun. If the person was pleased, then "It" would go on to the next person and ask the same question.

The "Old Joe Clark" games were similar to the Square Dance like we have presently. Instead of instrumental music and a caller whose calls direct the action of the dancers, the whole group sang and each song had specific actions.

One was: "First two gents across the hall Swing 'em by the right hand; Honor your partner by the left and promenade the girl behind you. Oh that girl, The pretty little girl; The girl was left behind me,

PUBLIC SCHOOL DAYS

> Honor your partner by the left and promenade the girl behind you.
>
> Next two gents across the hall, etc..." The dance goes on till all the boys in the large circle have "crossed the hall" (circle).

Another song with different action was:

> "Ole' Joe Clark is dead and gone, Hope he's doing well; He made me wear the ball and chain, It made my ankle swell. Round and round, Ole' Joe Clark, Round and round I say; Round and round Ole' Joe Clark, Ain't got long to stay."

And another was:

> "Ring up four in the middle of the floor, Shoe tangle, shoe tangle, shoe. Right hand crossed, you don't get lost, Shoe tangle, shoe tangle, shoe.
>
> Left hands back you don't get slack, Shoe tangle, shoe

DAUGHTER OF DESTINY

> One time more, in the middle of the floor, Shoe tangle, shoe tangle, shoe."

One final song was:

> "Great big tater in the sandy land, Great Big tater in the sandy land. Great big tater in the sandy land, So early in the morning. Oh, how I love her, Ain't that a shame, Oh, how I love her, goodbye Liza Jane."

There were many others but this covers some. I'm not sure how the songs and actions originated but it was wholesome activity giving us fun and a way to socialize.

Valedictorian

Time passed and graduation from high school drew near. I wondered about my rank in class and if I'd be able to go on to college. I wanted to continue my education very much but with Mama becoming more and more disabled, I just didn't see how I could leave home and her. The nearest college was East Texas State Teachers College at Commerce, Texas, about a hundred and twenty miles away. Another hindrance was the "Great Depression," which was in full swing and meant that there was no money for room and board. Again, Mama was a "Rock of Gibraltar," vow-

PUBLIC SCHOOL DAYS

ing that God would see to it that there would be a way somehow! She was so patient and good in bearing her sickness, and she wanted me to continue my education. She encouraged me to think positively. I resolved to just take each day as it came and, sure enough, I was valedictorian of my eighteen-member class.

If the school had been accredited with the Texas Department of Education, I might have earned a scholarship. My high school superintendent told me that I should enter on "Individual Approval" if I found I could go to college. When I asked him what I'd have to do, he said, "List your age as 21 because you can pass for that age." His words all but took my breath because what he was suggesting would be untrue. I knew I had to give the idea much thinking and praying.

I was in a dilemma! But if I did not follow the suggestion of my superintendent, I would have to take a college entrance examination and this worried me because I had no high school science. It was not offered in our small country school.

I put this matter out of my mind. I would think of it if and when the circumstances arose. When school was out, I found myself wondering, "Can I really go to college? God, I'll provide the will if You'll provide the way." He had never failed me through all my difficulties. But did I have enough faith to believe I could reach this impossible goal? I knew my ambition to qualify myself academically through college in

DAUGHTER OF DESTINY

that day and time was not as mandatory as it is in the present era. Nevertheless, I had a driving hunger to go farther in presenting myself to God and society as "... a workman that needeth not to be ashamed...." in knowledge, wisdom and expertise.

GALATIANS 6:9

"And let us not be weary in well doing: for in due season we shall reap, if we faint not."

CHAPTER 5

COLLEGE

The summer of 1933 proved to be rather eventful. I made my first trip to the dentist in DeKalb who filled a tooth. I also had a tonsillectomy in Texarkana while I stayed with Irene and Floyd who lived there.

Soon I was home doing the usual things, except now I continued to be concerned about my chances of getting into college. How could Mama do without me? And, where would I get enough money for tuition and board?

By mid-summer, I had found out that many students worked to help pay their board. I also learned of the cost of the tuition per semester and the date for registration.

There were a few businessmen in surrounding communities whom Papa felt might have money to lend. First, we went to see Mr. Hub Meadows, who was a partner in a cotton gin. When he learned our mission, he turned us down because he was sending both a son and daughter to college in "these difficult days, economically." We then approached a Mr. Harris with the same results. A determined third effort went

DAUGHTER OF DESTINY

to the Simms brothers - Harvey and Lim - who owned miles and miles of land and gave their name to the small town of Simms. Surely they had enough capital to lend us enough money for me to get into college. Papa told them how hard I'd worked to get through high school but to no avail. Their answer was "no" also.

I was very discouraged after three denials, but Papa was not giving up; he had one more place to go and Mama kept having hope!

"Carlene," Papa said, "we'll go see Charlie Crump, president of the bank in DeKalb."

"Do you think it will do any good? The others thought I was an unsafe risk." I replied. "They think since I'm a girl I will marry and never work to pay the borrowed money back."

Anyway, we went to see Mr. Crump at the bank where Papa had borrowed and repaid money for years. I was rather fearful, having been turned down three times already. We were ushered right into his office and after Papa introduced me, he told Mr. Crump our business.

"Now Luther, you know these are hard times," he said. "And besides, what makes you think your girl will stay there and finish?"

Papa assured him that he felt I would, based on my determination to get through high school, listing sev-

COLLEGE

eral difficulties I'd had in finishing high school at Cross Roads. The bank's president turned to me and asked, "What do you plan to do if and when you finish college?"

"I want to be a school teacher, Sir," I answered. I had decided on that as I taught Sunday School in church and always enjoyed explaining math and grammar in high school.

"But don't you know we have more teachers than we have vacancies for teachers," he countered. And with that, he started making long rows of C's on paper lying on his desk. Papa told me he always did that when he was doing serious thinking. I wasn't sure whether this was a good sign or not.

While I was contemplating an answer, Papa spoke up. "Mr. Crump, Carlene is a hard worker. We have faith that she can find a place to teach if we can somehow find a way to help her become prepared."

I impulsively added, "I hope to get a job and help put myself through school. Many people do, I understand."

Mr. Crump paused awhile before answering, continuing to make long strings of C's.

Finally he looked up. "How much do you think she can make out on, Luther?" he questioned. "I think she can pay tuition and part of her board on 75 dollars," Papa said. I didn't know how far that would go

but went along with Papa's suggestion. Mr. Crump's secretary was summoned and asked to bring him the appropriate note and he began filling it out. I breathed a sigh of relief!

"I'm making this note out to you, Luther. You've always paid me back. We'll put the money in the bank here and your daughter will have a checkbook to have access to the money as she needs it."

And so it was! I had 75 dollars in the bank and a checkbook to write checks for my expenses at college. This was the most money I had ever had but quick calculations made me realize it would evaporate quickly.

Now I had to find a way to get to Commerce and find someone to stay with my parents. We began to search and found that Mama's niece by the name of Geneva Ritchie would stay with them for a small sum and board.

Minnie Shafer Burden, a good friend, had a car and agreed to take me to Commerce and help me find a part-time job. She already had a year of college behind her and was now teaching on a temporary certificate. She was going to school summers to complete her degree. Minnie was worlds of help to me as she told me what to expect.

For the next few days I got my clothes together, packing them in a large weather-beaten trunk. I had few clothes but the trunk was the only luggage avail-

COLLEGE

able so I've always imagined my clothes rattling around in that big old trunk like a peanut in a coconut shell!

The day finally arrived for Minnie to take my trunk and me to Commerce. I can still see that trunk in the "rumble seat" of Minnie's car. Of course the first thing to do was to find me that part-time job. Typing was not offered in the schools I had attended so I was without the ability to use the touch system in using a typewriter. Therefore, we sought a place where I could work for my board doing cooking and cleaning in a home that kept boarders. We went to several places and finally found a home at 1313 Greenville Street where Mrs. Knight kept boarding students. She hired me. Board and room was twenty dollars per month and she could allow me twelve per month for my work.

"You'll have to pay me eight dollars per month in addition to your work," she informed me. I quickly calculated to myself: Thirty-two dollars and fifty cents for tuition, room and board for four and one-half months at eight dollars equals thirty-six dollars. That would make sixty-eight dollars and fifty cents.

"I think I can manage that," I said and we unloaded my trunk and I had a place to stay.

Minnie took me to the college where I registered. When I filled in the date of birth, I put down a date that would follow the advice of my high school superintendent so I wrote December 23, 1911. Also, as he

DAUGHTER OF DESTINY

had suggested, I entered on "Individual Approval." My schedule was such that I would be at my boarding house most of the mornings and meet classes in the afternoon. I was only a block or two from campus so I fared well.

Mr. and Mrs. Amos Knight became my house parents. Mr. Knight was the town constable and drove an old model Ford car. When he got home from work each day, he went to a little locked cabinet, opened it and was careful that I didn't see what he removed from it. I soon figured it out. He was taking a little "nip" of whiskey! He was tall, thin and if he hadn't been clean-shaven, he'd have been the very image of Abraham Lincoln's pictures.

Mrs. Knight was heavy-set with graying, stringy hair, piercing eyes and false teeth, which she kept in a glass of water most of the time.

My duties included shelling beans or peas, peeling carrots and potatoes, sweeping floors, washing dishes, serving the table and making two pies every day. Those duties might have overwhelmed the average seventeen-year-old girl, but I eased right into my routine because I had done all this before. I think Mrs. Knight soon realized she was getting a lot of work for twelve dollars per month. It was there, with all that practice, that I became a good pie maker. There were three boarders who ate there and two of them were Mr. Hub Meadows' son and daughter, Hubert and Muriel. Muriel was my roommate. Mr. Meadows had no money for my schooling, but he still

COLLEGE

benefitted me without intending to do so. (God's providence at work for His child.)

No one had counseled me on what I should take in college so I selected the same subjects I had taken in high school: English, Spanish, math (college algebra), history, home economics and physical education.

I met Nannie C. Barry (Nan) and learned she lived on Greenville Street, just two doors from me. We became pretty good friends. I went home with her for a weekend and discovered how people lived in the Greenville, Trenton, Whitewright area. When it rains there you dare not step out on that black land. If you do, your tracks get bigger and bigger and your feet grow heavier and heavier as that black mud sticks to your footwear.

I found a church home, First Baptist of Commerce, a member of the Southern Baptist Convention, and attended Sunday School and the worship services each Sunday morning. I didn't even have a nickel for the offering plate but I knew God understood. While registering for school, I indicated my church preference and soon found a warm welcome at the Baptist Student Union building on campus. There I met Miss Everett Whitlock, Student Union Director, who became my substitute mom and confidante.

I started going to Training Union each Sunday night where we studied the Bible and our church doctrine. Dorothy Kenemer was president of the union and be-

DAUGHTER OF DESTINY

came a wonderful influence upon my life. When she graduated, I was chosen - over my protest - to take the presidency of the Ideal Union. I felt so inadequate and unqualified! Mama's encouraging words, "You can do it" of the past led me to accept. Faith kept me going. The first night I served, we had five students in attendance. I was very discouraged. I mentioned Training Union to everyone who would listen and when I graduated, we had 29 regular members and I later learned they divided and made another union. Divide and grow - a good principle!

While home for the Christmas holidays during my college freshman year, Leon married Enois Shafer, sister of Pearlie, who encouraged me to accept Christ; sister of Rosa Shafer, my best friend as a teenager; sister of Minnie (Shafer) Burden, who had carried me to Commerce and helped me so much and daughter of the Mr. Shafer who brought Papa to pick me up at Myrtis Foster's house. Enois proved to be a real sister to me and I was genuinely proud that Leon married her. She was a fine Christian girl and I knew she would be a steadying influence on Leon. They were married on my eighteenth birthday! That would be December 23, 1933. It was Enois who made and brought me a cake on my nineteenth birthday, the first birthday cake of my life. Her thoughtfulness overwhelmed me.

As mid-term approached in January, I didn't know if I would be able to attend the second semester or not. My money had run out! Franklin D. Roosevelt was the president of the United States during that period

COLLEGE

of economic difficulty in our nation and the world. He started numerous Government programs to help our country out of the depression. One of them was the National Youth Administration (NYA) to which I applied and was accepted. Praise the Lord! Again Providence provided.

The spring semester was divided into two parts of nine weeks each and the tuition would be sixteen dollars and twenty-five cents each. Papa told me to stay in school because he was expecting a small check for jury duty service. I could register and start to class without paying tuition for a few days but would not get my books till the tuition was paid. When I told Mrs. Knight my circumstances, she went to her bank and borrowed the money for me to pay my dues. "I want you to be registered and get your books just like everyone else," she said.

I continued working for her and also worked two hours each day on the NYA job in the book bindery of the campus library. Here I learned to re-bind books, clean, mend and trim them to look almost new. We made new backs from cardboard and artificial leather (buckram). Name, author, and classification numbers were even stamped in gold on the outside. By the time the second nine-weeks session began, Papa had sent money to repay Mrs. Knight and I was able to pay my board bill from my fifteen dollar monthly check from the NYA job. Jesse Burks, a senior, was our boss in the bindery and worked four hours daily for the same wage we received. I was serious about my job and was rewarded by his feeling

DAUGHTER OF DESTINY

pleased with my work. This was especially true when the other NYA workers and I tied some pamphlets. Most of them came back unsatisfactory because they came untied when the knots were pulled upon.

"I don't believe those I tied came undone, Jesse," I said. "I tied square knots on the ones I did. I was taught to tie with a square knot and never with a 'granny knot' by my father." I then had to teach the other workers the difference between a square knot and a "granny knot." This time they held.

I talked with Jesse about the possibility of my getting his job when he graduated in May. I also told him of the hardships I had endured to finish high school and to reach this point in college. He assured me he would recommend me to the head librarian, Miss Opal Williams. I was elated!

When the spring term ended, I had not been notified whether or not I had been hired by the college to take Jesse's place so I had to remain in town. Mrs. Knight let me stay on, helping her clean up the apartments behind her house that she rented to male students. Each day I went to the bulletin board where notices were posted. I worked for Mrs. Knight for my total board, anxiously waiting to see if I had the job at the college. Finally my name appeared and I had the job! I put myself through college on thirty dollars a month, completing my requirements for a B. A. degree in August of 1936. This was the same year Texas celebrated her one hundred years of statehood. Back home during my early collegian days

COLLEGE

my parents had many different helpers in our home. Geneva got married and my folks had to find someone else. I always felt bad when they lost a helper and had to spend time looking for a replacement. Often they just made out on their own without a housekeeper while Mama's Parkinson's disease disabled her more and more. In the spring or summer of 1934 she became unable to feed herself. Some of the neighbors told her I should come home and take care of her. She would have no part of that!

"No," she replied, "Carlene has a job now and can make it on her own. We'll make out somehow. We want her to stay in school and get her degree."

Wonderful, patient Mama! When I felt distressed and blue because I couldn't be in two places at one time, her words would come back to me. "God will provide; don't give up."

An Unforgettable Train Trip

In August of 1934 Nan Barry was to spend the three weeks between summer school and the fall semester with me at home. She caught a ride to Wards Creek with some students who lived in our area. I had to remain on campus awhile longer to finish my hours of work and pick up my check. I planned to ride the Cotton Belt train to Bassett, where Nan, along with Boyce Richardson and his brother, Coy, were to meet me. When I went to the station to get my ticket, the agent told me there was no active station in Bassett and it would be dark when I arrived. I mentioned the

arrangement I had made with friends to meet me there and I knew everything would be all right. Foolish words! He was very reluctant to sell me the ticket but I finally persuaded him to do so.

We chugged out of Commerce late in the afternoon and it was a pleasant trip as I anticipated being home for three weeks and having Nan with me. I was dating Boyce and I felt sure Nan would enjoy knowing Coy. My mind was filled with happy thoughts. The sun set and soon it was dusky-dark. I could see lights blinking in the small towns through which we passed. I had no worry about there not being a station master in Bassett for I was confident that my friends would be there to meet me.

As we neared Bassett, the train's conductor came back to my seat and said, "I guess you know there's no station master at Bassett. There will not be a light and it's really dark outside."

I glanced out the window and was surprised at how very dark it looked. All at once I felt an uneasiness I hadn't realized before. The present light in the train was reassuring but I had no idea what awaited me when I arrived in Bassett.

I could tell the train was slowing down and soon the conductor was telling me that we would arrive shortly. I threw my shoulders back, mustered up my bravest smile as the train came to a screeching halt. The conductor escorted me with my two bedraggled suitcases to the exit and then helped me disembark from

COLLEGE

the train and deposited my suitcases on a rickety old platform. "Are you sure someone will meet you here? I don't see a soul or any sign of an automobile," he, with noticeable concern, said.

"Surely my friends will be here soon as they promised," I answered. But my confidence was waning.

He swung his lantern around to indicate readiness for movement, reentered the train and I was left alone. I had never felt such loneliness as the lights of the caboose gradually faded and were swallowed up by the darkness.

I looked around to get some idea of my situation. I could see nothing except total blackness. I could all but feel the darkness even penetrating my clothes. I felt marooned and trapped in a mass of blackness. I opened and closed my eyes trying to adjust to the darkness.

I stood still, afraid to take a step in any direction until my eyes could focus. I looked up into the sky but there was no moon, visible star or anything but, maybe, a lighter shade of night.

Finally, and it seemed such a long time, my eyes could just make out the silhouette of the platform and suitcases. Then I could make out some larger dark outlines that I assumed to be boxcars on a sidetrack. Maybe someone lived there, I thought. I listened and peered anxiously into the dark for a glimmer of light but there was nothing.

DAUGHTER OF DESTINY

By this time I could tell my directions and could see the sky was lighter toward the north where the highway and little town of Bassett were located. I could hear traffic but it seemed so far away. I really began to be frightened. What had happened to my friends? Was the store still open where they could find out where the train would let me off? What if I were stranded for the night!

I looked east where I had seen the caboose lights disappear; I looked north where the sky was lighter and I could hear highway traffic. Then I looked west. Was that a flash of light up in the trees? Instantly, it was gone. Was it a car? I did not hear a noise so I dismissed that thought and waited. There it was again! Waiting and watching ensued for some time. Then I could see it flash more regularly and seemed to be coming nearer.

I could wait no longer so I took a few cautious steps in the direction of the flashes of light. Then I yelled as loudly as I could for help. I got no human voice in response. Only the night sound of frogs, crickets and an occasional owl hoot.

"Please help me, whoever is flashing the light," I yelled at the top of my voice.

I listened and it seemed I could hear muffled voices and the sound of footsteps as they trudged down the railroad tracks, gradually coming nearer. As I listened I could tell the sounds were getting closer and I could also see a light flashing on the railroad tracks

from side to side. Those coming toward me did not respond. As they came closer, I rushed forward with a boldness prompted only by fear. The figures looked like men dressed in rough hunting clothes and boots, carrying rifles and spotlights. They looked wonderful to me, even before I saw their faces.

"I don't know you," I said, "But I'm Carlene Walker from Wards Creek and I need help!" As they came closer, I continued, "I've been hollering for help but couldn't get an answer."

"We're Truman and Vanoy Holley, brothers from Maud. We were down on that little creek spotting and shooting bullfrogs when we heard you yelling. We thought it might be section hands (railroad workers) who live in boxcars down here. Sometimes they get too much to drink and carry on rather loudly. That's why we didn't take the yelling seriously at first. How can we help you?" Truman was the spokesman I learned later.

I explained my situation and soon they had my suitcases and we were on our way toward where I had heard the traffic. That spotlight surely did make a difference.

When we arrived at the small grocery store in Bassett, I introduced myself and asked if three young people, two boys and one girl, had been there asking for me. "Oh, yes, they were here some time ago," the storekeeper replied. "I told them the train wouldn't stop here; it hadn't for years. They went on to Naples

to catch it there." Truman and Vanoy would not leave until they knew I had a way home. After a brief wait, my friends arrived and were as relieved as I. They were in Naples when the train stopped to let off passengers but of course I didn't get off and they could not see me on the train. They were bewildered as to where I could possibly be. We certainly had lots to talk about as we drove home.

Several years later, I was teaching in the Eylau school system when a new principal was selected for our school. Guess who he was! The same Truman Holley who had rescued a frightened college student from a pit of blackness just south of Bassett.

I. CORINTHIANS 15:57

"But thanks be to God, which giveth us the victory through our Lord Jesus Christ."

CHAPTER 6

CAREER

The three weeks Nan visited me passed much too quickly and I found myself back on campus. This time I would do light housekeeping with other girls. Four of us shared a large bedroom with minimum kitchen facilities where each cooked for herself.

Boyce entered college at East Texas State that fall, too, so I had a little more social life but not much. Working four hours each day in the book bindery of the library, cooking for myself and keeping up my grades was a full-time job. Pep Squad bonfires before a big football game, church socials and an occasional movie with Boyce pretty well covered my life socially.

I still had to watch my pennies to stretch that thirty dollars per month to pay my tuition, room rent, and buy groceries. As I saw other students going for a hamburger and coke, I would wish I could do that. It was not possible so I had to put it out of my mind and look forward to the day I could graduate and get a teaching job. Irene and Iva were good to send me hose and other necessities. Occasionally one or the other would make me a skirt, blouse or dress and send it to me. This helped considerably. Time passed and as graduation drew closer, I began wondering if I

DAUGHTER OF DESTINY

would be able to pay for my cap and gown expense and other expenses connected with graduation. When I mentioned this to Irene, my oldest sister, she and her husband, Floyd, let me have $65 from an insurance settlement they had received when Floyd was injured on the job. That paid the bill.

As graduation neared, I sent applications for teaching jobs to the DeKalb School System and to Cross Roads, from which I had graduated just three years before. I was accepted for positions in each of the two schools. I accepted the job at Cross Roads because the work was about the same at each school but I could stay at home and ride the school bus to my high school alma mater. That made it possible for me to live with my parents and be of help to them. With school teaching jobs so scarce, I could hardly believe I had two offers. Mama was right! God does provide. My salary would be $90 a month, which doesn't sound like much now but it was three times the amount on which I put myself through college.

Graduation Day

I shall never forget Graduation Day. I wanted so much for Mama and Papa to be there. They had no car at the time, but Mama's brother, Uncle Otis Howard, had one and agreed to bring them to the graduation ceremony. With Papa on one side and Uncle Otis on the other, they helped Mama up the long flight of steps at the front of the building and into a seat near the back. The date was August 17, 1936 and there was no air conditioning!

CAREER

I can still see those ceiling fans making about one or two revolutions per second. They hung down from the high ceiling about 12 or 15 feet and were still that many feet above our heads. What a hot day! But I was glad that my parents could see me walk across the stage to get my bachelor of arts degree. They had sacrificed so much and I had worked so hard.

My First School Teaching Job

My assignment at school was fifth and sixth grades, teaching all subjects except music. I also taught seventh grade English. Disciplining a few boys was not easy for me at first. After all, I was the same Carlene who had graduated from there just three years earlier and now I was Miss Walker, their teacher. My students soon learned I was to be respected; they also sensed my caring for them so the discipline problems were reduced to a minimum.

I was assigned the privilege of coaching the junior high boys' baseball team. What a joy they were! Just a few days before the Christmas holidays, I caught the mumps. All the boys who had already had that problem piled into John Riley Meadows' car and came to see me at my home. They didn't even laugh at my swollen jaws and bulldog appearance! They told me later that they wanted to but couldn't bear hurting my feelings.

In April most all the schools in Bowie County took part in literary and athletic competition, called a "Field Meet." It was held at the school grounds of the

DAUGHTER OF DESTINY

New Boston school. My boys' baseball team entered the athletic competition and some of my homeroom students participated in spelling. We didn't win in either of the contests but it was lots of fun with students and teachers, alike, enjoying it.

We traveled to New Boston on the school bus but a cousin of mine asked some of my students and me to ride home with him and a friend. He and this friend were home on furlough from the Army. My cousin introduced the friend as **Malcolm Maxwell**, who - I learned - was an older half-brother to one of my students, Sybil Gaither.

As we rode home, I sat between two girls in the back seat and Malcolm sat in the middle in the front seat. Every time I looked at the rear view mirror, Malcolm was staring intently at me. I would glance away but something drew me to look again. His gaze was steady. Maybe he's interested, I thought. He certainly looked interesting to me!

My cousin, Wilburn, delivered each of us home and soon I was back in school, trying unsuccessfully to get that nice looking soldier off my mind.

About a week later we were having a nighttime program at the school. Our car was not running so Papa told me to go home with a student from school in the afternoon so that I could return to the school that night for the program. If he were able to get the car repaired, he would come get me. When considering whom I should go home with, Sybil Gaither came to

CAREER

my mind. Several things entered into this decision, one of them being her good-looking older brother, home for a few days from Army duty.

As we waited for supper in the Gaither home, I sat down at the piano and began strumming "The Waltz You Saved For Me". Malcolm didn't know it but that was about all I could play other than church hymns.

Following the evening meal, I primped a bit and we left to walk to school, only a short distance away. Of course Malcolm and I walked together and got better acquainted. I was hoping against hope that Papa wouldn't get the car fixed and I'd have to spend the night with Sybil. Malcolm asked me if he could take me to a movie sometime while he was home. I replied with a glad "yes." Since he did not have a car, we would go when Wilburn had a date.

I suppose the program was enjoyable but I had other things on my mind! I kept looking for Papa, hoping he wouldn't come. But as luck would have it, I soon spotted him in the crowd. After the program I had to go home. I had hoped so much that I would get to spend the night with Sybil so I could talk with her brother some more. However, we did have a few dates before his furlough expired.

Just before school was out for the summer, I was told I was hired for another year. A few weeks later my home community school, Wards Creek, consolidated with Simms, causing Cross Roads to lose students. Since I had been hired as a tenth teacher, I became a

DAUGHTER OF DESTINY

fifth wheel and was the one who had to be released. There were only enough students for nine teachers. Papa was angry and wanted me to hold them to their contract but I resigned, feeling that I would be able to find another teaching position.

I sent applications to several surrounding schools and soon received acceptance from two of them. My choice was the one closest to home, Hubbard Chapel. I could stay home and drive back and forth.

One day, about a week before the Hubbard Chapel school was to start, a man who had known me all my life, Ivy Gauntt, drove up to our house with three men, strangers to me. I invited them into the house. Mr. Gauntt introduced the men to my parents and me. They were trustees of the Eylau school, where Mr. Gauntt was the principal. It was a nine-grade school about five miles southwest of Texarkana, Texas. Mr. Gauntt sat down at the table with me to do some calculations, showing me that it would be to my advantage to teach with him. Their school year was longer and had already started.

Papa reminded me that I had a school and if I decided to go to Eylau, I should get released from the Hubbard Chapel school. Only then would it be right to accept this offer. I agreed so the men drove me around to the Hubbard Chapel trustees and got me released.

When I asked Mr. Gauntt when I would start at his school, he replied, "We're taking you with us and you

begin tomorrow." "But, Mr. Gauntt," I objected, "this is Thursday. I washed this morning and the clothes are still on the line. Besides, do you want me to start on Friday?" He made it all sound so easy. I would spend Thursday night in one of the trustee's home, teach Friday and Mr. Gauntt would bring me home for the weekend. Meanwhile, he had previously arranged for a place for me to live at Eylau. And so it was; I almost felt kidnapped! Things happened so fast that my head was spinning.

My living quarters were with another teacher, who had rented a two-bedroom-house just off the campus. I had no car, as most of my first year's salary went to pay overdue taxes on my parents' home, so I rode with her when transportation was necessary. We split the rent and utilities and I chipped in on gasoline.

Fire!

Early one morning in the spring, we were awakened by a pounding on our door. The young man doing the pounding informed us that our school building was on fire. He left to alert others while we called the fire department. We could readily see that the school building was blazing brightly. Having dressed, we rushed to the school but there was nothing we could do. It was a total loss! We had prepared samples of our students' work, awaiting a visit from the state inspector whose approval was necessary for maintaining state accreditation. We were absolutely devastated; we had worked so hard and now it was gone. We had to conduct classes in two community churches in

DAUGHTER OF DESTINY

the area to finish the year. The state was lenient with us, other schools loaned us their surplus books and we were able to complete the year. These conditions - meeting in the Methodist and Christian Church facilities - continued through the next year while our new building was under construction. We did get to hold graduation for the ninth grade at the end of the '38-'39 school year.

After the first year at Eylau, I changed my living arrangement and boarded with a nice family living near the Christian Church where I had my classes. Each summer I would return to Wards Creek and stay with my parents.

When school opened in the fall of 1939, I had bought my first car, a blue Oldsmobile. We had moved into our new school building. Another teacher and I had a room with kitchen privileges in the home of Mr. and Mrs. Truman Holley. He was now the principal of the Eylau school and the same one who rescued me that dark night on the railroad tracks near Bassett! Oh, how he enjoyed telling the students how he and his brother found me in the woods, yelling like a cheerleader or a drunk person! He was quite a kidder.

Malcolm was now out of the Army. He stayed with his sister and her husband and had a job at Owens Horse Auction Barn, doing all kind of work around the barn. He also drove a truck carrying cattle or horses to and from other towns. By this time we were going steady. We discussed marriage but decided to wait. My income was small and his even less than the

CAREER

salary I was earning. He wanted to get married on Christmas but I put him off awhile. After all, his birthday on December 1st, mine on December 23rd and Christmas on the 25th were too many special occasions to observe in the same month. We finally chose March 30, 1940.

Soon after the New Year he gave me my engagement ring and we began making plans. We found a furnished apartment nearby and decided where and by whom we would be married. We had no money for a honeymoon so, at the invitation of Leon and Enois, we would spend our wedding night in their home. We selected Brother George Pinkham, longtime pastor of Wards Creek Baptist Church (now affiliated with the American Baptist Association) and the minister who had officiated at Mama and Papa's wedding plus that of Irene and Floyd. He performed our wedding ceremony in his home at DeKalb.

A Close Call

The night before our wedding day, Malcolm's boss sent him with a load of horses to a small town just south of Alexandria, Louisiana. The trip would take most of the night so I decided to go with him. Hauling a live load is difficult even in the daylight because the animals shift to the back of the truck when going uphill and to the front when going downhill. At night, on an unfamiliar road, it's much worse.

We had made it successfully about halfway when the horses shifted to one side and the truck slid from the

pavement on the right side into a hole on the shoulder and splashed muddy water onto the windshield. We could not see our way and for a frantic moment I wondered if there would be a wedding the next day! Malcolm kept a firm grip on the steering wheel plus a cool head and soon the windshield wiper cleaned the muddy water away and we were back on the pavement, no worse for the scare. It could have been a tragedy!

We had no other mishaps and made it back by daybreak to Texarkana. I was going to sleep most of the day so I would be fresh for the wedding but sleep forsook me. I kept seeing the muddy water blinding us and feeling the horses shift. If Malcolm had hit the brakes, the horses could have smashed through the truck's cab and crushed us. God had been with us! He surely had something in the years ahead for me to do.

ROMANS 8:28

"And we know that all things work together for good to them that love God, to them who are the called according to his purpose."

CHAPTER 7

MARRIED LIFE

On Monday morning following our Saturday night wedding, we were in the newly rented apartment and back to our jobs. We lived in that apartment until school was out; then found a small house and moved into it.

We had to pinch our pennies to make ends meet so in the fall, Malcolm joined the Army Reserves to bring in a little more money. War was going on overseas but we felt safe in the United States. Nontheless, in February of 1941, Malcolm was told to report to Ft. Sill, Oklahoma for active duty. It was a sad time for both of us! However, I at least had a job and could support myself. Many wives were not that fortunate. They were unskilled, unemployed, some followed their husbands to army camps, and some moved back to live with their parents. I did go to Ft. Sill to celebrate our first anniversary - the only one we had together until our sixth one.

When school was out, I went to Ft. Sill to spend the summer with Malcolm. We found an apartment with kitchen privileges at Medicine Park, a small village a few miles northwest of Ft. Sill. The apartment was actually one long room extending from front to the back of the house, which was built on a hillside. Win-

dows at the back of the room were shoulder high inside, but if we raised the window and reached out, we could feel the grass growing and see the ground sloping upward.

The front porch was six to eight feet above the ground, then the street was another distance of the same dimensions below this. Two flights of steps were used to come up to the living quarters or go down to the clay and gravel street. A few feet lower was a large stream of mountain-fresh water with a dam below forming a big swimming pool. Just across the pool was a large building containing the bathhouse and a skating rink.

Malcolm deposited me and our belongings and went back to Ft. Sill where he was on duty that night. I really felt lonely in a strange place without him. He was a cook and was on duty 24 hours, then off the same amount of time. When darkness came I sat on the porch and listened to the music from across the pool as a nickelodeon blared out "Three Little Fishes," "Mairzy Doats," "The Hut-Sut Song" and other tunes of the times.

I glanced to my left and could see lights flashing at a distance here and there on a mountainside, and I wondered what it could be. I could also hear a roaring sound (even above the loud music) coming from the same direction. From what we had seen in the daylight hours I knew this was a beautiful setting and I determined to learn more about it when Malcolm was off duty.

MARRIED LIFE

I asked the landlady what were the blinking lights off to the left on the mountainside. She explained, "That's Mt. Scott and the lights are lights of cars winding their way to the top of it. The roar you hear is the water pouring over Lake Lawtonka Dam and flowing on down here. We've had more rain than usual and although the dam has been raised, water is rushing over the dam and makes the roar." Her words made me eager to see it in the daytime.

During Malcolm's first time off duty and each time thereafter, we drove over every road and lane in the area. We were taking chances on those rocky unpaved roads because tires (and many, many other things) were rationed. But we were lucky; our tires held up! The Wichita Mountains were full of manmade lakes so we sought out places Malcolm might fish. There was Lost Lake, Lake Osage, Lake Elmer Thomas, Rush Lake, and Quannah Parker Lake. He didn't try the last one till summer was half over, and it proved to be the best!

For our first trips out, Malcolm bought minnows, but he soon decided that it cost too much so we explored a stream not far from our apartment for catching the minnows. We took off our shoes and started wading upstream. The water was so clear and cool and he dipped up minnows at every little pool. We were thinking of the money we were saving and how good the fish would taste, not noticing that we had gone quite a distance and that our feet were feeling sensitive to the gravel on the bottom of the stream. "Let's turn back, Malcolm." I said, "We have enough and my

DAUGHTER OF DESTINY

feet are hurting." He agreed and we started back to where we had left our shoes. I thought we would never get to them! The distance seemed twice as far as going upstream. I limped on first one foot and then the other. Finally we saw our shoes. By this time the soles of our feet were so sore we could hardly walk. We went back to the apartment, greased our feet and decided to go on fishing.

One day we decided to give the car a free washing. We drove to a place where water of Lawtonka was over the road about six inches. A shallow drainage ditch and some scrubby trees separated the road and the lake. We eased the car into the water, took off our shoes and set them between the front and back seats of the car. We got our rags and began washing the car. We were having so much fun! We splashed each other as we washed the car and soon the job was finished. We had failed to notice that the water level had risen. I looked inside to get rags to dry the car off and our shoes were floating around. I hollered at Malcolm to get in the car and back out. Water was in the exhaust pipe. Then we saw that the car seemed to have drifted closer to the scrubby trees. Malcolm quickly got in and cranked the car. He tried to shift the gears into reverse, but they were stuck. If we went forward the water was deeper and I could see the car drifting into the ditch! We pushed from the front; then from the back trying to rock the car. Malcolm kept working the gearshift and finally was able to get it into reverse allowing us to back out. He drove to a station at Ft. Sill, the attendant drained the crankcase (Malcolm had changed the oil

only a few days before), flushed it out and refilled it with fresh oil. The attendant said we were lucky not to have burned up the motor. Some free car wash!

A few days later Malcolm decided he would use flies instead of minnows for fishing bait. He would drive to Quannah Parker Lake and try out his greenish-yellow flies and a red one he had purchased. He drove up to the water as close as possible and found a large rock, three to four feet in diameter, where he could fish standing. I stayed on the bank while he jumped out onto that big rock. We could see the May flies hovering just over the water, darting here and there, and soon the fish were jumping up to catch them. He tried the yellow fly on his line since that was the same color as the live May flies. Not too much luck! Then he tried the red one. He dragged it on top of the water and the fish began to bite, giving Malcolm a fish at almost every drag. Since I was standing on the bank, I took the fish off the hook and put them in the minnow bucket. It was so much fun; he wanted to stay past the legal time limit to quit.

The summer passed far too quickly and I had to plan my return home. The day before I came back, we were to go to Quannah Parker Lake a bit earlier than usual so I could take some pictures. Malcolm was tying the fishing cane on top of the car, and slid his hand down the cane, sticking the hook of his little red fly into his finger past the shank of the hook. We knew there was no way we could remove it so we drove to the Ft. Sill base and a physician there

DAUGHTER OF DESTINY

removed it. Malcolm told the doctor, "Do what you have to do with my finger; just don't ruin my little red fly." We drove on to the lake and he caught 11 big white perch with that little red fly!

The next day I headed for home. Our time spent in Medicine Park was as near as we ever came to having a honeymoon.

Shortly after my return, school started and I got back into my routine. I continued to live in the small rented house, where I heard the news that Hitler was on the rampage in Europe. I could not help but worry about world conditions. Then on December 7, 1941 Japan attacked Pearl Harbor and we were at war!

Malcolm's outfit was moved from Ft. Sill in February of 1942 to Camp Bowie in Brownwood, Texas. I finished out my school year and resigned. I just knew it would not be long until Malcolm would have to go overseas, and I wanted to be with him as long as he was in the States.

When I arrived in Brownwood, we found a place to live. We boarded with a couple who had two other army couples staying there. One couple was "Puddin" and Bill Lands; the other was Lt. Bob Bryan and wife Ada, who was expecting a baby. It made life much more enjoyable to have other army wives to do things with and we became good friends. Ada was lots of fun and we promised to keep in touch. She and Bob were transferred to Ft. Sam Houston in San Antonio, Texas, where their baby girl was born just before Bob

MARRIED LIFE

was ordered to England. As I expected, Malcolm's unit had to be in New York for departure on January 23, 1943. His last night in Brownwood was December 20, 1942. Of course we had known this was coming, but we kept pushing it away from our minds. We resolved to be brave, so we went to see an Abbott and Costello movie. Their funny antics kept us from being so blue at the next morning's sad parting.

I returned to my parents' home. Almost immediately I was contacted by the James Bowie School System's superintendent to teach first grade. I finished the school year feeling sure those first graders taught me much more than I taught them!

During the summer I received a letter from Mr. Leslie Griffin, the **new** superintendent at the Simms school (James Bowie). It was a survey sent to all teachers to ascertain whether or not they desired to continue teaching at the school. In my answer I told him I wished to teach in the school system, but not the first grade. When Mr. Griffin looked at my transcript, he assigned me to classes in Algebra, girls Physical Education and Geometry. I was able to continue in this place of teaching and stay with Papa and Mama while Malcolm was overseas.

PROVERBS 4:23

"Keep thy heart with all diligence; for out of it are the issues of life."

CHAPTER 8

MALCOLM GOES TO WAR

I didn't hear from Malcolm for quite some time and I began to worry. I continued with my teaching, but prayed every day that he was safe. Ada and I kept in touch, and I learned that Bob, her husband, had been sent to England.

I finally heard from Malcolm that he was fine but had gone through a scary time. About two days out to sea from New York harbor, the troop ship they were on was rammed by a Navy tanker in the same convoy. The only explanation was that they got their signals crossed as they navigated in their zigzag pattern trying to avoid German submarines.

These poems, written by a major and nurse on board, tell the story.

"A Shipwrecked Soldier"

It isn't dark and stormy
On the ocean here tonight,
A little stormy, I would say
But stars are shining bright.

Just why that Navy tanker hit
No one will ever know,

DAUGHTER OF DESTINY

But man she hit a mighty lick
My goodness! It was a blow!

She cut a gash some eighty feet
Along our starboard beam,
And down three decks and on below
Our water line it seems.

And now the bells and sirens sound
"Prepare to abandon ship,
Dress quickly, men, with heavy clothes
To take this icy dip."

The men filed out upon the deck
As calmly as you please,
No other nation in the world
Has soldiers such as these.

We're standing by our stations now
With rafts and lifeboats, too,
Awaiting the Skipper's orders
To tell us what to do.

The ocean waves are splashing high
And spraying on the deck,
And causing chill bumps up the spine
And all around the neck.

We're listing now but still afloat
As time goes slowly by,
The Captain thinks he'll save the ship
At least he's gonna try.

MALCOLM GOES TO WAR

The convoy ships pass one by one
Till all are out of sight,
A lonesome feeling now we have
God knows, I hope we're right.

We've turned about & set our course
To make the nearest shore,
A long way off it is, I think
Eight hundred miles or more.

For days and nights
We splashed along,
And left an oily path
But not a sub sighted: forward or aft.

Of course you know we made it
But you'll never know how grand,
A ship-wrecked soldier feels to know
We finally sighted land!

Major Edwin R. Nash

"Convoy"

Have you ever stood on deck at night
With thoughts of death so near,
You lift your head to the sky above
That your prayers be easier to hear.

Around you water is thrashing
And the wind's a blowing cold,
You reach a hand for something
Just something for it to hold.

DAUGHTER OF DESTINY

There are many with you standing there
with heads turned toward the sky,
And they do not seem to realize
The other ships have passed us by.

Before you, chained closely to the edge
A lifeboat you faintly see,
Will it be necessary to use it
On that rough and raging sea?

A feeling of emptiness arises
As you wait in the black of night,
And you know that others around you
Are filled with the same thoughts of fright.

The sound of a voice at last you hear
Above the troubled waters,
It's hard to believe the words it speaks
"All hands return to your quarters."

The boys with injuries untold
Are brought up from below,
The doctors work to ease their pain
In the many ways they know.

As nurses, we know each minute counts
That there's things **we** can do,
To help the boys in their pain
That compose the unfortunate crew.

The boys we lost will never know
Just what our ship had met,

MALCOLM GOES TO WAR

> But we know the courage they had
> Stays in our memories yet.
>
> And now that fright is over
> We're ready to start again,
> For foreign shore or distant land
> To help and fight to win.
>
> <div align="right">Cynthia Holt, Nurse</div>

The shore on which they had landed was Bermuda. As soon as the wounds were healed and a seaworthy ship was available, they set sail and in due time arrived in North Africa.

Malcolm told of cork trees in the area. As Malcolm's outfit, the 77th Field Artillery, moved eastward, the move was far enough for them to hear the guns as fighting was going on in Tunisia. They heard but saw no action in North Africa.

Having been in North Africa several weeks, the 77th was planning on moving out to join active units in Italy. The evening before his unit was to move out, Malcolm was burned severely when flaming gasoline splashed from a bucket onto his leg from the knee down. He was rushed to a field hospital's surgical unit where it was determined he had third degree burns and had to remain hospitalized.

Several days later, he caught malaria fever and was transferred to the medical unit of the field hospital. While the medics were treating the fever, his leg was

neglected. He lost consciousness (from the fever) and was unable to tell them about his leg, which - days later - became gangrenous. Finally a nurse smelled the decayed flesh and Malcolm's serious condition was discovered. With so many wounded soldiers brought in from Tunisia and other fighting fronts, it is understandable how this problem was overlooked.

Immediately the medical personnel went to work on the infected limb. The putrefied flesh sloughed off and left a hole in his shin. He regained consciousness but had to remain in the hospital for some time. Then he was placed on the limited action list. He wondered about his buddies and wished to rejoin them.

All this time I was wondering why I didn't hear from him. A letter from Ada depressed me even more. Bob had written to her, asking for a divorce. He had fallen in love with an English girl.

"I hope Malcolm is true to you, Carlene," she wrote. Somehow I had faith that he was and had a good reason for not writing.

Sure enough, in a few days I got a letter telling me of his long hospital stay and why he had not written. My faith was justified and my prayers answered.

It took Malcolm a long time to get over his two maladies, and he was eager to rejoin his outfit. Then in December, when he was recovered, he was given the

MALCOLM GOES TO WAR

choice of remaining in North Africa (good cooks were in demand) or rejoining his buddies who were in Italy. He chose Italy! The orders for his sailing group were to cross the Mediterranean to Naples under cover of darkness.

It was December 24, 1943 when they quietly anchored in the Bay of Naples and remained on board. The next morning, just as breakfast was finished, there was a terrible explosion. Some were killed; others wounded. Malcolm was unscathed. It was later learned that the ship broke anchor in the night and drifted out to sea, hitting a V-mine. A V-mine was two large charges of explosives joined by a long heavy chain. The ship hit the chain causing the large explosive devices to swing around and hit both sides of the ship.

Anzio Beachhead

Again there was waiting for another ship or repairs to that one. In due time they left Naples and went by water to Anzio Beachhead.

Here his unit and others dug in. His kitchen was set up below a high railroad track. They were under heavy fire constantly. It was well-known that the Germans were very accurate with their special gun called "Big Bertha" but it was weeks later when they learned the reason why. Finally, with air reinforcement, they were able to advance. The Germans deserted "Big Bertha" and retreated or surrendered, but thousands of Americans were dead and many others

DAUGHTER OF DESTINY

were wounded before this happened. The "Big Bertha" spree had lasted some three to four months.

The Allies located the German's abandoned camp and found the **big** gun. It was so huge it took a flat railroad car to hold it. The barrel was 16 inches in diameter. The railroad tracks ran back into a cave and outside that cave the tracks were camouflaged. This emplacement was situated in the mountains with a perfect view of Anzio Beachhead. Those who made it through this devastation were very fortunate. Many did not!

I learned most of this after Malcolm's discharge. His letters were censored so he was careful to write only what was allowed. At home and school I would read about particular armies being in certain places and wondered where my husband was. I knew from the papers that General Patch was fighting in Italy as was General Patton so I devised a scheme to find out to which army Malcolm was attached. Letters to the military were not censored so I wrote, "Malcolm, if you are in General Patch's army, say something in your next letter about my patching something. If it's General Patton's army, a word about a pat on the back would let me know."

Several weeks went by with my forgetting about this singular letter I had sent. It took quite a while for our letters to reach one another. One day a letter came with the usual greeting; then it said, "I'm so glad you got a new dress but I'm sorry you tore it. But I know you will make it look new again. You are

MALCOLM GOES TO WAR

so good at sewing and patching." My first thought was, "Has Malcolm flipped his lid? Has he broken under the stress of war?" When I told Mama what he had written she was amused. "That's the answer to your question about which army he's in," she reminded me. I felt a bit foolish but was happy that I could at least know the general area he was in as I read the daily newspaper accounts of the war's progress.

The Allied troops moved out of Anzio and finally marched into Rome on June 4, 1944. Two days later, June 6, 1944, American, British and Canadian forces went ashore at Normandy Beach in northern France. It was a bloody and costly venture but it proved to be the turning point in the war. Malcolm's group left Rome sometime later by ship and landed in southern France. The fighting in the European Theater of Operations was fierce and day after day the Allied troops pushed farther into France.

The Enterprising Chef

It is said that an army moves on its stomach and Malcolm saw to it that the soldiers, who were his privilege and responsibility to feed, were well-fed. I was thankful he wasn't in the infantry or a gunner in the field artillery because his chances of coming through alive would have been lessened. Yet he played as important role in the war effort. He told me of taking military issue items, many times, out into the countryside of France, Austria and Germany to swap for dairy products, fresh eggs, fresh poultry

DAUGHTER OF DESTINY

and vegetables to serve at meals so that his men could have the very best that was available.

When the war was over in Europe on May 8, 1945, Malcolm was in Innsbruck, Austria. When peace was declared, I felt sure he'd be home soon.

School ended and Malcolm's letters arrived full of hope that he'd be home before long. That was the longest summer I have ever spent! Soldiers were being discharged from France based on a point system. Personnel with the highest numbers were discharged first. Malcolm got rather discouraged when men with lower numbers than he shipped out ahead of him.

Then in late October I learned he had landed in New York and I knew it wouldn't be long! I also understood that he would go to San Antonio (Texas) first to be mustered out and receive his discharge papers. Finally word came (and it seemed like an eternity) that Malcolm would be home Saturday, November 2nd. I had mistakenly supposed he would arrive later in the day so I'd have time to freshen up after helping Papa with the cream separator on the back porch. Nothing could be farther from the truth! Wearing a purple and gray plaid everyday dress and sloppy shoes, I happened to look up and, breathlessly watched as a car came down our road from the north. I could tell that the car had stopped. Then I heard a door slam shut. I ran to the front of the house, untidy as I was, and there he was! I had prayed so long for this day. My feelings of that moment are beyond

MALCOLM GOES TO WAR

description. He looked so good to me and I think I looked good to him. We had been separated thirty-three months and all that time I had prayed that God would protect and bring him home safely. And He did! Many marriages broke up under the strain while the men were giving and risking their lives overseas for our safety. I had always felt that Malcolm would be true to me and I knew I would be faithful to him.

Of course we exchanged letters regularly while he was away, but we still had lots to talk about. He wanted to know everything I'd done and it gave me a chance to reminisce and share some things I had left out of my letters. He knew that I'd lived with my parents and taught at James Bowie High School but he did not know of a dangerous experience I had had.

A Scary Experience

One Saturday morning I was cleaning house. The weather was cool so the butane space heater had been lit in my bedroom. I had sprinkled some kerosene on my broom to keep the dust down. I'd just swept the floor under the bed and was standing between the bed and a scarf-covered cedar chest, which was under the curtained windows. I accidentally hit the flexible rubber hose, causing it to come off the heater. Suddenly, the gas caught fire and hemmed me in a close place. The flame at the end of the connecting hose ignited the fringe of the scarf on the cedar chest. I had to act quickly! I extinguished the fire before it reached the curtains. But how could I

DAUGHTER OF DESTINY

put out the flame at the end of the hose? I could not get to the turnoff valve at the floor so all I could do was stop the oxygen or gas supply. But all I had with which to do it was a broom with kerosene on it! Thinking quickly, I laid the tight-sewn straw part of the broom on the flame and pressed it with all my might. It worked! The flame went out. I was shaking all over! Papa came in about that time and asked, "Why didn't you turn the gas off at the floor?"

Bursting into tears, I cried, "Aren't you even interested if I'm OK? I couldn't get to it, Papa. I was hemmed in and had to put out the fire before it really caused trouble." I continued, "I was doing just what I had always been taught to do. Stay with a problem until you conquer it."

He then checked to see if I was burned and found only slight burns on my hands from snuffing out the flames on the scarf on the cedar chest. You can bet your boots that we replaced the rubber connecting hose with a copper one pronto!

There was so much to catch up on that Malcolm and I would talk many times far into the night.

We stayed on the farm for the rest of the winter and I finished my school year in May. We spent the summer at the farm, but I could tell Malcolm was not happy. He loved my parents but this farm life was not for him. He worked at the tomato shed in DeKalb through tomato season but that was only temporary. He began to look elsewhere for work. He had a sister

and brother-in-law, Floriene and Reginald Jones, at Nash, five miles west of Texarkana on Highway 82. He stayed with them until he could find a place to buy and, of course, get a job. He did find us a house and we moved to Nash, Texas on September 2, 1946.

PROVERBS 3:5

"Trust in the Lord with all thine heart; and lean not unto thine own understanding."

CHAPTER 9

LIFE AND DEATH

Having lived with my parents during all those months that Malcolm was overseas, I found it difficult to move out. But my place was with my husband and they understood that. Now they must find a housekeeper or a couple to move in with them. This worried me!

Mr. Musgrave, from whom we bought our house, was a school trustee and let me know right off the bat that there was a vacancy in the Nash public school. He took me to the other trustees and I was soon elected. I resigned my teaching job at James Bowie in Simms. How God does provide!

When we moved into our new home, Malcolm did not have a steady job, so for awhile he worked for my oldest sister, Irene, in her upholstery shop. Though appreciative of Irene's kindness, he was not suited to that kind of work so he kept looking.

This looking paid off in discovering there was a grocery store for rent (right down Malcolm's alley). When he mentioned this to Reginald, he said, "Sounds good; I'd like to be your partner," and so it was. The store was next to the Nash schoolhouse and had living quarters in the rear of the building. It was

mutually decided by us that the Joneses would live at the store and the Maxwells would continue to live in their newly-purchased house on Dodd Street.

War Nerves & Stomach Trouble

Malcolm was having difficulty in adjusting to civilian life. He tried to soothe both his pain and anxiety with liquor, which just seemed to make matters worse. He even had nightmares! There were times when he would roll out of bed and down onto the floor, yelling, "Get down, get down! They're coming in fast!"

I would strain every muscle to support and comfort him, saying, "You're home, Malcolm. The war is over; there are no German planes. You're with me, remember?" Soon he would calm down and go back to sleep. (And just think: one man, Adolf Hitler, caused this to my beloved, to myriads of others and God only knows what else!)

Malcolm also suffered a great deal from stomach ache. I often noticed him pressing on the pit of his stomach with his thumb at home and the store trying to subdue the pain. This having gone on for awhile, I was finally successful in getting him to see a doctor. His problem was diagnosed as an ulcer of the duodenum. Malcolm felt sure that the stress of war (and there was lots of it in different varieties) caused or contributed to his having the ulcer so he applied for war-caused benefits. However, a V.A. physician in Dallas, some 180 miles west, vowed he found no sign

LIFE AND DEATH

of an ulcer or any other physical trouble. On this basis, Malcolm sought reinstatement of his V.A. term insurance but was turned down because of the diagnosis in Texarkana. He just couldn't win for losing! So he resolved to live with the nerve-racking pain, hoping dieting would help.

He liked the grocery business and seemed to steadily improve at it. I was glad to see him making the adjustment to civilian life. Students at the adjacent school were in and out of the store before and after school for cokes and snacks. The larger boys loved to kid with Malcolm and occasionally would take him on at arm-wrestling. He loved this; he also enjoyed the smaller children, who seldom left the store without a piece of bubble gum or a stick of candy he insisted on giving them.

We both desired children of our own and the interaction with school kids made us realize it more and more. While we were living in Brownwood, a physician diagnosed me with an inverted uterus which, he said, would make my chances of having a baby very unlikely. Disappointment followed each month that revealed non conception but we kept hoping.

I usually went by the store each afternoon after school to help, if needed, before going home.

Watch Out For That Gun!

I noticed one afternoon that Malcolm was not himself. His speech and the look in his eyes told me he'd

been drinking. P.T.A. was meeting that night and I urged Floriene to go on to it, saying that I would stay and help with late customers and closing up. Something seemed to tell me I might be needed.

Customers cleared out and it was about closing time when I happened to look over to where Malcolm stood behind the counter at the cash register. I supposed he was getting ready to check up and close out the register. **Then I noticed the gun!** Customarily, it lay under the counter but now, it was in his hand. About that time Reginald closed the front door and upon turning back, saw the gun in Malcolm's hand.

"Hey, Mac," he said, "everything's all right. Just put the gun back under the counter and let's close up." There was no reply, but Malcolm brandished the gun in a careless manner. Then he pointed the .38 calibre pistol toward the ceiling and pulled the trigger. Bang! Reginald, not waiting to see what would happen next, made a beeline through the store, living quarters and out the back door!

I really didn't know what to do but I knew I had to do something. I walked slowly toward Malcolm, asking him to give me the gun. My mental calculation was that the alcohol in him was causing him to relive wartime days and that I must deal with him gently. I proceeded toward him slowly, praying that I was doing the right thing. "Please give me the gun, Malcolm." I said softly but firmly. "You're in no danger here. You don't want to injure me or someone else. Please let me have it and I'll close out for

LIFE AND DEATH

you while you go lie down." He then handed me the pistol and after steady insistence from me, left for the living quarters in the rear of the store. Breathing a sigh of relief and shooting up a bullet-prayer of gratitude to God, I hid the gun in a safe place. Then I called Reginald in to help me close up. I thanked God again that I was safe and that no late customers came in during our scary episode.

The Nash Girls' Quartet

Not long after I began teaching at Nash, I spoke to some talented girls about organizing a girls' quartet. They were hesitant. "I've noticed that you sing well at church." I said. "We'll work on gospel songs and I'll help you individually to learn your parts," I concluded. They agreed to at least give it a try. None of them knew much music and I knew very little more. I had gone to summer singing schools as a girl and had taken some piano lessons so I felt I knew enough to at least get us started.

We began with simple church songs and I would play the notes for them individually. **Juanita Braswell** sang soprano and required little help because she knew the tunes. **Lorene Sisk** learned the alto quickly and **LaJuana Harrison** carried the tenor notes. **Charlene Edwards** had a deep husky voice so she sang the bass notes. Of course tenor and bass notes were a bit unusual for teenage girls, but they learned quickly. Soon they were singing in nearby churches and before long, outgrew my ability to help them. **Mr. Braswell**, Juanita's dad, took over their leader-

ship along with help from others who knew much more music than I. They earned quite a name for themselves as the "Nash Girls' Quartet." I was always happy knowing that I had a part in getting them started.

Malcolm's Christian Conversion

During the summer of 1948 our church, the First Baptist Church of Nash, was conducting revival services with Bro. Melton Kressey, of Denison, serving as the evangelist. A family, by the name of Green, living in Hooks (the home of the prominent football player, Billy Sims), but members at Nash, had recommended him.

Many of our church people were interested in Malcolm making a personal commitment to Christ and were praying that he would do so. I, too, had beseeched God on his behalf since early in our marriage. For some unknown reason, we had not been able to reach him. After the doctor had diagnosed his ulcerous condition, Malcolm had quit smoking and drinking. Really he was a good moral man and felt he was as good, if not better, than some of our (weakest) church members.

One night at the revival service, he left my side and made his way down the aisle. He professed his personal commitment to Christ as Savior and Lord of his life and requested church membership. There were many tear-filled eyes in the church house that night and my joy knew no bounds! Soon the "Revival" end-

ed and there was a baptismal service. Malcolm, along with others, was baptized in a nearby stock pond by our pastor, Brother George Hooten, into the fellowship of the church. This was in the days when few of the smaller churches had inside baptistries, as they now have. I found out later that Morris Crumpton, a friend and deacon of our church, had told Malcolm how to experience the "new birth." I was most grateful to Morris and told him so in a Thanksgiving card I sent him later.

A Son is Born

The Texas State Teachers' Convention was meeting in Dallas in the fall of 1948 on a Thanksgiving weekend. By this time Malcolm and I had bought out his partner, Reginald, making us sole owners of the grocery stock. We had also bought the building and lot from Ray Norton, sold our house on Dodd Street and moved into the store's living quarters.

I kept in touch with Ada Bryant through the years, who now lived in Dallas. Malcolm and I discussed my going to the convention and staying with Ada while I was there. Nan Ladd, another teacher, was going with me and Ada welcomed us both to come and stay with her. At the last minute, Mrs. Ladd backed out. I almost did, too, but Malcolm urged me to go on alone.

"I don't know my way around Dallas," I argued, "I've never been in a big city. I could never drive there." But Malcolm had a quick answer, "You can travel by

DAUGHTER OF DESTINY

bus to Dallas, get a taxi at the bus station to get you to Ada's with no trouble. Call a cab to take you to the different sessions of the convention. You will do just fine."

He built my confidence enough that I went. It was good to see Ada again and to also see little Mary Alice, born to Ada and Bob while they lived in San Antonio.

After the divorce from Bob, Ada had remarried, but now she was divorced from that husband and carrying his child. I could tell she was only a couple of months, if that long, away from delivery but she never mentioned it in all our talks while I was there. We even discussed Malcolm's and my wanting children and our inability, thus far, to realize that experience. I kept feeling sure she would confide in me and tell me about her pregnancy but she didn't and it seemed to me that it would be unethical on my part to come right out and ask her about it. The convention was over soon and I found myself back at Nash fitting into my daily schedule.

I had only been home about a week, when a letter came from Ada that would really make some changes in our lives!

In that letter she did explain about her pregnancy and told us she would like to come and stay with us till the baby was born and then allow us to adopt the newborn. We would pay the doctor and hospital bills. Ada was certain the infant would be a girl and would

LIFE AND DEATH

arrive before Christmas. She was wrong on both counts! She asked us to think it over and then let her know our decision. We called as soon as possible, but since she was on a party line, we got very little information. She promised to call the next evening when she could do so on a private line.

The next day was Saturday and we had a considerable amount of time to think and pray about what to do. As the day went by, Malcolm and I would pass each other in the store with that look in each other's eyes of "I wonder what you're thinking, yes or no." That same day our pastor was in the store and we shared our opportunity with him, asking him to pray that God would lead us to know what to do.

"I can't tell you what to do," he said, "but I do know the baby would have a good home and be reared rightly."

By nighttime, when we had to have our answer ready for Ada, we had discussed many things. Taking a baby sight unseen was a big responsibility. What if this baby had a physical deformity? What if this child were retarded? We came to realize, however, that's a chance all parents take with their bringing children into this world in order to have a family. When Ada called, our minds were made up and we had our answer. **We wanted that baby!**

We arranged for her to come stay with us till the baby was born. Ada had told Mary Alice, who came with her, that the Maxwells were going to get a baby

DAUGHTER OF DESTINY

for Christmas. Earlier when Mary Alice asked her mother about getting so fat, Ada told her that while they were visiting us she would see a "fat" doctor and he would take it all away.

We made Ada an appointment with a physician, who advised her that she was in good health and would just have to wait out the <u>allotted</u> time.

Mrs. Musgrave and her daughter Katherine gave me a baby shower and the small community of Nash was in a dither. December the 25th came, and so did Santa Claus but he didn't bring us a baby!

As time passed, we asked Mrs. Gaither, Malcolm's mom, if she would come stay with us to take care of our baby when he or she came. I planned to finish out the school year in my teaching, then stay home with the baby.

I was still at school on the afternoon of January 4, 1949, though it was then four o'clock, when Ada called, telling me she was in labor and strongly advised our heading for the doctor. This is it! Oh boy, I'm going to get that Christmas baby on January the fourth! (Maybe!)

The doctor, upon examining Ada, said, "Rush her on to the hospital - this baby is ready to be born." I did just that. While the nurses were preparing her for delivery, I called Malcolm to bring the things we had prepacked for the hospital stay and I went to buy some lipstick and a magazine. I was getting ready for

LIFE AND DEATH

"the long wait" I'd heard so much about. On returning to the hospital, I met Malcolm in the hall. We headed for the waiting room, when en route we met a nurse and asked her about Ada.

"Oh, she had that baby on the gurney on the way to the delivery room," she answered. "She's back in her room now and both she and her little son are fine." A boy! Ada was so sure it would be a girl. Suddenly, I thought to myself, "What a wonderful way to become parents! I go out to get lipstick and a magazine - I come back and I'm a mother!"

Our little son weighed seven pounds, four ounces, and was twenty and one-half inches long. We were told we could take him home in twenty-four hours after he was circumcised. The baby was named after Malcolm's uncle and father, giving our new son the name of **Robert Sidney.**

Ada stayed an extra day or two in the hospital and then with us until we took her and the baby back to the doctor for their ten-day checkup. Then she with her daughter went back to Dallas. I have seen neither of them since, but Ada and I have kept in touch.

Not long after we got our baby boy home, we discovered we weren't going to get much sleep. In the daytime Mrs. Gaither looked after him and I rocked him at night. Sometimes he would cry until the wee hours of the morning. I would turn him on his stomach across my knees, pat his back, and rock while crying with him. The doctor changed his formula, giving him

one full night of sleep, but then it started all over. As I tried to do my school teaching, words and letters began running together because of my lack of sleep and rest. Mrs. Gaither and I diagnosed the problem as three-month colic. We tried to work out a schedule that would give each of us some relief.

Health Deterioration And Death

Meanwhile, Malcolm's ulcer was giving him fits! He and his doctor concluded that surgery was the only solution; dieting was not enough. So with our baby five weeks old, Malcolm checked into the hospital. The Sunday before, we took Robert to church with us for his first time and it turned out to be the last time for Malcolm. He was so thrilled in showing off his son!

The following Wednesday afternoon, Malcolm was taken to the Pine Street Hospital in Texarkana by the store's (Texarkana, Texas Co-op) student worker, Lavan Power. This was something I strongly wanted to do but Malcolm insisted that I go right ahead with my teaching responsibility.

"I'll go by Penney's, pick up a couple pairs of pajamas and go on to the hospital," he said. "You can come see me tonight." And that is what we did. We thought the surgery would be simple and Malcolm would be home in a few days. Dr. Henry Carney, at the appointed time, did the surgery and Malcolm came through fine, we thought. Some member of his family stayed with him during the daytime and I was

LIFE AND DEATH

there at night. Malcolm desired that such be the pattern. While Mrs. Gaither attended our colicky baby boy, Mr. Musgrave and Lavan ran the store. The morning shift was handled by Mr. Musgrave and the afternoons to closing time by Lavan. Malcolm was now suffering continuously with painkillers having little effect. I discussed his condition with Dr. Carney.

"I live and breathe Mr. Maxwell's case," he said, "I've done this operation many, many times successfully with no complications, but this one has me stymied. If he doesn't improve soon, I'm calling in an internist for consultation."

I had to be content, but oh how I prayed that God would lead the physicians to a solution. They decided to open the incision and take a look, but the morning this second (exploratory) surgery was scheduled, a school bus was involved in a serious accident and injured pupils took all available surgical rooms and surgeons. Malcolm's operation was put on hold.

When the emergency was over, the consulting doctors decided to clip some back nerves, hoping that would give some relief. It did practically nothing toward helping his situation. In fact, his condition worsened. Oh, how it hurt to see him suffer! I would lean over the bed, put my hands under him while he'd wrap his arms around me so I could move and turn him enough to give a little ease. Once, while I was doing this, he looked into my eyes, asking, "Carlene, be honest with me. Tell me what my condition is. Will I

DAUGHTER OF DESTINY

live?" I had begun having doubts about his recovery, but I had to tell him, "Honey, I think you're going to get through this."

Saturday night, February the 17th, I went across the hall to the bathroom. That's where I often prayed aloud, but I never lingered there except for a few minutes. When I reentered his room, I found him sitting on the side of the bed. He had pulled the stomach tube from his nose and had a wild look in his eyes.

"Get my clothes - I'm getting out of here and going to my baby," he said. Realizing he was in terrible shape, I called the nurse. I couldn't reason with him, but I knew his mind was not functioning properly. I asked the nurse to call Dr. Carney and I called Irene, requesting that she come to the hospital. However, her presence just seemed to agitate Malcolm more. He had superhuman strength, preventing our getting him back to bed. I finally, in desperation, had the nurse call a policeman off the street to keep Malcolm from trying to walk out!

The doctor came and after sizing up the situation, prescribed a sedative that knocked Malcolm out. I breathed a sigh of relief as they got him back to bed. It was horrible seeing him in such a pitiful condition. All I could do was pray and wait. Dr. Carney insisted that I go home and rest, which he said, was the best thing I could do right then. When I returned to the hospital the next day after refreshment, I found Malcolm still knocked out and resting. What a joy to

LIFE AND DEATH

see him asleep and not suffering. Friends from the church stayed in the waiting room in case I needed them that night. I did not realize it, but even then he was in the throes of death. He died about 11 a.m. Monday, February 19, 1949.

My Dilemma, God's Answer

As I poured my heart out to God, my prayer led me to question, "Lord, we have little Robert Sidney. It was only last summer that Malcolm was saved and baptized. We were just beginning to live; why do we have to give him up? He had found work he enjoyed. Why Lord, why now?"

Suddenly, a peace settled over me and I knew it was God's presence. His answer was, "Why not now? I protected him through two shipwrecks, I was with him through those weeks he was in the hospital in North Africa, I saw him through Anzio and on into Rome, France, Germany and Austria. I answered your prayers to bring him home safely to you. He is my child and I've brought him home to be with me. You will see him again when you, too, come to be with Me in the place I've prepared for you."

In my heart I had to say, "Thank you, Lord, Your will must be done." And I had **peace** in my heart. Besides, I must look forward. I had a tiny baby boy to rear and I knew God would be with me to help and guide me. I did not know why things happened like they did, but I did know that God is real and, by His grace, I could face the future!

DAUGHTER OF DESTINY

I PETER 5:6-7

"Humble yourselves therefore under the mighty hand of God, that he may exhalt you in due time: Casting all your care upon him; for he careth for you."

CHAPTER 10

PICKING UP THE PIECES

After buying a cemetery lot of three grave sites in Hillcrest Cemetery, I saw to it that Malcolm had a beautiful funeral. Brethren Kressey and Hooten were in charge. Pete and Clara Williams, dear church friends, kept my baby during the funeral arrangements and the actual funeral itself.

I often wonder how people make it through times like this without Christian friends.

Wanda Henderson, president of our church's Women's Missionary Union, directed serving the food brought to the house by friends prior to and the day of the memorial service. Others helped also.

Robert continued to have colic and I didn't have much time to grieve. Frankly, my world (to a large extent) had been shattered but I knew what I had to do. **I had to pick up the pieces left and go on with life!**

I taught school all day and rocked Robert all night! Mr. Musgrave continued to help Lavan in the store, but I had to do the banking, ordering etc. I knew I could not continue this heavy responsibility so I rented the store out but continued to reside in the

store's living quarters at the back. Mrs. Gaither remained with me to look after Robert. She had a birthday on March the twentieth so we decided to celebrate by going to Kilgore to visit Floriene. The only trip recollection I have is that Robert's colic suddenly ceased. How wonderful to get a good night's sleep!

Malcolm had bought a panel truck not long before he entered the hospital. I worried about how I would pay for it because Malcolm had no life insurance. Then, one day, I received a phone call telling me the truck was paid for in full! The debt was insured by CIT which canceled all future payments at the death of the insured. I was able to sell the vehicle for almost enough to pay for a car. God was still providing.

My first effort in renting the store proved to be a flop so my second try was to a distant cousin, Lesley Ramsey, who made a success of it.

Finalizing The Adoption

The fact that Ada had given Robert to us and we had paid her doctor and hospital bills incurred did not finalize the adoption. I consulted an attorney friend on how to legalize and solidify the matter. A case worker from Child Welfare came to the house, investigated the home in which Robert lived, and then contacted Child Welfare in Dallas to secure his birth parents' signature on the papers. Ada had no way of knowing how to find the father so she inquired about

PICKING UP THE PIECES

doing it another way. The child care worker explained that by waiting till the child was two years old, I could adopt him on the grounds of "parental desertion." Ada chose this option and I was advised of her decision. I was disappointed in not getting legal custody immediately and friends feared that Ada might change her mind (and want Robert back), but there was nothing I could do but wait and have faith.

School out, Robert and I escaped to the farm for the summer. Papa had never been an adoption advocate, in fact he didn't see my priceless boy until he was three weeks old. By the time summer was over and our stay ended, Papa was Robert's greatest fan. It was so good being with my parents and being a help to them. Since I wasn't a field hand this time, I got to spend more time with Mama. Her wisdom and observations were astonishing. Sitting in her chair by the east window, she observed the moving of the sun as the earth tilted.

One day she asked me, "Carlene, did you ever see the sun move?" "No, I was of the opinion that it always stood still," I replied. She pointed to a sunny spot and shadow on the floor and said, "Watch that shadow. As the sun moves you can actually see the shadow move." Sure enough, I could see the bright sunny spot and the shadow move. Then she pointed to a certain light pole southeast of our house and across the road quite a ways. "When the sun goes south in the winter (earth's tilt being north) that's as far south as it will rise," she stated. She then focused her

DAUGHTER OF DESTINY

gaze northeast and picking out a certain landmark, said, "That's as far north as it will rise in the summer."

I marvelled that she sat there, unable to move until someone did it for her, but she spent her time observing God's meticulous order of the Universe, never wasting her time whining or bemoaning her fate.

Before school started, we moved back to the living space in back of the store at Nash. Mama came to live with us and I hired Marie Hollingsworth, a recent high school graduate whose family I had known for sometime, to stay with me to care for Mama and my son. Marie loved children and was good with my mom, so she worked out just fine. Papa stayed at the farm but came as often as possible to be with us.

Soon after school began that fall, I learned of a house and three acres of land for sale on N. Pecan Street, fairly close to school. I called the man holding the note on the store to inquire if he cared to finance it for me. He advised, "Offer them $4500, (which was $1500 below their asking price) and I think we can work it out for you." I still owed him $1200 on the store and had never gone it alone before in making a debt of that amount. I made the offer of his suggestion and it was accepted. After the paperwork was finished, I had a lot and a store building on Highway 82, a house and three acres at 470 North Pecan and a debt of $5900! February of 1950 we moved into our new home.

PICKING UP THE PIECES

Time passed rapidly. Papa was now living with us, Marie found a better job and the closest sitter I could find for Mama and Robert lived nine miles from me without any transportation. That meant two eighteen-mile round trips daily for me. This lady could not live with us because she still had school age children. This arrangement lasted for at least two school terms.

Meanwhile, Robert was a handsome, happy baby and growing fast. He began talking at about nine months, but did not walk till he was 17 months old. I could not help but worry and wonder if he had a physical problem, but he didn't. He was just physically lazy!

Church Pastoral Change

Early in 1949 Brother Hooten resigned as pastor of our church. Brother W. B. Carraway (this book's publisher) became our new pastor in June of that year. I was teaching a Sunday School Class and singing in the choir, as I had done since moving to Nash.

Our new pastor was 24 years of age, had just finished his junior year in college, had a beautiful wife (June) and an eight-month old son (Don). He, a former pastor in the Baptist Missionary Association of the State of Texas (he grew up in it), commuted weekly to Henderson State University, located 90 miles east at Arkadelphia, Arkansas, that fall and the next spring to complete work toward a bachelor of arts degree. He graduated in May, 1950, fourteenth in a class of 140. Highlights of his sojourn among us were

DAUGHTER OF DESTINY

a revolutionary stewardship revival and the raising of $10,000.00 toward the erection of a new brick church house, constructed later after he left in August of 1951 to enter Southwestern Baptist Seminary in Fort Worth (from which he earned a bachelor of divinity degree) and pastor (for seven years) the Farmers Branch First Baptist Church on the north edge of the city of Dallas. Among the beloved members who united with the church during this period were O. O. Smith, Lawrence Arrington, Buddy Musgrave, Cleon Howell and family and Alvin Pounds.

Brother Carraway was followed by Brother John Berrier. I was elected Training Union Director and genuinely enjoyed my duties. The church chose to send Louise (the pastor's wife) and me to the State Training Union Convention to be held Thanksgiving weekend in Waco.

We left Nash early Thanksgiving morning in my car with me driving. Kate Martin, a member of our church also, had planned to accompany us, but at the last minute was unable to go. The weather was cloudy and damp. When we neared Waco, I asked Louise to drive so I could remove pins and rollers from my hair and comb it. She had driven only a few miles and I had finished with my hair when she got over too far on the right side of the highway, causing the right wheels to drop off the pavement into deep ruts on the shoulder. Her first reaction was to swiftly turn the steering wheel to the left, but seeing an oncoming car, she quickly turned back to the right. The road was damp enough to be very slippery. Using

PICKING UP THE PIECES

reflex action, she probably hit the brakes because the car flipped twice, skidded on its side, and came to rest in a shallow ditch with the front end of the car facing back toward Texarkana. Seat belts had not made their appearance yet and I remember bouncing about, hitting knobs and the dashboard. When the car did finally stop, Louise was on her knees in the driver's seat with her head and shoulders draped over the back of her seat. Her shoes (pumps) were sitting upright as if she'd just stepped out of them. I was sitting quite naturally, but when I looked myself over, I saw blood running down my right leg into my shoe.

As we stepped out of the car, Louise revealed to me she had no Texas driver's license. **Then she keeled over in a faint!** The Berriers had moved to our church from Louisiana just a few months before and she had not changed her Louisiana license to one from Texas. Not wanting her to get in trouble and, also, since it was my car (and she had been relieving me for a few minutes), I told the investigating officer I was driving.

An ambulance took us to the hospital, where her neck was x-rayed and I was given a tetanus shot. She complained of a severe headache and I had a deep puncture in the calf of my leg.

The car was towed to a car lot and a courtesy car from the convention carried us to the home where we were to stay. The house mother said we looked terrible. Then the courtesy vehicle transported the two of

DAUGHTER OF DESTINY

us to my automobile to get our clothes, and believe it or not, we were on time for the first convention session. I later learned that night in our room that I had purple bruises on both sides and a badly bruised shin. What little sleeping I got that night was on my back.

The Car A Mess

My car was just awful. Every glass was broken out except the windshield and the glass on the passenger side door. I had to get the car road worthy for our trip home on Sunday. A new rear wheel was required and a cardboard improvising took care of glassless windows. An electric pole had left its imprint on the right rear side as though it had leaned over and smacked us with gusto. It was good that Kate had not come; she (in the back seat) could have been killed. Each time, on the way home, we stopped for gas we had to explain the car's pitiful looks. But, nevertheless, we made it home! The dear lady with whom we stayed wrote a poem and sent it to us:

"To The Baptist Convention"

>Two ladies came to my home
>Just after a serious wreck
>One found standing on her head
>The other bruises from feet to neck.

>One's shoes were found missing
>The other's heart beat slow
>Can't say just how the car looked
>But think we ought to know.

PICKING UP THE PIECES

When I met them at the door
Their faces were long and sad
I said, "Don't worry any more
It isn't near so bad.

Be thankful there's no broken bones
Or even an ugly scar
I know it's bad and I'm sorry
But you can get another car.

Since there were no broken bones
And lots of cars to buy
We just decided we would laugh
It would do no good to cry.

Material things mean little
And God has saved your life
One a much needed daughter
The other a precious wife.

Later I saw the car all bent
I said, "Insure against accident
If this should happen another day
You wouldn't have the bill to pay.

Knowing you as I do
I see why Jesus watched over you
Yes, he was there by your side
To care for you, that's why you're alive."
by
Mrs. J.N. Crawley
Waco, Texas
10-14-51

DAUGHTER OF DESTINY

Since I had no collision insurance, the church paid for students in a paint and body class at the Texarkana, Arkansas High School to repair my car. They charged little and did an acceptable job. I was without transportation several days, but friends helped out and with arrival of the Christmas holidays, I got by real well.

Wanda Henderson, the dear lady who had so graciously served the food when Malcolm died, passed away in 1951 to be greatly missed by the church. Our church continued to grow, under the leadership of the new pastor and I kept plugging away at directing the Training Union.

Cows And Old Bell

Papa brought cows and his favorite mule, Old Bell, from the farm. I had vowed to myself when I left the farm I would never have cows to milk if I ever had a home of my own. Papa rented 26 acres behind my property so that the animals would have a pasture for grazing. He was supposed to do the milking, but before long something would come up and I'd have to milk. Papa used Old Bell to plow and make a big garden - big enough for us; big enough for the whole community! He loved raising corn, peas, watermelons, beans, and we even had strawberries. He always grew more than we could use, but he had no trouble giving fresh produce away to the elderly, widows, and others. Of course the boys up and down our street were delighted to get the surplus melons. Loyd Howell, a church deacon and a friend to the Walkers

for many years, was contracted to add on to the small barn on my place so there would be a shelter for the cows and mule. I helped Papa lay off a terrace in the garden to keep the soil from washing down. My dad would put all wet garbage (potato peelings, etc.) and all barnyard fertilizer on the garden. He built up the soil from washed-out clay to rich, productive earth. No wonder we always had a surplus!

Before The Judge

When Robert was two years old, my lawyer and I appeared before the judge to start the adoption process. In 45 days we went back before His Honor, I signed some papers, received legal instructions about the new relationship and Robert was mine! He was such a joy to me. Never was a baby more loved! And he helped to fill the emptiness left in my heart with the death of Malcolm.

A Suitor Comes A Calling

Sometime in 1952, T. Ray Henderson of our community began casting his eyes in my direction. I really wasn't much interested in dating. My time was rather full teaching school, being a mother (and dutiful daughter) and serving as I could in my church. He had lost his wife, Wanda (the wonderful lady already mentioned) the year before. At first I discouraged him, but he had a way with words and was very persistent and persuasive. He was an artist, poet and an articulate speaker. <u>Who's Who in Poetry in the South</u>

DAUGHTER OF DESTINY

and Southwest listed him. So I started dating him and for about a year I was never so "courted" in my life. I reasoned in my mind he must be a fine man to have been Wanda's husband. Besides, he was very active in church, giving devotionals, teaching Sunday School, and even filling the pulpit on laymen's day. But he was rushing me a little too fast; he was interested in marriage.

He presented a strong case for himself. He had taken part in local talent minstrel shows and had close friends, who had performed at the old Saenger Theater, located on the Texas side in Texarkana. They were Arthur Hardin, a juggler, and his wife Eva, who managed the theater. She was the organist with splendid talent and a reputation of having a wide repertoire of music. T. Ray still had his purple and gold satin minstrel frock-tailed coat (convincing evidence). He bowled me over with tales of his accomplishments, and I was gullible. When he wrote and printed in eye-catching design (he was an employee of Southwest Printers in Texarkana) a complimentary acrostic poem to me, I was elated! and who wouldn't be overwhelmed with such flattery!

The acrostic poem he presented to me (and shown at the end of this chapter) just about took my breath away. I consented to marry him - later. I prayed earnestly about this, but I knew he was lonely and I thought he would be a good dad to Robert.

My parents objected to my marrying him because he was 20 years my senior. I delayed my "yes" for far too

PICKING UP THE PIECES

long to suit T. Ray because he had a teenage son, Post, still at home. Combining two households would be very difficult.

Love Is Blind

Not long after we became engaged, Post came to the school where I was teaching, asking if I'd seen his father the night before or that day. "No I haven't." I replied. "Is something wrong?"

"Well, he didn't come home last night and he hasn't come home today." Post said. "I'm getting worried."

"Maybe he's in New Boston at Wanda's relatives. He probably spent the night there." I suggested. I told Post to let me know when he learned where he was and if he was all right.

T. Ray finally did come home and the story he told me of his whereabouts the night before was this: He was home the day before and decided to go to New Boston to see Wanda's cousin. Before setting out, he had taken a few drinks of wine, which the doctor had recommended after Wanda's death because he could not sleep. En route to New Boston he felt sleepy and pulled over to the side of the road to take a nap. He was awakened by a highway patrolman and taken to jail. That's where he spent the night.

He laughed it off but the incident should have raised a **red flag** to me. He took it so lightly and convinced me he was not a drinking man. He assured me that I

DAUGHTER OF DESTINY

had nothing to worry about. However, I did wonder why he would be arrested and jailed if his story were true.

The matter faded from my memory and we set a date for our wedding. We would maintain both places with T. Ray spending as much time with me on North Pecan and I with him at his place as we could. This was not exactly an ideal way to begin a marriage, but we could still have a considerable amount of time together.

So we were wed in June of 1953 at Fouke, Arkansas, in the home of Brother George Hooten, a former pastor of our church.

PSALM 51:6

"Behold, thou desirest truth in the inward parts: and in the hidden part thou shalt make me to know wisdom."

IN MY HALL OF FAME

To you, my. . . .

C ONFUCIUS was a man of wit,
 A sage, so I've been told,
 The Chinese prized his epithets
 As if they were pure gold.

A ND then we have Napoleon
 The idol of all France,
 Who came to grief at Waterloo
 Because he lost his pants.

R APHAEL, the artist of,
 Madonna and the Child,
 A painter of the arts and science,
 Is putting it too mild.

L INCOLN also holds a place,
 High in the Hall of Fame,
 And one can justly feel a pride,
 At mention of his name.

E INSTEIN is the genius,
 Who harnessed—split—the atom,
 The Russians do not care for him,
 Because it can get at 'em.

N OW you have read, and quite agree,
 The ones above are greater,
 I thought so too, until I found
 Another one still later.

E XCUSE me please if I refuse,
 To pen my choice here,
 Let this suffice—I think she's nice,
 You see, she is, "My Dear."

T. RAY HENDERSON

CHAPTER 11

DIVORCE

Filling the role of devoted wife, obliging daughter, mother to a small son, and public school educator proved to be a big assignment. I'm sure I, as a wife, did not do a lot of things that a new wife should do. T. Ray spent much of his time with me at 470 North Pecan and I reciprocated by being with him at 600 New Boston Road. The two places were about one-half mile apart. We soon set a routine, which functioned rather satisfactorily. My new husband loved Mama and Robert; he tolerated Papa.

It wasn't long until Post finished high school and married Pauline Lindsay about a month later. They lived in T. Ray's house and he moved in with me. Few adjustments had to be made because he left all the furniture in the home for his son and daughter-in-law, bringing his clothes, personal things and little black dog, Peewee, to my place. Robert and Peewee became immediate friends.

T. Ray, being a typesetter for Southwest Printers, was well-read and had a broad vocabulary. We could always find common ground for discussion. He also knew how to please a lady and, occasionally, would surprise me with gifts. They were always nice and in good taste. One gift he gave me stands out above the

others. It was a beautiful black beaded blouse, far more expensive than I would have ever bought myself. Then when my birthday came, I walked into my kitchen to find a gorgeous cake on the table. One day, upon arriving home from school, he handed me a picture he had painted that day. It was a rustic scene of rolling hills, winding road, trees, and a cabin with smoke rising from the chimney, done in appropriate colors of pastels. He could be so thoughtful!

There were times between big jobs at his place of employment that he wasn't needed, giving him several days of vacationing at home. On those days he worked in the yard, leveling the ground, tending the lawn and flowers. He took a keen delight in making things look their best. He built a picket fence, made an arched gateway and our home was the prettiest place on the street.

In the summer of 1954, T. Ray suggested we take a trip to Colorado Springs, Colorado. A home for retired printers was there, about which he had told me. His terms just glowed as he talked about this home and he wanted me to see it. He also had, voluntarily, mentioned that he would be living there when and if his health failed in old age. He assured me that I would never have to look after him if he became an invalid in his later years. So we planned the trip for July, expecting to be gone about ten days at the very most. We had made arrangements with some of the neighbors to check from time to time on Mama and Papa.

DIVORCE

We took off and spent our first night in a small New Mexico town. Robert began complaining about jaw pain when he ate certain foods. I wasn't sure as to what it could be, but by morning there was no doubt. He was taking the mumps! Assuring us that he felt well enough to travel, we continued our journey. We thought it best to keep him away from other children, if possible, and if he had fever or other complications, we'd see a doctor in Colorado Springs. Much to our satisfaction, he did all right and was able to take the Pike's Peak tour with me. T. Ray did not go with us because he was allergic to the high altitude, but insisted on our going.

We saw snow on the ground at the higher elevation, and as we descended, sleet could be seen in the roof valleys and gutters of the houses. It was an unusual sight for us in July.

Then we drove out to see the home for retired printers where T. Ray visited with some old timers he had met while hospitalized there a few years earlier. The trip was good for T. Ray and me, giving us a breather from the stressful two-family situation at home.

T. Ray changed the fence between the yard and the barn lot. He had my permission, but Papa was rather disgruntled because he liked it as it was, and thought it was being changed just to spite him. Papa was very plain-spoken and blunt almost to the point of insult. He had no use for flattery and T. Ray was a master of it! Mealtime was difficult because there was most-

ly silence or conversation that led to conflict. Mama, Robert, and I would make light conversation to ease the tension. Two men were never more different! They were each jealous of any attention I showed the other. I was being pulled in two directions, making it extremely difficult to keep peace in the two-families-under-one-roof arrangement.

With the passing of time, I realized that something had to be done to keep a semblance of peace and, also, for me to retain my sanity. I talked with T. Ray about a possible solution. Our conclusion was that I build a house for my parents on the north end of my three acres. They were agreeable. I'm sure they wanted relief from the tension as much as we. My house was on the south end so that would leave the garden between us. What Papa could not do for Mama and himself, we could hire someone and I would be available to help as needed.

Leslie Ramsey did the building and, with Papa providing lumber from the farm, I bought the other necessary materials and a snug little house was the result. We settled them in during the summer of 1957. I hoped against hope that the move would ease the stress I had felt.

The Orrs

When T. Ray wasn't working, he spent a lot of time drinking coffee with Brother Orr under the pear tree in his back yard. The Orrs had moved into a small house just south of me since shortly after I had come

there. He was a retired minister and was subject to blackouts. They were diagnosed as epileptic seizures, which usually attacked at night or early morning. When they occurred, Mrs. Orr would call for me to come over to help turn him off his back onto his side, which caused the seizures to subside quicker. She was unable to handle the matter alone because of her husband's size and weight - 300 pounds. Mrs. Orr waited on him constantly, fulfilling each of his many demands. One day, after getting his cigarettes, fixing his chair just so, and serving him coffee, she sat down only to have him say, "Mama, what do I want?" When she was working in the yard or garden, out of sight, while he was sitting under the pear tree drinking coffee, he would ask me, if I happened to be nearby, "Miss Carlene, where's Mama?" Each time I told him, he would say, "I just get so lonesome for her." He was quite a character! They had no car so I often took Mrs. Orr shopping and we worked together in the yard and garden during summers. She was a wonderful lady.

The Van O. Martins

Brother Van O. Martin had assumed the pastoral reins of our church in 1954 and his wife started teaching at the Nash public school soon after. We worked together at school and church and became the best of friends. She wanted to finish college work toward her bachelor's degree and I was ready to start working toward a Master of Education degree. The two of us were school girls in the summer of 1957 at East Texas State University's second summer school

session of six weeks. We came home each Friday and returned on Sunday afternoon. We followed this schedule the entire summer of 1958 and completed our individual requirements. Jamie Holcombe, another teacher, also attended ETSU with us that year, and earned her master's degree. The three of us spent a lot of time together when not in class. I can still see us walking to town or on campus with short-legged Jamie having to take two steps to one of her long-legged companions in order to stay abreast of us! We would apologize and slow down. The three of us formed a bond of friendship that lasted through the years.

Robert Finds A Diamond

One Friday afternoon I arrived home from college to be greeted by an excited son. "Mother," he exclaimed, "I found the set from Daddy's ring." Sure enough, after a rain shower, Robert was playing in the dirt beside some hedge bushes and found something shiny. He took it to T. Ray and asked, "Daddy, could this be the set that you lost out of your ring?"

I remembered that T. Ray had told me that he had lost the set out of Wanda's ring, which he wore on his little finger. It had vanished several months before as he was digging some post holes in the back yard. Thinking it could not possibly be that stone, he looked at the shiny object just to please his stepson. To his amazement, it was the lost diamond! He could hardly believe his eyes! It would be phenomenal for such a thing to happen once in a million years. It was

DIVORCE

remounted and given to T. Ray's son, Post, who treasures it in memory of his two deceased parents. Post was an only child of T. Ray and Wanda.

T. Ray had not done a lot of drinking while Papa and Mama were living with us, but later it became more frequent and he became verbally abusive. There were times when he, becoming angry, would take his clothes and go back home where Post and Pauline now lived. Usually this was during heavy drinking. I wouldn't even know why he left, but later I would learn that Papa had come by to leave a message for me. When T. Ray would sober up, he would beg to come back, and I would let him because I wanted so much for the marriage to work out. Of course his son and daughter-in-law soon tired of his going there to drink.

John Barleycorn Wins The Contest

One Sunday T. Ray filled the pulpit at College Hill Baptist Church, a small country church several miles south of DeKalb. He came home elated. A lady had come forward to profess her surrender to Christ and join the church. I was pleased for him and happy that they had invited him to go back the next Sunday. But he didn't go! Instead, he went to town, got a bottle of whiskey and spent the day drinking. That just about did it for me! My faith in his sincerity and promise to cease drinking was shattered. When I would speak to him about getting professional help with his drinking problem, he would scoff, "I don't have a drinking problem; I can take it or leave it!" Understandably, it

DAUGHTER OF DESTINY

became increasingly difficult for me to not only feel love in my heart for him, but respect as well. Yet my tears soon turned to quiet acceptance - for awhile.

In the spring of 1959, my doctor discovered that I had a fibroid tumor in my uterus. He said there was no urgency and I could wait until school was out to have surgery.

In June of that year I had a complete hysterectomy. When the incision to remove the tumor was made, a serious case of endometriosis was revealed, necessitating a full hysterectomy in order to guard against cancer.

My stay at the hospital was short and soon I was home. My oldest sister, Irene from California, came for a vacation and to be of service if I should need her in my recuperation. Of course I was weak from surgery and certainly neither physically nor emotionally ready for the two bombs that exploded in my life on the day T. Ray took me to the doctor to have my stitches removed!

Shocked And Hurt

We were early so I asked him to drive me by a department store downtown to buy something in the piece good's section. I managed to hold to the handrail and get down to the basement where I needed to get the items. I had known the lady who waited on me for some time and one of her daughters had been in my homeroom just the previous school year. While

DIVORCE

I was sitting on a stool looking at materials she brought, she suddenly said, "I've been wanting to talk to you about my daughter's role in the end-of-school play which you directed."

"They did a very good job didn't they?" I replied. Then I noticed there was anger in her eyes and facial expression. She continued, "You know my daughter is the prettiest girl in that class and should have had the heroine's part, but you cast her as the family cook, a black character."

"But I didn't cast the characters according to beauty and I certainly showed no favoritism. When I had them read for parts, she was the only one who could talk and act that part," I said in defending my actions. I further said, "I felt it was a compliment to her that she could fill a role no one else could." The irate mother acted as though I had not spoken and still proceeded to berate me for putting her daughter in that role. Her attack caused me to feel faint; it had come so suddenly and without warning. I said no more, and managed to get back up the steps and out to where T. Ray was waiting in the car. I couldn't discuss what had just happened without tears so I did not mention it to him.

Getting the stitches out was minor. I noticed T. Ray was silent, but I thought it was because I was not talking. I was not at all prepared for the bomb he dropped on the way home! "When you get on your feet, I'm giving you back to your family," he said. "You're a career woman. You have never been a wife

DAUGHTER OF DESTINY

and you surely won't be one now." He went on to say, "Now you're just a shell of a woman, devoted to your job and parents. You have no time or capabilities to be a wife."

Stinging words, but I knew my time had been stretched in too many directions. Maybe I hadn't been a good wife. I thought I was doing my very best, I reasoned to myself. He had known all the circumstances when he had asked me to marry him. I sat silently all the way home, pondering his every word. I knew he was sober and meant what he had just said. I wanted to pray and think it all through very seriously before responding.

Sleep forsook me that night because I had to make a lifetime, irrevocable decision. I thought, first, of the good things in our union. He had been good, at many times and in numerous ways, to Robert and me, but I also had to consider his drinking, his unjustified and unprovoked anger, and his caustic verbal attacks. Before the day dawned, I knew what I had to do.

The morning following his announcement to me, we finished breakfast and T. Ray went to the bathroom to shave. I called to him saying, "I have something to discuss with you. I have my answer for what you said to me yesterday. Please come to the kitchen when you finish shaving."

I was still weak - very weak - from surgery but I had strength from a Higher Power and was prepared to speak to him when he came to where I was. Irene got

DIVORCE

up from her chair to give us respectful privacy but T. Ray insisted that she stay to hear what I had to say. If he wanted it that way, it was fine with me.

"T. Ray," I said, "I've given serious thought to what you said to me yesterday. We need not wait until I'm on my feet; I believe you can find a place to live in two weeks, and I want you to move out by then. I'm tired of your drinking, the Yo-Yo, back-and-forth, in-and-out type of behavior you've been practicing. I want you to go now; I can make it all right."

Later in the morning he asked me about getting a divorce, saying he had found someone else. Divorce had not been in my thinking when I demanded his departure. I just wanted a separation, a permanent one this time. Too, I sort of doubted he had a new girl friend or wife **in mind** but I let that opinion pass.

"You'll have to get the divorce," he said, "I don't have any grounds." I believed then it was a valid rule that in Texas, one didn't need particular reasons for divorcing a mate but just the desire to not be married any more. But I remained silent, feeling that what he was really saying was that I would have to pay the expenses, and I was willing to do that just to have peace of mind.

Moving was more complicated for him because he had worn out his welcome with Post and Pauline with his drinking; a terrible shame, he was such a talented man. As I recuperated, he searched for another place

to live. One afternoon I was doing some finger sewing on a dress and he joined me in the back yard. He became argumentative and critical, showing me plainly that he was somewhat intoxicated. Jo Ward, a neighbor, had called a bit earlier to tell me that she would be visiting me about three o'clock. Not wanting her to see T. Ray in his condition, I called Loyd Howell, a deacon in our church and lifetime friend of our family, and asked if he would mind taking T. Ray for a ride. Loyd knew the situation because I had confided in him when the going got (real) rough in the past. He came, took T. Ray for a ride so I could visit peacefully with Jo.

Later that same afternoon, T. Ray was having coffee with Brother Orr and I thought by then he had sobered. I was washing out the hemline of a dress on which I'd been working. I heard T. Ray as he came through the back door and even before I could look up, his coffee cup hit the splashboard right in front of me, sending pieces of pottery in every direction.

His eyes showed that he was still under the influence of liquor. I did not think he was throwing the cup at me, necessarily, but had thrown it out of the frustration he was feeling over the difficulty of finding an apartment. I also realized that, due to the circumstances, his thinking was not normal.

To add insult to injury, however, he grabbed hold of the dress I was washing and refused to let go, eventhough I asked him to several times. Irene, heard the commotion and eased up on the side of T. Ray to aid

DIVORCE

me if he became physical. As he gave a hard yank on the dress, I **slapped** him across the face! My blow broke his cigarette into bits and he turned loose. Irene felt his arm muscle constrict, but he did not retaliate.

I was not proud of what I had done. I had never, ever slapped a person before, but that seemed to be the only way to bring him back to reality.

He finally found an apartment within the two-week limit and moved out. Meantime, I had discussed the conflict with Post and Schley, T. Ray's brother, with both of them assuring me they understood perfectly well. I deposited some money in an account for him because I did not want to be further obligated to him in any way. Pauline agreed to keep my car and take me where I needed to go, as I was unable to drive for six weeks.

I filed for divorce as soon as possible, which became final the following September. There had never been a divorce in our family and I was deeply sorry that I was the first. But it seemed the only way out and the thing, in such a case of cross fire, to do.

Perhaps in marrying T. Ray I had taken a detour from God's direct will for my life, but He had permitted it and I tried to learn from the experience, taking the good and **trying** to forget the bad.

T. Ray remarried after a few months, an unhappy one I was told. He later developed larynx cancer, due

DAUGHTER OF DESTINY

(possibly) to his many years of heavy smoking. The voice box was surgically removed and replaced by a small metal device. I did not see him after his surgery, but I'm sure he was miserable. He loved so much to talk and was a very good speaker.

After surgery he could only speak in guttural sounds and only when he placed his finger over the hole in the gadget replacing his larynx. He lived only a few years following the surgery.

Thus ended the life of a very talented and unusual man, whose life touched mine for six years.

PSALM 119:92,93

"Unless thy law had been my delights, I should then have perished in mine affliction. I will never forget thy precepts: for with them thou hast quickened me."

CHAPTER 12

A MAN AND A MULE

The 1959-60 school year was not an especially eventful year. Robert was ten years old and had gone from thin in the first grade to husky. He had found out by doing kitchen chores for the school cooks he could go back for seconds of his favorite foods. He was now in the fifth grade and made decent grades. Not long after his school pictures arrived, I had a letter from Ada, asking if I would send her a picture of him. I gave that some serious and private thought. He was a fine looking fellow, and I did not want to cause Ada any regrets about my adopting him. So I did not send a picture; I just ignored her request. Ada and I continued to keep in touch by mail once or twice a year.

In the early summer of 1960, Mr. McGill, principal of the Nash public school, asked me to be prepared to teach English when school started that fall. He knew that my undergraduate major was English and felt I could do the job. He had lost both a math and English teacher. He had applicants for teaching the math course and was confident he could count on me for English. Hearing of some extension classes being taught at Lone Star, Texas by teachers from East Texas State, where I had received my degrees, I inquired further and learned that the designated per-

son for the class was one of my favorite English teachers who would be teaching a course that I needed to refresh and improve my capabilities. "Teaching High School English" was the name of the course I would be taking. Other area teachers found courses being offered that they needed so we formed a car pool and attended.

It was an enjoyable class and I was looking forward to being an English teacher again. I had taught courses in English many years before. When I got home from Lone Star the last day of classes, I had a call from Elmer White, who after having taught math several years at Nash, was leaving to teach it at the Liberty-Eylau High School. He told me that his new school was looking for a counselor and I should contact them at once. I called Mr. George Jackson, the principal, who advised me to bring my transcript and talk with Mr. C. K. Bender, the superintendent. Upon my arrival, Mr. Bender looked over my transcript.

"I've promised the job to a man who is a co-op counselor working several schools in Cass County," he said. "If he wants this job, it is his; if he doesn't, the job is yours." This man lived in Cass County and drew traveling money in addition to his regular compensation. I came home to think and pray about what to do if the Cass County counselor did not take the position. It seemed that God just might be opening a door for me in the field I had chosen for my Master's degree. I prayed, "Dear Lord, you can open this door and you have power to close it. I will honor the thing

A MAN AND A MULE

that You dictate." Would you believe it: the other job prospect declined and I was elected! I would work ten months each year but would make quite a bit more money than I was making as a classroom teacher. However, I would have to drive about 14 miles, round trip, per day. I disliked telling Mr. McGill he'd have to find another English teacher, but he was most understanding.

Mr. Bender was a wonderful boss. Being their <u>first</u> counselor, I did not receive a job description and I was free to set up my own program. Right away I was given some extracurricular assignments. I would sponsor the pep squad during football season, and ride the bus with them to out-of-town games. I was also asked to sponsor the student council. Needless to say, I was a busy faculty member, both inside and outside my counselor's office. I appreciated and enjoyed my new job, but I'll admit I missed the close class contact with students and the actual teaching assignments of the classroom.

Old Bell Acts Up

One particular Saturday morning in October of the year, I chose to sleep late. Robert had a friend spending the night and we'd gotten home rather late the night before from a football game. Just the same, my phone rang early and sleepily, I opened my eyes. When it rang only twice and stopped, I knew it had to be Papa calling. I picked up the phone to hear the clacking of the party line and said, "Hello" and it was my Papa. "Come down and fix our breakfast; I'm not

feeling well," he said. As a rule he prepared that meal. "I'll be there shortly," I answered, but I really wanted to go back to sleep!

When I arrived at their house, Mama was sitting in her chair and the coffee water was boiling. Papa was not there. When I inquired of Mama as to where he was, she said he had gone to check on a cow that was about to give birth to drive her up to the barn. I turned the fire down under the coffee pot and searched the refrigerator for breakfast fixings. About that time I heard a yell. I assumed I was needed to open the lot gate, but then the yell came again, as though it was a cry for help. I bounded down the back steps, across the yard and through the gate. It was necessary to fasten the gate behind me, but I could tell, by this time, Papa was desperate and needed help immediately.

"I'm coming, Papa, I'm coming," I called out to him. I looked in the direction from which the voice came, and over a slight rise and down in a ravine I saw the large form of something brown. My first thought was that Papa was being attacked by a wild animal.

Again I hollered, "I'm coming, Papa," as I looked for a stick, board or something to ward off the beast. Along with his cries for help, I heard grunts and snorts that I couldn't identify. I had no idea what I was about to face. As I neared, with board in hand, Papa staggered up the little rise. I rushed to him at full speed! He was bloody and weak from the ordeal through which he had just gone and these words were

A MAN AND A MULE

tumbling over one another, "Let me lie down; Let me lie down!" "No, Papa, we've got to get you to the house. If you ever lie down, I couldn't get you up," I told him. I could see that the skin was hanging loose from the back of his right hand, his right ear was cut into two parts across, and there was an injury behind it.

Mrs. Orr heard the commotion and came running from her house to mine, where I had brought Papa. At my request, Mrs. Orr called Mr. Ward, a neighbor, to help me take Papa to the hospital. As soon as I got Papa in the car, I alerted Robert and his friend, Thomas White, that Papa had been seriously hurt by Old Bell, his plow mule. I asked Robert and Thomas to watch over Mama while I took Papa to the hospital. While Mrs. Orr called the emergency room at Texarkana's Wadley Hospital, Mr. Ward, Papa, and I were on our way.

Mr. Ward kept talking to Papa and wiping his face with a wet cloth to help ward off shock and a sick stomach. We were still in the dark as to what had actually happened.

After being attended by the doctor, Papa was able to fill us in on the details. He had gone into the woods where the cows and mule grazed. He found the cow with a new baby calf, of which Bell had literally taken possession. Papa was aware that Bell loved baby calves, but the calf needed to nurse soon after birth to gain urgently needed strength. Papa had observed his plow mule through the years and knew Bell well,

DAUGHTER OF DESTINY

like the back of his hand. He had raised her, a mare mule, and had learned he must keep her away from baby calves.

When Papa found Bell standing over the calf that morning, he tried to drive mother cow and calf to the barn. He made very little progress because of the mule's interference. He tried a reproving, telling her to scat but she stayed right with the baby calf. Picking up a small piece of tree limb, Papa cracked Bell across the nose, only to have his mule rear up and paw him to the ground. Baring her teeth, she went for his face. When he threw up his hands for protection, she grabbed his right hand in her mouth and shook him "like a rag doll," (his expression) while her knees pressed his body and her back hooves hit his shins. Had it not been for his rubber boots, Papa believed his lower legs would have been broken. His testimony concerning the fracas was that he couldn't have stood much more!

When the newly born calf bleated and went toward its mother, Bell heard it and left Papa to go after the calf. That's when he managed to get up and start toward the house, and that's where I came on the scene.

Some neighbors, who had riding horses, heard the incident's facts and roped Bell, tying her to a tree; then drove cow and calf to the barn and fastened the door. Then they released the mule. Papa remained in the hospital several days. The skin of his hand was re-attached and his ear sewn back together. His legs,

especially the shins, were black and blue for days. Many people, having heard the story, asked him if he planned to kill Bell or have her killed?

"No," he replied, "It was my own fault. I knew she wanted all baby calves and would even take them away from their mothers. I should have separated Bell from the cow before the baby's birth." He continued, "Furthermore, Bell did not recognize me; I didn't have on my usual clothes and old work hat. To her I was a stranger trying to take away her baby." So Bell lived and pulled the plow for six to eight more years as Papa continued gardening. The little town of Nash was buzzing for days over this episode. Many wondered how a 78 year old man could live through such an ordeal.

Time Out For Vacation

By the time school was out in the spring of '61, I had become acquainted with most of my Liberty-Eylau students, elected officers for the student council and organized the pep squad.

That summer Robert and I joined a group organized by Reba Kirby to take a three-week bus tour of north central and eastern United States. My friend and fellowteacher, Jamie Holcombe, was also a member of our group. I employed two neighbors, Mrs. Scott and Mrs. Oden, to work for my parents, alternating as suited to their time schedule. They had worked for us before when I had to be away. Rooming arrangements placed Jamie, Robert and me together and our

DAUGHTER OF DESTINY

friendship with Jamie grew even more during that three weeks. Having prayer before departing, 35 adults, six youths and the driver left the Trailway Bus Station in Texarkana and as we got underway, I had an assurance within that we were in for a an enjoyable three weeks.

Our first night was spent in St. Louis, Missouri, where we visited the Botanical Gardens. Botanists had been able to create just the right temperature and humidity for every kind of flower possible under the domed climatron. Our ah's and oh's at every turn could be heard repeatedly.

In Chicago, Illinois, we stayed two nights because much sightseeing was planned for us. One evening we went to a famous Scandinavian dinner playhouse where we had our meal smorgasbord fashion and then saw the marionette show. Our boys had heard there was to be a baseball game in town between the Chicago White Sox and the California Angels, so they wanted the group to attend. The smorgasbord is supposed to be eaten slowly, returning to the food-laden table again and again between leisure conversation. The marionette show started at 8 o'clock and the male members of our assemblage were on pins and needles, waiting for it to be over so we could see the ball game. They persuaded Reba to leave the show early and off to the ball park we scampered. Since the ball game was not on our itinerary (and not included in the price of our tour package) we expected to have to pay for it out of our own individual pockets. But the gatekeeper let us in free since the

A MAN AND A MULE

game had just gone into the sixth inning. I enjoyed the rest of the game more than the marionette show, especially when a player hit a grand slammer! The organ burst into loud music, bells rang, lights flashed, and the crowd went wild.

Our Chicagoan tour guide, excellent in his description of several tours we took, told us that much of Chicago is on land reclaimed from Lake Michigan. He ended every (memorized) speech with, "Golly, folks, we have everything in Chicago!"

From Chicago, it was off to Buffalo, New York, then to Niagara Falls, nearby. Here we spent enough time to enjoy the falls, both Niagara of the U.S.A. and the Horseshoe Falls on the Canadian side. Viewed from all angles the Horseshoe Falls are more beautiful and larger than Niagara. When we took the boat ride below the falls, we were provided yellow slickers and hats to protect us from the spray. The roar from the cascade was deafening and made conversation among us impossible. Due to the sun shining on the sprays of water, beautiful rainbows were formed. It was a spectacular sight; my camera clicked constantly.

Leaving Niagara Falls, we crossed over into Canada and spent the night in Toronto, a beautiful and clean city. Toronto, one of our tour guides informed us, has no slum district. Residents or visitors were fined if they threw even an empty cigarette package on the street. A Toronto tour highlight was a house sitting on top of a hill with the hillside yard terraced with row after row of lovely flowers and shrubs. Our guide

DAUGHTER OF DESTINY

said that an 85-year-old man lived there and had taken first prize several times in the annual beautiful garden contest.

Our next stop was Montreal, after traveling along the northern shore of Lake Ontario and the shore of the Saint Lawrence River. We saw Mount Royale in a unique way; we were in a wagon pulled by Clydesdale draft horses. Our boys well remembered the Queen Elizabeth Hotel for it was there where they were not allowed to carry our luggage to the rooms. **It was the only hotel on our trip that had such a rule.** Our tips to our young men for this service had spoiled them!

After Montreal, we hit Maine. Because of bad weather, we only went a short distance in this state and then headed south. In Montpelier, Vermont we had our picture made with the governor on the steps of the state capitol building.

Boston, Massachusetts came next. The two-night stay afforded us the opportunity to see the Paul Revere house, the Old North Church, where the lanterns in the steeple indicated whether the British would be coming by land or sea to Concord in early Revolutionary War days. We traveled the road where Paul Revere **rode a borrowed horse** while he was shouting, "The British are coming!" We also visited two other important places of the Revolutionary War. They were Bunker and Breeds Hills. Seeing these sites and sights made us appreciate even more our heritage and present freedoms which we often refuse

A MAN AND A MULE

to cherish as we should. In New York City, where we spent two nights, we saw the Rockettes and went atop the Empire State Building. A boat ride took us to Liberty Island (formerly called Bedloe's) to see the Statue of Liberty, a gift from France. What a colossal figure of the goddess of Liberty holding high the torch in her right hand and the tablet in her left! We ascended the circular stairway to the crown of her head, but repairs being made prevented our going up higher in her arm. Her measurements are tremendous! The distance across an eye is two and one-half feet, the length of her nose is four and one-half feet, the width of her mouth is three feet, and her right arm is forty-two feet in length. Other measurements are proportionate. Downtown New York City offers entertainment of all kinds. The sky-scrapers hide the sun except for a few minutes in the middle of the day. I came away with a negative opinion of the "Big Apple" city and glad to be an East Texas country girl.

Philadelphia was the following big city of historical significance on our itinerary. We were impressed with the Betsy Ross house, Independence Hall, the Liberty Bell, and a downtown cemetery where we read the epitaphs of revolutionary heroes.

We passed through Baltimore, Maryland on our way to Washington, D.C. for a two-night stay. The Senate and House of Representatives chambers were viewed but the highlights there to me were the two personal privileges we had. The group had its picture taken with the late Wright Patman, representative from our

DAUGHTER OF DESTINY

district and Robert and I had dinner with a former Eylau school principal of mine, Ivy Gauntt.

The Smithsonian Institution, a repository for the "increase and diffusion of knowledge" stands out in my memory because of a unique incident that happened there. Our guide, on our way to it, grabbed our interest and stirred our imagination with his description of its immense size and contents. He stated that if we spent one minute observing each item on display, eight hours per day, seven days a week, it would take years and years (he gave the exact number) to see everything contained therein. Then, as we debarked from the bus, he said, "Meet me back here in forty-five minutes!" Ludicrous!

Lexington, Virgina gave us views of Washington and Lee University and V.M.I. At Natural Bridge, in this state, Jamie and I took some free time to explore the area under the Natural Bridge and saw Salt Petre Cave, Lost River and Water Mist Falls. That night our group saw and heard "The Story of Creation." The lighting, thunderous sound effects, and the deep resonant voice representing God as he said, "Let there be light" and other creative commands sent goose bumps up and down my spine. Truly, it was a high point of the trip. Our next stop from Natural Bridge was in Abington, Virginia for lunch. This lunch was memorable because we had hot corn bread and butter, the first hot bread since we left home!

"Unto These Hills" was a play we attended during a stop in North Carolina, portraying the ejection of the

A MAN AND A MULE

Indians from that region by the early white man. It was presented in a large amphitheater where the stage down below was so large that props were rolled on and off it on wheels. The acoustics were amazing! No matter where one sat, he could hear as well as if he were in a well-planned theater. Coming through the Smoky Mountains in this area was also an experience I shall long remember.

Traveling through South Carolina, Georgia and then on into Alabama, we came to Birmingham. As we were now in the last night of our fabulous tour, getting home was on everyone's mind. It had been a wonderful trip; we had made friends with our fellow travelers, but Texarkana looked mighty good as we rolled into town. We had lived out of suitcases for three weeks while going through 22 states and two provinces of Canada. It was quite tiring and, believe you me, the hometown looked very, very good.

Soon I was home and resumed my duties there. I was relieved to know that I was not indispensable to the well-being of Papa and Mama, who had been well-attended in my absence.

Robert Becomes A Christian

In the late summer of 1961, Robert began asking questions about becoming a Christian. I told him the plan of salvation; he also talked with Pastor Martin. One Sunday night, soon after, he walked the aisle and made his public profession, united with our church and was baptized a few weeks later, being the

DAUGHTER OF DESTINY

age of twelve. I could not help but remember that twelve was the age of Jesus when he, while discussing spiritual matters in the Temple at Jerusalem, later told his parents, fretful over not knowing where he was, "... know ye not that I must be about my Father's business?" (Luke 2:49) Robert's conversion was a very happy moment in my life!

PSALM 139:9,10

"If I take the wings of the morning, and dwell in the uttermost parts of the sea; Even there shall thy hand lead me, and thy right hand shall hold me."

CHAPTER 13

SLEEP, LITTLE MAMA

When Robert was between 13 and 14 years old, the phone rang one day and he answered it.

"It's for you, Mother," he said. When I answered, the voice on the other end said, "Do you know who this is?" "Yes," I replied, "It's Ada." I had not heard her voice since she left Nash when Robert was about 12 days old to return to Dallas. Her voice had a distinctive quality that was unique. She queried, "Was that the boy?" and I said, "Yes, that was Robert."

As we talked, I learned she and her family lived in Queen City, a small town about 23 miles south of Nash. She invited us to come visit her, but I insisted that she come to see us, which she never did. Later they moved and I did not hear from her again for several months. I explained to Robert who called, but he was not curious about his biological family. Just the same, I was always truthful and open with him about his background. He - at all times - seemed happy with his family arrangement as he knew it. Leon and Enois had three sons, Larry, Luke and Howard, about three years apart. Robert was three years younger than Howard and really looked up to all three of the boys. Actually, they were almost like his big brothers.

DAUGHTER OF DESTINY

Robert completed the eighth grade at Nash in May, 1963 and entered Liberty-Eylau High School that fall. Children of employees, who lived outside the district, were permitted to attend there without paying tuition. This was an ideal situation for us. It did, however, require a lot of driving on my part, because Robert stayed after school for football practice (in season) while I ran home to see about my parents, then return to pick up my son. Since he had no living dad or siblings, I felt he needed the exposure to rough and tumble exercise which contact sports furnished.

Mama Goes To A Nursing Home

With the passing of time I could see a gradual change in Papa's physical and mental health. In fact the deterioration began with the attack by the mule. He continued to plow the garden in season, but he went to work later, rested longer at noon and quit earlier in the afternoon. His equilibrium was bad. He stumbled a lot and worried that he might fall as he had to move Mama from place to place in their home. He worried, especially, about getting up at night to take her to the bathroom. Serious injury was possible. He decided that the proper thing to do for Mama's care and keeping was to put her in a nursing home.

Upon investigation, I found that most of them had a waiting list, but Tanglewood Nursing Home accepted her sometime later. Tanglewood was in Texarkana on the Texas side. There is, too, a Texarkana, Arkansas.

SLEEP, LITTLE MAMA

At the appointed time we took her to see the home. I had already looked and was satisfied. I told her this was an inspection trip for her to see if she liked it, if not, she did not have to stay. We wheeled her around to see all the various facilities and back to the room to which she had been assigned. We met her roommate and visited with Mama awhile. At about 3:30 p.m., she said, "It's time for you and Luther to go home."

"Do you think you'll be satisfied here?" I asked her. Her answer was instantaneous, "I came to stay and I'll be satisfied." I knew her mind was made-up and this would be her home as long as necessary.

For quite some time, I saw her daily after school and took Papa to see her each Sunday or at his request between times. She seemed satisfied from the very first day, but that was Mama. She always had the inner strength to adjust to the circumstances in which she found herself. Not long after entering the nursing home, she developed raw places on her protruding ankle bones from sheet burns. The mattresses there were extremely firm so I was allowed to replace hers with a softer one. Her ankles healed within a few days.

The nurses seemed to be caring people and I felt Mama would get good care there. Her stiff, drawn hands prevented her pressing the nurses call button so a cousin, Louise Cooper, brought a small bell with a handle which Mama could manage. When the nurses heard the jingle, jingle of her little bell, some per-

son would respond immediately; they knew she rang it only when necessary. My visits became less frequent as I saw she was happy and receiving excellent care. Being alone was a difficult adjustment to be made by Papa, but as time passed, he became reconciled to the circumstances.

I continued to cook Papa's breakfast at my house and take it to him each morning as I had done since his encounter with the mule. We worked out other cooking and household chores three ways: Papa, the hired housekeeper and me.

Desegregation

In the fall of 1965, "Freedom of Choice" in schools was activated as the beginning of the desegregation movement. Several black teachers were hired to teach at the Liberty-Eylau campuses. During teacher work days before the students started, a large jovial black high school teacher, Grady Wallace, came into the main office where I was talking with the school secretary. She introduced us and then asked him how his summer had been.

"I hear you went to Florida this summer. How was your trip?" she asked.

"Oh, we had a wonderful time, especially at the beach," he politely answered. Then pointing to his forearm he added, "See what a tan I got?" We had a good laugh and I knew right then I was going to enjoy working with him.

SLEEP, LITTLE MAMA

That same fall two girls, Brenda and Bonita Proctor who had been in our school for the spring semesters of 1964 and 1965, entered our school again. I was glad to see them back because their parents moved from place to place so much I was afraid the girls would not get to stay in the Liberty-Eylau school. Brenda was a senior and Bonita was a junior.

I knew the girls when they were tiny but had not seen them in years until they came to the Liberty-Eylau spring semester of '64.

I had taught their mother, Vera Tefteller, at James Bowie, Simms, Texas and she had even stayed a few weeks with me when she was having some difficulty at home. Later she married Chester Proctor, a boy I had known most of his life.

The summer after Malcolm's death, while Robert and I were on the farm with my parents, Chester, Vera and their one and one-half-year-old Brenda had lived in a rent house on Papa's place. Vera was expecting another baby just any day.

Late one afternoon Chester came and asked if I could take Vera to the doctor in DeKalb because she was in labor. We made a bed for her in the back seat of my car and I drove them to the physician's office. There she delivered a beautiful baby girl. Chester put her back on her improvised bed in the back seat of the car and I drove three people back to their home; Chester, Vera and little Bonita, whom they let me name. Feeling that she was absolutely the pretti-

DAUGHTER OF DESTINY

est little baby girl I'd ever seen, I chose for her name Bonita, Spanish for "little pretty"!

Since then because of so many moves, I had not seen these girls until they came to Liberty-Eylau as teenagers. They were smart, pretty and well-liked by teachers and other students. Soon Brenda started dating Donald Giles, another well-liked and respected senior. Things went along fine for awhile. Then one day Brenda came to see me with a downcast face. I learned that Donald was casting his eyes at another pretty senior girl, and Brenda needed a shoulder on which to cry. I comforted her as best I could.

Sometime near mid-term Brenda came to see me again. This time it was not boyfriend trouble; it was parent trouble.

"Mama and Daddy are talking about moving again," she said, and I could tell she was hurting inside. She continued, as I gave her a hug and a sympathetic ear, "I don't want to move again. I've never been able to complete a whole year at the same school except when I finished fifth grade at James Bowie. I like it here and I want to graduate from here."

"Don't worry, Brenda," I told her with concern. "If they decide to move, you can come live with Robert and me." She seemed relieved and went on with her classes. Chester was rather changeable so I wasn't sure if he really was serious about moving, but a few weeks later, Brenda returned to my office and I knew

SLEEP, LITTLE MAMA

that she had something important on her mind. "Did you really mean I could stay with you if Mama and Daddy move?" "I really did," I answered. "Well, they are definitely going to move in a week or two," she concluded. "When they do move, just bring your clothes and stay with us," I assured her. "And don't worry another minute about it!"

Mama Passes Away

About this time Mama took sick with fever and congestion in her chest. The doctor saw her at the nursing home and diagnosed her as having pneumonia. I knew somehow that Mama would not survive this time. I called Iva and Irene in California, told them the diagnosis, and that I felt her time had come. Medical personnel had previously explained to us that Parkinson's disease in itself wasn't fatal, but in the patient's weakened condition, pneumonia usually was. Mr. Bender released me from my school duties so I could spend as much time as I could with her.

She worsened every day. On Saturday morning, March 21, 1966 she slipped into a coma. Pauline Henderson, my dear dependable friend, came in to see her and to be with me. Mama's breath was very shallow. I knew she couldn't last long. I bent over her and repeated two or three times, "Go to sleep, Little Mama," and God released her from that stiffened, stooped body and took her to be with Him.

Her funeral service was at Nash First Baptist Church and her body was laid to rest in the cemetery located

DAUGHTER OF DESTINY

at Wards Creek. At the service in Nash, Vera Proctor came to me and asked if I still wanted Brenda to come stay with me and finish school? "Aren't you afraid it would be too much on you at a time like this?" she wanted to know.

"Oh no," I answered. "I'm looking forward to her coming. She will help fill the void left by Mom's death." A few days later Brenda moved her box of clothes in with us and I was happy to have a "kinda like" daughter. I'm not sure Robert, at first, was too keen on the idea of having a girl in the house, but he soon accepted her as a part of our family.

PSALM 116:15

"Precious in the sight of the Lord is the death of his saints."

CHAPTER 14

PAPA JOINS MAMA

In February or March I always encouraged graduating seniors to explore possibilities of summer work programs and helped them with scholarship applications. I assisted Brenda in applying for both. I felt sure she would qualify on the basis of need and her good grades. Knowing the counselor at Texarkana College, I recommended Brenda highly to her and to the right people at Red River Army Depot, located near Hooks, and this helped. She was accepted for both and was elated. She later said to me, "I never dreamed I would ever get to go to college. I thought only people with money could do that."

"God gave you a good mind, and now you'll have the opportunity to further develop it," I told her.

Red River Army Depot, where she would work during the summer, was a **large** government installation and the biggest employer of the Bowie County area. A car pool of adult workers, who passed my house, took care of Brenda's transportation problem, allowing her to ride free of charge.

Early in the summer her dad, Chester, came to my house and as we all sat in the kitchen talking, I was apprehensive as to the purpose of his visit. Shortly he

came right to the point, "Brenda, your mother has left and I need you back home to help me take care of the kids." There were two boys and two girls younger than Brenda and Bonita. I felt sure that Brenda knew they could manage without her, but both my Robert and I sat quietly by, waiting to see what her answer would be. We were hoping and praying that she would refuse him.

"Daddy, you know I now have an opportunity to make some money this summer and the chance to enter college this fall." she answered, after a bit of hesitation and pondering. "If I come back and live with you, my money would go to help run the home and I would be denied the chance of furthering my education. I can't do it, Daddy! Nita and Ola Ann can help you." I was so proud of her insight and stamina! She was only 18 but was making a wise adult decision.

Her father did not press the issue, leaving soon without starting a fuss. Robert and I both told her how glad we were over the decision she had made. She and Robert had begun to act like brother and sister with playful little squabbles. One day he told her she talked too much and he was going to tape up her mouth. "You and who else?" she wanted to know. He grabbed the medical adhesive tape and started chasing her. She ran into the bathroom, and before she could lock the door he was inside. As he started to apply the tape, she put up both hands in defense so he just wrapped her wrists and then went to her neck, wrapping the tape around it also. They were laughing, she, too, as much as she could all taped up. Soon

PAPA JOINS MAMA

he removed the tape but it was an escapade they both long remembered. Brenda fit right in with our Sunday School and Church attendance. Our youth director had the young people's choir sing at each Sunday night service. Brenda had a fine voice and enjoyed singing, but Robert had trouble carrying a tune when singing alone and in a group, his notes really got lost in the crowd.

When he was in the fourth grade, Mrs Martin was conducting their music class and the students were singing their hearts out. A boy standing next to my son, raised his hand, seeking permission to speak. When the music teacher recognized him, he said, "Mrs. Martin, I think Robert is singing off key." Her wise response spared the feelings of a sincere young fellow, who was doing about the best he could with what he had! "Well," she said, "the Bible tells us to make a joyful noise to the Lord. Robert may be off key but he's still making a joyful noise to the Lord." So as a teenager in the youth choir of the church, he continued making a joyful noise to the Lord.

During Brenda's summer work, I found great joy in finding material and having a dress ready for her to try on when she came home in the afternoon. I had helped make her Easter dress and a white graduation outfit so I knew what she liked.

Another thing we did was walk and jog on our quiet street. Some neighbor boys, from time to time, would join us and we would jog or fast-walk together. It came natural for me to tell Brenda about college and

DAUGHTER OF DESTINY

what it would be like or the best and safest way to do things. She was a teacher's dream! Sometimes if we had slowed down to a walk and had been silent for a while, Brenda would say, "Tell me some more things I need to know." Her gratefulness for any little thing I did for her, gave me more than I gave in our close association.

When her summer employment ended, the adult fellow workers collected $50 for her to help with college expenses.

She began college that fall and was fortunate again in getting free transportation. Mrs. Lois Jarvis, who cared for some small children for a college couple, dropped Brenda off as she passed by. Brenda worked in the dean's office and her hours coincided with those of Mrs. Jarvis.

It wasn't long until Brenda's and Donald's paths crossed on the Texarkana College campus and they were dating again. Robert was a high school senior that year and I had that same familiar routine of driving home; then going back for him after football practice. I mentioned to the coach that I was driving those extra miles each day for Robert's sake, even though he spent most of the time during games on the bench.

"We've got to have extras on the bench to keep the team going. They're important too," he assured me. "Don't worry about Robert; he gives me 110 percent and that's even more than I ask." That got us through

PAPA JOINS MAMA

another football season. As winter turned to spring, Brenda and Donald began to get serious and Robert was looking forward to graduation. On Awards Day, the Outstanding Social Studies award and a $200 scholarship donated by the Rotary Club went to Robert to attend the college of his choice. We sent his transcript, along with an application, to Texas A&M and he was accepted.

By the end of her first college year, Brenda and Donald were making wedding plans. She brought me material and a pattern to make her wedding dress. Soon thereafter, her mother called, saying she needed her, so Brenda moved back with Vera. All the other Proctor children were now with their mother. I assured Brenda if she had difficulty in making her dress to let me know and I would finish it or do whatever she needed.

The wedding date was set for August 11, 1967. About three weeks before that date, Brenda brought her dress for me to complete. "I can't work in that little house with five kids, Mama and a dog in it," she said. "There's no table big enough to work on and I'm afraid it will get soiled." I took the dress and we discussed beading, veil, and other details and set a time to try it on for a final fitting. I had been unable to bear children, but here I was doing for Brenda what every mother dreams of - working on the wedding dress of her daughter. It was, indeed, a labor of love! When she came to pick up the dress not long before the big day, she asked me if I could be her mother by proxy, and if Robert could be her father's

substitute. Vera had recently gotten a job working swing shift and had not worked long enough to have any time off. Chester was working somewhere too far to come to her wedding. I didn't have to think twice for my answer to Brenda and Robert was happy to oblige when I asked him, so we made plans.

When, in the ceremony, the minister asked, "Who gives this woman to be married to this man?" Robert proudly answered, "Her parents and I." And there I sat in the honored seat of the bride's mother. I was pleased as punch and so was Robert.

Papa's Demise

Meanwhile Papa was just not doing well. He did manage to make a small garden, but he spent more and more time on the bed. Robert had entered Texas A&M that fall. My work at school was about as usual - helping students with schedules, giving aptitude and achievement tests and interpreting them, counseling students and doing the many things I'd been doing as a counselor since the fall of 1960.

I missed Brenda and Robert, but Papa was requiring a lot more attention. By the spring of '68, although he was spending quite a lot of time abed, he refused my plea that he see a doctor. He would, after much insistence on my part, agree to my making an appointment, but would not go when the time came. His arteries had been hardening for some time and he complained now mostly of his head. His nerves were frayed and I had difficulty communicating with

him because he was suspicious of me for no reason at all. If I happened to disagree with him, he would fly into a rage. His legs and feet were so swollen I had to buy shoes a size or two too large.

When school was out, I asked him to let me take him to the old homeplace where Irene was spending some time, thinking it might help him. I just had to get some help from someone else in the family to convince him that he needed to see a doctor. I realized that the hardening of the arteries in his head affected his nerves and thinking. It took two to three weeks to gain his consent, but finally he agreed to give it a try. He was only there a week or so and Irene brought him home. Neither could she reason with him. A bit later, I was successful in getting him to visit Leon and Enois, but the nerves and agitation continued, and they returned him after a week. I continued to beg until he consented to seeing a doctor, who hospitalized him immediately. The doctor called in a psychiatrist for consultation after a few days. When I'd go to see him, he would beg to go home. This would break my heart and annoy him when his request was denied by the hospital.

He remained in the hospital several days; then the doctor dismissed him, but only to go to a nursing home. Loyd Howell, at my request, accompanied me when I entered him into the nursing home. I was afraid he might become violent on the way and try to get out of the car. The doctor, evidently, sedated him before we left the hospital and he was meek and quiet. The nurse at the nursing home knew his condi-

tion and asked me to stay away until she could get him weaned away from home and me. **He lasted less than a week and died on the morning of July 31, 1968.** No one in the family was aware of his being so sick. He had always been so strong and forceful that we thought he was indestructible. His funeral was at Wards Creek Baptist Church and his interment was in the cemetery there.

Robert decided to leave Texas A&M for Texarkana College that fall and I was very pleased. Papa's death was much harder to bear than Mama's. She had been frail and almost helpless for so long. Papa had always had a strong impact on our lives, and having Robert with me helped get through my grief.

After Papa's passing, I rented their little house to Barbara and Dave Oden and I sold Old Bell to a farmer who lived in an adjoining community where I felt she would have a good home. By now Robert had his own transportation and he seemed to enjoy his courses at Texarkana College. He particularly liked his psychology teacher and class so much that he decided to make psychology his major.

In the fall of 1969 after a year at Texarkana College, Robert entered East Texas State University in the town of Commerce, my alma mater. Liberty-Eylau desegregated its schools on all campuses, causing adjustments to be made, but the transition from all white to mixed races went rather smoothly. I felt sorry for the athletes who came to us from the community of Macedonia, which had been all black. They

had to relinquish their school colors, their mascot and accept ours. I'm sure that wasn't easy. Too, some of their expressions were different and unfamiliar to us. I remember a girl coming to my office and asking if I had a "solid dime." I had never heard that expression before, but I knew she wanted a dime for her two nickels. A pencil sharpener was to them a pencil trimmer. I did quite a lot of individual counseling to help them understand our graduation requirements and make adjustments to our regulations.

Leon Is Bush Hogged

When school was out in the spring of 1970, Robert got a job in Dallas, working at a building materials store. I was home as usual. One Friday in July, Enois came by the house with a new piece of furniture, a commode or chest, to go in her entrance hall. She wanted me to go home with her and spend the night. "Go with me and together we can have this all set in place when Leon comes in from the farm," she said. I hesitated a moment, remembering I was making a dress and had to shampoo my hair the next day. When I told her what I had to do, she insisted, "Bring the dress and other things you need and follow me home in your car. We'll surprise Leon." I had no reason to refuse so I hurriedly packed and followed her to their home in DeKalb. I had not spent a night in their home since March 30, 1940.

Early next morning, Leon left for their farm to do some bush hogging. Enois went to our old homeplace to pick figs. While she was gone, I washed and rolled

DAUGHTER OF DESTINY

my hair; then sat down at her sewing machine to work on my pink linen dress. She returned and was washing the figs. I heard the whining of an ambulance siren and my thoughts carried me to Robert in Dallas. It can't be him, my brother was at the farm, their three sons were already out on their own in different places, but I knew some family was hurting from a serious accident or life-threatening sickness. Enois had been on the phone to one of her sisters, but as soon as she hung up, the phone rang. I heard her say, "Oh, my Lord!" I rushed to her and she said, "That ambulance was taking Leon to Texarkana to the hospital. We must go; the bush hog ran over him."

She hurriedly dressed, I put a scarf around my head, we got in the car and sped to Texarkana. We knew not the extent of his injuries, but all the way we prayed that they were not too serious. We assumed he fell off the tractor and under the bush hog and we knew that was serious enough.

When we reached the hospital's emergency room, we heard a doctor talking with Leon about Leon's son, Luke, who was a baseball pitcher for the Pittsburgh Pirates. I knew this was an effort on the doctor's part to keep Leon's mind off his pain. Enois approached and informed the physician that they had two other sons, Larry, a surgeon in Nacogdoches and Howard, a farrier near Houston. Leon kept talking about his sons until they wheeled him into surgery. Later, when Leon was able to talk, we were told the details of the accident.

PAPA JOINS MAMA

He was cutting on some rough terrain just below the dam of his pool when the tractor hit an extremely rough place, throwing him from the tractor and under the shredder. It happened, fortunately, that he fell face down with his face in a hole or low place. He felt the long rod to which the blades were attached hit his head three times and the blade cutting into his back. As the tractor was headed uphill, the motor died, the tractor went backwards, rolling the bush hog off him.

He crawled out, climbed the hill to his truck, got in and drove through two wire gaps and two gates, getting out of the truck each time to open and close them. He could hear air wheezing as it passed out the gash in his back. He drove about a mile, with his vision coming and going as he almost passed out. He was blowing his horn all the way, as he drove to the house of Bill Walker, our cousin. Bill, seeing that he was bleeding profusely, jumped in the truck and drove Leon to DeKalb.

Later, when talking to my brother about his narrow escape, I said, "Leon, if you had not been a strong, healthy man and if God had not been with you, you probably would have been killed." His reply was rather serious, "My being strong had nothing to do with it."

It was a miracle that no bones were cut, no major arteries severed, no damage to the heart or liver. The lower part of one lobe of his lungs was cut off, which caused the wheezing he had heard. His healing

took some time, but he was back in his DeKalb high school classroom teaching biology by the beginning of the second six weeks of the fall term.

Brenda and Robert Finish College

I learned that Brenda and Donald moved to the state of Arkansas, Magnolia to be exact, where Brenda enrolled in college as a junior. Robert graduated from East Texas State in December of 1971 and on January of 1972 went to Florida with Mike, whom he had met in school. Mike told him he could make good money there as a bouncer or bartender. He painted a rosy picture, telling Robert he could save money and return the next fall to work toward his master's degree. Though I did not approve of that kind of work, I felt Robert was on his own now and should make his own decisions.

Brenda graduated from college in August of 1971. Sure enough, none of her family attended her graduation exercises, but she had a family there by proxy. Mrs. Jarvis and I drove the 60 miles to see her graduate. We were as proud as if she had belonged to us. It was rather late when we got back home that night, but we felt it was well worth it.

Brenda got a school near the place where she and Donald lived, but was terminated in January of 1972 because she was pregnant. Expectant mothers could not teach then in Arkansas. Her baby girl, Amy, was born in May and Brenda returned to teach the '72-73 school year. Donald had dropped out of college, due

PAPA JOINS MAMA

to a lack of interest, and learned the trade of an automobile paint and body man at which he did well and made a good living for his family.

PSALM 46:1

"God is our refuge and strength, a very present help in trouble."

CHAPTER 15

DOGS IN MY LIFE

The story of my life would not be complete without including a story of the dogs that touched my life.

"Watch"

The first family dog I can remember was old Watch, a fairly large, mixed-breed, black dog with a white breast. He was our watchdog when I was a child. The thing I remember most about him was that he hated snakes with a passion and would grab them in his mouth and sling them back and forth, beating them against the ground until they were dead. Occasionally, he would come home sluggish and feverish with his neck and head swollen. Papa would examine and doctor him with whatever medicine he happened to have on hand. Watch's condition told him that the dog had not been quite quick enough with a snake and was bitten. Watch lived through several of such experiences but would always attack snakes when and wherever he found them.

"Buster"

The next canine I remember was Buster, brindled-brown in color and part bulldog. He would catch a pig or other small animal if they strayed from where

they were supposed to be. He, too, was a good watchdog and excellent at rounding up the farm animals.

"Fellow"

Our neighbor, Mr. Dan Elkins, had a collie dog called Polly. He could talk with her in a conversational tone, "Polly, it's time to get the cows." She would run across fields, woods, and pasture till she found them and would drive them home.

Polly had a litter of puppies once, one of which Mr. Dan gave us. He was black with white on his belly and face. This occurred while I was staying with my parents, teaching at James Bowie, Simms, while World War II was going full blast and Malcolm was overseas. I named this dog Fellow. He was almost as smart as his mother; he would round up cows or horses as commanded when he grew up.

I rode the school bus to and from school and old Fellow would be waiting for me at the mailbox each day. One day I rode with a fellow teacher and arrived home ahead of the bus. Fellow had been home alone all day because Mama had spent the day with Enois and Papa was selling farm produce to displaced farm families, who worked at a war installation at Hooks.

Fellow, evidently, did not see me come home. I was inside reading the mail when I saw Fellow come around the house and go to the mailbox. I looked down the road and here came the bus. As it approached, I could see Fellow watching it and wagging

his tail. The bus didn't even slow down and whizzed on by. Fellow watched it go by; then slowly turned toward the house with his head down. He ascended the porch, raised his head and let out a wailful cry. I felt like crying, too! Calling him by name, he saw me through the window, wagged his tail and I'll always believe I saw a smile come over his face. This event endeared him to me more than he already was.

Not long after Papa moved in with me at Nash, he brought Fellow from the farm, who was a constant companion for Robert. T. Ray's little black dog, Peewee, and Fellow became friends at first sight. The first paper Robert wrote, while in the third grade, was how Fellow and Peewee managed Rex, a neighbor's large dog, who had the run of the street. When Rex would come into our yard, Fellow and Peewee would scat under the car for safety, barking constantly. Then Peewee would ease out and catch Rex's tail. When Rex turned to rid himself of Peewee, Fellow would grab his tail. This would go on until Rex tired and went home.

After Peewee died and Fellow got killed by a car in his old age, Wilma Watkins, a classmate of Robert's, gave him a hound pup. He was black with brown markings here and there. His ears were as long as his legs and he had half-closed eyes. He just wasn't much for looks, but as he grew up he was dear to Robert, who taught him some tricks. When he was only a few years old, someone poisoned him. We tried to doctor him but he was too far gone to respond, and he died in the back yard in Robert's arms.

DAUGHTER OF DESTINY

"Prince"

The last and most precious dog we ever had, came to us as a tiny puppy. We asked neighbors and friends of the area as to where he belonged, but could not find his owner. We loved him, cared for him, and called him Prince. He was brown and, as he grew, looked a bit like a collie but was much smaller. He was loyally devoted to Robert and me, even following me as I drove to school. Of course he had to give up and return home, but he was at the intersection of Pecan Street and New Boston Road, without fail, to meet me when I came home in the afternoon. He raced as fast as he could to greet me at the house.

One Sunday, while Robert was in his senior year at East Texas State University, Prince followed me to church, as he always did. As I came out of church that day, Post Henderson met me saying, "Carlene, your little dog has been hit by a car." Post and I rushed to where he lay. There was no blood except from his mouth and he was still breathing so I thought there might still be hope for his life. I went to the church office and attempted to get a veterinarian, but to no avail. Post put Prince in the back of my car and went home with me. I tried again to reach a vet but none was available. I was about to try each one again when Post called to me that our pet was gone. I wrapped him in a piece of old bedspread and Post buried him for me, after going home to change clothes. I called Robert at his fraternity house and when I told him about Prince, he exclaimed, "Not my little dog, too!" When I asked him what he meant, he

DOGS IN MY LIFE

explained that one of his frat brothers was in a Houston hospital as a result of a serious accident in a motorcycle race. I then realized that the death of Prince hit him hard at a bad time. Sure enough the boy died too, a double blow for Robert!

Prince's death was difficult for me to handle. With Robert away at college, Prince was my family. Thoughts of his devotion and loyalty bugged me till I finally composed a poem to his life and memory. I called it:

"Tribute To Prince"

No royal blood could he ever boast
No pedigree or fame,
He was just a little mongrel pup;
Without a home or name.

He came to us, this ball of fur
One cool November day,
He won our hearts and got a home;
Because he came to stay!

We loved this mutt and named him "Prince"
Just why we couldn't say,
Neither his manners nor his looks;
Hinted of a princely way.

He scratched up flowers; chased the cat
And did the usual things,
That growing pups are prone to do;
(Not suited to future "Kings")

DAUGHTER OF DESTINY

He followed us where'er we went
Nor could we coax him back,
To town, to church, or down the street;
His legs made a racetrack.

No sooner had we parked the car
At church whether day or night,
Old Prince was there to guard that car;
With all his little might.

One Sunday morn he left his "post"
And ran across the street,
To run and play with other dogs;
That he had chanced to meet.

When church let out he knew that he
Must hurry to the car,
For soon his mistress would be there;
And he had strayed quite far.

He raced toward the church yard
But he had to cross the street,
He ran, not looking right or left;
On flying little feet.

But little dogs are not a match
For speeding automobiles,
And Prince just didn't make it;
Past the skidding wheels.

Such true devotion and loyalty
Is surely from above,

And Prince has proved his "Royalty";
When he gave his life in love.

Not long after Prince's death, Kevin Markham, whose dad I worked with, wanted me to have a puppy from a litter his dog had just had. I thanked him but refused. "I don't want to get attached to another dog as I did Old Prince," I explained. "It hurts too much to lose him."

JOHN 15:13

"Greater love hath no man than this, that a man lay down his life for his friends."

CHAPTER 16

A WEDDING AND A TRIP

I couldn't help worrying about Robert down in the state of Florida, being a bouncer at a Lounge, called Big Daddy's. He took little money to his new destination and it didn't flow in from the lounge work like Mike had led him to believe. But anyway, he got a room at a male school teacher's house and survived.

For some unknown reason, he had not taken his car to his new state, but he sorely needed it. While discussing his situation and need with my high school principal, I was overheard by a student. He was a life saver! "Mrs. Maxwell, I'll drive Robert's car to his residence in Florida just for the trip," offered the student, Jerry Rauh. He proceeded, "All I'll expect is money for gasoline and a bus ticket home."

We worked out the expenses of the trip, I gave him the currency he would need, and we both got what we wanted. I could all but hear Mama saying, "God does provide."

Night after night I prayed that another job would come along because lounge work was certainly not that for which I had sent my son to college. In my prayers I would quote scripture and further study the word of God for guidance and assurance re: Robert's

DAUGHTER OF DESTINY

welfare and life style. The promise in the Bible that kept coming back to me, over and over, was that as found in Proverbs 22:6, "Train up a child in the way he should go: and when he is old, he will not depart from it." However, it seemed to me, perhaps in my impatience, that God took his time in answering.

At Christmas time, I flew to Florida to spend it with him. The home where he rented a room had decorations in the yard, also shrubs and flowers, but it did not seem like Christmas. The weather warm plus the decorations and lights seemed sparse compared to those back in Texas. On Christmas day, we looked and searched before we found a place open where we could eat. We finally found a Chinese restaurant, where we ate Chinese food for Christmas dinner!

Rita Atwood

After a few months, Robert became a bartender. Of course to me that was no better than a bouncer, but he started dating a girl, Rita Atwood, who was a secretary in the sheriff's office. She didn't want my Robert to work in a lounge either, and she helped him look around for better work. He found it as a counselor in West Palm Beach Halfway House, working for the state of Florida. Here he related to young lawbreakers, 14 to 17 years of age, who needed to be rehabilitated, if possible, so they could become contributing citizens. Now his psychology major from college could be utilized, and I found myself worrying less and less about him, now that he was in the work for which he had been trained. Another matter

A WEDDING AND A TRIP

that eased my anxiety concerning Robert was the steadying influence that his relationship with Rita was having upon his life.

Ole! South Of The Border

Time passed with my staying busy at school, teaching my Sunday School class of young women, keeping house and doing yard work.

Charles Andrews, Spanish teacher at Liberty-Eylau, and his students had planned for months to take a trip to Old Mexico. He needed cars for transporting the group to the border and sponsors for the trip. I agreed to go. Other adults, with whom I would be associated, were Marie Taylor, the school nurse, and Virgil Sanders, a history teacher.

On a Friday morning in March of 1973, we teachers and sponsors, with nineteen Spanish students left on the first leg of a trip to Guadalajara, Jalisco, Mexico. We teachers were about as excited as the students; all except Andrews and Taylor. They had made the trip before.

We drove to Waco, Texas, where we spent the night; then continued on to Laredo the next day. Here we stored our cars at the Plaza Hotel and took taxis across the famous international bridge to the train station in Nuevo (new) Laredo, Mexico.

Our trip director, Mr. Andrews, had purchased our pullman tickets since first-class accommodations also

would expose us to chickens, ducks or any small animals the natives desired to bring aboard the train. On our pullman, the students had berths and each faculty member had a private roomette. In this little cubicle of about four feet by six feet was a padded seat across one end of the facility. At the other end was a mirror, a sink hidden in the wall until needed, a rack for our luggage, and a flushable "john". A small closet that would hold a change of clothes was at the side. For privacy the roomette entrance had zippered curtains and a sliding door that locked on the inside.

Above the seat was a lever by which a bed could be pulled down, not very far though, and I felt it was almost to the ceiling. The bed completely filled the length of the enclosure when it was made ready for sleeping, a task I accomplished by standing in the doorway with my feet facing inward. I soon learned that all preparations for sleep had to be made before the bed was readied. I'm glad I took the trip when I was younger because I don't think I could close up the bed and open it so I could go to the bathroom two or three times during the night as required in later years of one's life.

The bed was comfortable but I heard and felt every clanking stop and lurching start made by the train throughout the night - and that was quite often. As the train would round curves on the mountainside, I realized the hazards of the trip. I rolled from side to side and slept very little. The next morning we ate a good breakfast for a very reasonable price, minus the

A WEDDING AND A TRIP

tip, which was not expected in Mexico on a train, but that was not the rule everywhere else. After enjoying our breakfast, we had time to observe the passing countryside.

Mesquite and various species of cacti made up the plant life. Goats and burros could be seen often. Padded-out trails here and there led to small square adobe huts. Wherever the train stopped, a cluster of these adobe huts was visible. Their drabness was brightened by shelves of colorful blooming, potted plants in painted cans, buckets and pots. People of all ages lined the tracks and small children held up their hands, begging for candy and coins from the passengers.

Arriving in San Louis Potosi, we took taxis to the bus station and ate the remains of lunches bought while waiting for the bus. The bus ride from San Louis Patosi to Guadalajara carried us over and around small mountains. We saw hillside farms, fences made of rock stacked without mortar. Along some of the streams, adobe bricks were being made and laid out in the sun to dry. Mesquite bushes were used as clotheslines on which the freshly washed clothes were hung to dry. Farm methods were very primitive; oxen pulling wooden plows was common.

We traveled through several towns and in most of them the streets were so narrow the bus had difficulty making the short turns. Each time the bus stopped, the natives would either board the bus or hold up their wares of food or novelties to the windows trying

to make a sale. Even though we were beginning to get hungry, we dared not eat their food because of unsanitary conditions.

The most imposing structure in the towns through which we traveled was the cathedral or church. If there was much distance between towns, there were white stone markers which served as places of prayer and worship.

Guadalajara impressed me with the extremes found there - beauty and modern luxury alongside of dirt, squalor and poverty. Our motel was fairly modern with large rooms, beautiful grounds, a clean swimming pool and an adequate restaurant. While in this place, we made a trip to a nearby small town that is noted for its glassblowing, pottery making, silversmiths and tooled leather products. I bought most of my souvenirs there.

The downtown market gave us the best view of the life style of the average Mexican. Clusters of men leaned sleepily against the storefronts, while small boys, dirty and poorly clad, carried their shoeshine boxes from one man, walking the street, to another, hoping to earn a few pesos.

The marketplace itself was a two-story concrete pavilion-like structure, covering about a city block with an open courtyard in the center. Pedestrians reached the market by way of elevated crosswalks over the main streets. Near an entrance to the market, food exposed to dust and insects called to those

A WEDDING AND A TRIP

passing by for purchase. The unsanitary conditions and nauseating odor repelled any appetite we might have had.

Inside the market were continuous rows of stalls selling souvenirs of all kinds. It was certainly a carnival atmosphere! We learned right away not to pay the asking price to the vendors. We would haggle and it became a lively game as they would finally ask, "How much you give?" **The bartering and haggling was fun for me and was one of the highlights of the trip.** My meager knowledge of Spanish stood me in good stead.

We could not drink tap water for fear of contamination. The people at the motel were very nice to us; seeing to it that we had clean safe water, good food and good service.

How memorable was the old gray stone weatherbeaten church in downtown Guadalajara. The exterior was almost repelling, but the interior was beautiful. Gold leaf overlay covered the inside of the dome and there were beautiful works of art and gold trim throughout. Near this church was Mariacha Plaza, where we sat and had soft drinks and listened to the Mariacha bands.

On one trip to the market, Marie Taylor, our nurse, and I were looking for just the right cross and chain for her son. Someone bumped her and when we took inventory, we discovered that the jostler had taken her billfold. She, of course, reported the theft to the

police, who made a pretense of seeking the thief. She went through all the possible procedures to try and recover her loss, but to no avail.

Leaving Guadalajara for home, we retraced our route by taxi, bus, train and car and arrived back in Laredo, Texas, one week from the time we left. After a good meal and filling our cars with gasoline, we set out for home.

A Beautiful Wedding

The next fall I could tell that Robert and Rita were getting serious and soon they were planning to be married in December. A friend and fellow teacher, Mary Murdock, insisted on giving them an absentee shower. Friends liberally responded and when I drove to Florida for the wedding, the back seat was filled to the windows with gifts. Lois Jarvis, another good church friend, knew I was going alone that **twelve hundred miles** and insisted that I put a man's hat by the back glass. She provided one, assuring me it would scare away any would-be attackers.

Thankfully, I made the trip with no trouble and unloaded the gifts where Robert and Rita were to live. The wedding was pretty, done in Christmas colors. I met Rita's father, her aunt and grandmother (her mother was deceased) and, after a few days, made my way back to Texas with the man's hat still lying by the back window. I had no trip trouble - going or coming - till I had a flat tire in Mississippi. I pulled over on the shoulder, not giving the task before me a

A WEDDING AND A TRIP

second thought, and got ready to change it. I had set the brake, got out the jack and spare tire from the trunk when a young couple passed. Just a few yards beyond me, they stopped, backed back to where I was and took over the job I'd started. They told me where I could get the flat fixed, refused pay and strengthened my faith in my fellow-man. I completed my journey home with no further mishaps.

Christmas holidays were over, a new year dawned and I was settled into the second semester of school. The year was 1975.

PSALM 27:1

"The Lord is my light and my salvation; whom shall I fear? the Lord is the strength of my life; of whom shall I be afraid?"

CHAPTER 17

RETIREMENT

In June of 1975 my longtime friend, Jamie Holcombe, passed away. She was a widow so her son, James Lemuel, was sole heir to her property. I left word with Ruby Pippin, James' aunt, that I was interested in Jamie's house if he planned to sell it. I had admired the pretty red brick structure with white shutters ever since it was built. My house was old and had been remodeled several times. Furthermore, its being a framed lumber house made the repairs and upkeep rather expensive. I hoped I had a chance to buy Jamie's house and lot from James.

Several weeks passed and then one day James called to see if I was still interested in his mother's property. My answer was an emphatic, "Yes." He conducted an inspection tour for me and as soon as I heard his price and earnest money required, I agreed to sign a contract to buy it. It was an answer to my prayers!

James, who followed his mother in the school teaching profession, agreed to my having the inside of the house painted even before the final papers were signed. With this accomplished and notes for the mortgage signed, I made plans to occupy my new place. A distant relative bought my house and three acres of land immediately. The place where Papa and

DAUGHTER OF DESTINY

Mama had lived was still rented to Dave and Barbara Oden. By selling my property so quickly, I was able to pay off the new home mortgage in two years. How God does bless his children!

I moved in on Monday, August 4, 1975 and with the help of my sister, Irene, and good friends Pauline Henderson, Kenneth Markham and Stanley Cross, everything was inside my new house before night. I must not forget Lois Jarvis who fed the whole moving crew.

While Kenneth and Stan were moving furniture and boxes of everything under the sun, Kenneth asked me, "Did you say you lived in that house 25 years?" "Yes," I answered, "from 1950 to 1975." He had a quick reply, with a chuckle, "I don't believe you threw away a thing during all those years." It's no wonder I was known as a pack rat! Even at school when students would go to the secretary seeking something, if she didn't have it, she'd advise them, "Go see our counselor, Mrs. Maxwell. If she doesn't have it, we don't have any."

From the very first night and day I felt right at home in my new place. I could see that I had plenty to do to get the large lot cleared out. It had grown up pretty much while Jamie was sick, but getting the help of some men and boys from the church, it was soon cleared and ready for my trusty riding lawn mower and me. Before long I had everything settled, the property in beautiful shape and was the most grateful person "in the whole wide world"!

RETIREMENT

Early in 1976, our school entered into the Youth for Understanding program where families in the United States accepted exchange students from foreign lands. Having plenty of room, I volunteered to keep one of those students. When I met my assignee, a male from Rio De Janeiro, Brazil, at the airport, I was surprised at his stature and youth. His name was **Roberto Cersosimo,** fourteen years of age. He had a younger sister and his father owned a large horse ranch. Poor Roberto had lost his dictionary of words in Portuguese-English and his orientation in three weeks of English in Michigan before coming on to Texas was far from adequate. My meager knowledge of Spanish helped me to communicate with him some, since Spanish and Portuguese have similarities, and - with gestures - we could understand one another fairly well.

I introduced him to the young people at church, who took him out for cold drinks. I drove him over to a friend's house, where another Brazilian boy was staying, but nothing seemed to cheer him. He was so very homesick that he called home every night. He was unable to understand at school; he skipped classes and stayed at the store across the street. Even a tennis match, to which I took him, did not help; he was too homesick and young. He just couldn't adjust.

One night I heard him talking with his father and though I could not understand the words, I understood the emotions. After he had been with me about a week, a doctor friend of his family, who spoke English, called to advise me that the lad's father was

DAUGHTER OF DESTINY

allowing him to return home. He gave me dates and flight time numbers for Roberto's flight back home. Students and young people he had met, came to my home to give him a farewell party. When we were alone, he gave me a number of gifts he had brought from Brazil for his host family. I saw him off the next day, sorry that things did not work out better for him, but at his age and his lack of knowledge of our language, it was really no surprise.

Politics

About this time several citizens of Nash asked me if I would consider running for a place on the Nash City Council. I hesitated but upon their urging, I threw my hat in the ring! The election was to be the first Saturday in May. Don Rader, a fellow teacher at Liberty-Eylau, had some cards printed for me; I handed them out and got elected! I was sworn in about a week later and for a one two-year term I was in politics! I cannot say that I enjoyed this part of my life. In a small town like Nash there is always something that citizens differ on - and some rather adamantly. Conflict is just not my way of life, so that was my one and only venture into politics. I did accomplish one thing, however: I was the first woman ever to serve on the City Council of Nash!

My Summer Missionary

During the summer of 1976 I opened my home to a summer youth missionary. The program is sponsored by the Home Mission Board of the Southern Baptist

RETIREMENT

Convention. Teenage Baptist youth volunteered and were sent to various places to do missionary work in small churches. My missionary was Nancy Ussery from Springdale, Arkansas.

Nancy was a very pleasant and responsible Christian young lady, who took her work seriously. She and the other young missionaries were in and out of my home and Nancy became almost family to me. She called me her "summertime mom." Another member of the group was Linda Anderson, a student at Liberty-Eylau school, and they had swimming parties in her family pool.

The little house I had rented to Barbara and Dave Oden was now vacant. The Odens had bought a place and moved to it, so I needed to sell my house in which they had lived. Many couples wanted to rent it, but I was interested only in selling the property. Nancy and I discussed the matter and I asked her to pray with me about it. She suggested we make our prayer more definite, i. e., "Let's pray that if it isn't sold by a certain date, then you'll assume it is God's will for you to rent it."

This we did. We both strongly believed God would hear and answer our prayer. We set the time a few weeks ahead and sure enough, a night or two before the deadline, a couple came wanting to buy it, gave me a small earnest fee and were to return in a few days to finalize the sale. Their purchase would include the small house and one acre of ground. The next day James Smith, a friend, and Rev. W. G. Dove

DAUGHTER OF DESTINY

came to say that Brother Dove, a retired minister, was interested in buying the property. I was very sorry I had already made a deal. However, the next day the potential buyer called to tell me he had backed out and would forfeit the earnest money. I got in touch with James, who in turn notified the minister and we did business. Nancy rejoiced with me that God did answer as we had prayed he would.

Nancy took sick just before her allotted time was up and I had to take her home. My sister, Irene, went with me so I wouldn't have to drive home alone. We also wanted to take a little time to see the Passion Play at Eureka Springs, Arkansas. I met Nancy's family, we visited awhile; then Irene and I went to Rogers, Arkansas where we spent the night.

The next morning we had time to see some of the area since the Passion Play was performed just after sundown. We drove north, crossing over in Missouri. There we saw where a small skirmish had taken place during the Civil War. It was Pea Ridge Memorial Park, but there was little to see. Since we had never been over the winding highway from Rogers to the town of Eureka Springs, we left Rogers early. Nancy had warned us that the roads had sharp curves and up and down hills. Also there were interesting things to see at the site of the Passion Play.

We found the roads exactly as she had described them and being unfamiliar with them, had to drive slowly. We soon learned that we should have brought along our heavier jackets because seats of the amphi-

RETIREMENT

theater, especially where ours were located, got very cold. The Play was authentic and brought back the life and crucifixion of Christ realistically. I never see the Passion Play without crying, and this was a marvelous presentation. The night trip back to Rogers was worse than coming up in daylight. We had to drive even more slowly than previously, and that made our return trip seem much longer. We came back to Springdale the next day, spent a little time with Nancy and then drove back to Nash.

In November of 1976, Loyd Howell called to ask me to accompany him to a gospel singing the following Saturday night. Cesnia, his wife, had passed away early the January before. I knew that this longtime family friend had been dating a lady in Nash, and I had no desire to cause trouble. When I mentioned her name, he said, "She has no strings on me." So I agreed to go. We both liked gospel music and enjoyed the evening. Soon after that date, he called again. After two or three times together, he was in my home and we were talking. He spoke up, coming right to the point, "Carlene, I'll tell you right from the start I have no plans to get married again." I responded quickly, "Don't worry about that! I'm not hunting a husband. I have a decent income and am satisfied and happy just as I am." Well, we got that settled right quickly, I thought.

He continued seeing me, the other lady in Nash, and also went to Hot Springs, Arkansas to see another. He continued the three-way social life for several months. This did not upset me because since neither

of us was interested in marriage, we each were free to date whomever we pleased.

I Retire

As the spring of 1977 approached, I began to think more and more about my forthcoming retirement. The financial side of retirement was settled. My forty and one-half years in teaching and counseling plus the state's formula predetermined my retirement check. I had sold World Books and paid self-employment tax in order to receive Social Security when I reached age 62. I lacked two quarters having satisfied the Social Security requirements so I asked my neighbor and flower shop owner, Gayle Williams, about working those two quarters for her when school was out. She agreed.

Now that I had done all I could to take care of the financial side of retirement, I wondered if I were ready emotionally to say goodbye to a profession in which I had spent most of my life. As I looked back over the many years of association with students and school personnel, I knew it wouldn't be easy to leave it and go on in another direction.

Not long before school was out, Patty Davis, the teacher of journalism, asked me if I would visit her class and allow her students to interview me for experience in that phase of their study. I agreed and answered their questions pertaining to my school experiences and about preparation for entering the teaching and counseling field. A few days later I gave

RETIREMENT

Patty a poem for the school paper which her class published. It was my farewell and musings about retiring. When the paper came out, there was my picture, my poem and most of a page revealing the things they had learned from their interview with me. I was overwhelmed! Tammy Harris had outdone herself in writing the article. The poem I wrote follows:

Meditations on Retiring

This is it! This is really it! The day I've awaited
 with happy anticipation,
And now that it's here, I have mixed emotions;
 dulled elation.

When I think of all the students I've known in my
 forty-one years,
Mixed with my happiness, I find I have a few tears.
There's farmers, politicians, soldiers, teachers quite
 a few,
 Homemakers, technicians, policemen, yes,
 And convicts, too.
I've known them all, and an inner part of me
Cries when they're sad or laughs in their joys
 and ecstasy.

And now I close the door on the office that I've
 known,
No more appointments, tests, schedule changes,
 nor buzzing telephone;
No more letters to colleges for scholarships sought,
No more being behind with recording or other tasks

DAUGHTER OF DESTINY

that I ought
To be doing. For now I've really caught up!
My desk is clean.
I can't believe it! There was never a time that this
has been!

What will you do? I hear so many of you ask.
I really don't know yet, but I'm sure I'll find a task.
You might find me down at an old fishing hole,
Just sitting and daydreaming and holding a fishing
pole.
Or maybe sitting, rocking, watching the traffic go by,
Looking at the changing clouds as they float across
the sky.
I hope to have fun, rest, and play, but also do some
work
For "service is the rent we pay for the space we
have on earth".
And I'll find those who need me and the service I
can give,
For that's the way God made me and the way I
have to live.

I hope to go just where God leads, do what He wants
me to,
And be of help to those around in what I find to do.

Thanks to all of you for all you've done and for
just being there,
It was my joy, and I want you to know that I care.
I'll miss my friends at old L-E (I seem to still
belong),
I'm not really saying goodbye, just "So long."

RETIREMENT

> This I leave with you: Proverbs 3:5,6:
> "Trust in the Lord with all thine heart;
> and lean not unto thine own understanding.
> In all thy ways acknowledge him,
> and he shall direct thy paths."
>
> God bless you all,
> Carlene Maxwell

The school term was out and so was I, to something I'd not known before; retirement! I **worked**, with enjoyment, in Gayle's flower shop and seemed to have a natural bent for the work. Also, my being there permitted her absence as needed. My time there passed too fast, but just as I was about to have inactivity on my hands, Irene, my sister, and Nelia Trainor, a cousin, began talking to me about our taking a trip.

Through the rest of the summer I performed my civic duty by attending the Nash City Council meetings, cared for my flowers and yard, and continued to go out occasionaly with Loyd. I also was blessed by my church responsibilities of teaching in Sunday School and singing in the choir. There was a certain satisfaction at being able to have more time and not have such a tight schedule. I silently said to myself, this isn't bad, in fact it's great! great!

PSALM 118:1

"O Give thanks unto the Lord; for he is good: because his mercy endureth for ever."

CHAPTER 18

ON THE ROAD AGAIN

In preparing for the trip with Irene and Nelia, I had a citizens band radio installed in my car, and we notified relatives and friends on our northwest route the approximate dates and times of our arrival at their homes. The CB would help keep us in contact with people on the road, especially truckers, if we made a wrong turn or needed help. CB's were very popular about this time. Not knowing exactly what kind of weather we would encounter before the trip was completed, we packed clothes for varied temperatures.

Our first stop was Jefferson City, Missouri, the state capital, with Irene's granddaughter, Rosalyn Redel and family. It was a beautiful city. We saw the main sites there, and proceeded to Independence for a tour of the President Truman Library and Museum. Then it was to Abilene, Kansas, where we visited the interesting Eisenhower Library and Museum. From there, we moved on across Kansas to the high in elevation city of Denver, Colorado.

In Denver, we spent the night with Nelia's in-laws and toured the Government Mint, watching the minting of coins. Leaving Colorado, we entered Utah. In Salt Lake City we took an extended tour through the

DAUGHTER OF DESTINY

Mormon Tabernacle and other buildings open to tourists. The tabernacle was built in the mid-nineteenth century, and had almost unbelievable acoustics. Standing at the back, we could hear the guide at the front as he spoke in conversational tones. The huge pipe organ is the largest in the United States and still retains some of the original pipes of 1866, when it was installed.

From Utah we traveled to Idaho. We had trouble finding lodging because of the peach festival going on in the town where we stopped. We finally found a vacancy, but it was very late in the night when we retired. We drove to Pocatello the next morning and stopped overnight with Ethel and James Williams. Ethel had worked for Irene several years earlier in the upholstery shop. The Williams raised tomatoes and the peaches from the area were unusually good with our supper. Their house had a large basement containing sleeping quarters and much storage room. Shelf after shelf was filled with coffee and artificial sweetener, besides home-canned jars of fruits and vegetables. Ethel and James were both diabetics and there had been a scare that artificial sweetener would soon get to be scarce so they had stocked up. A storehouse in the yard was filled with cartons of paper goods. The explanation for the large inventory was: James drove a large transport truck and if a carton in his load had a break or tear, he could buy it for little or nothing.

We left Pocatello for Yellowstone National Park. Arriving early, we found our room, quickly deposited

our luggage therein, and took off to see the sights of the area. Pictures were taken at the Continental Divide and of the hot springs with bubbling hot steaming mud. We didn't have to wait long at the site of Old Faithful Geyser for it to spout a silvery cascade of water 120 to 170 feet into the air. It was a beautiful spectacle. The geyser got its name for being faithful in erupting on an average of every sixty-five minutes, summer and winter. It's not the largest geyser in the park, but it is the best known. Wild life there includes deer, elk, antelope, buffalo, moose and grizzly bears. Most of them, because of the protection and care they receive, have lost their fear of man and can be seen grazing the grassy slopes.

The complete tour of the park is 150 miles and takes two and one-half days to cover the total distance. We saw enough to cause us to gaze in wonder, even though we saw only a small part. This Park lies in Northwestern Wyoming and overlaps into Montana and Idaho. We left the Park and headed for Canada through Idaho.

The night was spent in the northernmost Idaho town. Next morning as we were about to leave the States, I advised my "fuel buyers" that we should fill the gas tank. Irene spoke up and said, "Let's just wait and do that in Canada so we can tell our families we used some Canadian gasoline." I felt uneasy about that decision, but said nothing as we went on across the border into Canada. Our map showed a highway going east, circling around to the north, then west and back to where we had entered. We went toward

DAUGHTER OF DESTINY

the east for several miles, seeing no houses; only a school bus and one car. Gradually circling north, we saw nothing but woods for miles. As we turned westward, I noticed the fuel gauge needle indicated empty and even Irene was now wishing we had filled the tank before crossing over into Canada. I drove slowly, coasting down each decline to conserve what little gas there was in the tank. Our hopes were lifted in seeing some gas pumps in front of a house just off the road, but fell upon learning they were no longer in use. However, our stop was not in vain in that we learned there was a gas station just a few miles ahead of us.

We relaxed now because we knew we could walk for gasoline if necessary. We soon reached the station, however, but the price was 99.9 cents per gallon, almost twice what it sold for in our native land! We bought just enough to get us out of Canada.

Hearing that Creston was nearby, we decided to stop there for lunch, which would be the last Canadian place we would visit before crossing back into the United States. Approaching this Canadian town, we saw apple orchards with the trees loaded with beautiful dark-red apples. After lunching in Creston, I called Loyd, as I had promised I would do; we shopped a bit and then headed for **our** border. Our route took us through a smidgen of northwest Idaho; then across southeast Washington, where we saw arid land with scrubby bushes and no towns for miles. We later learned that the scenic section of the state was in the north and western parts. We found lodging for

ON THE ROAD AGAIN

the night just inside the northern border of Oregon, after crossing the Columbia River.

The next morning we had a delightful drive going west alongside the beautiful river, we had crossed the day before. The clear blue water with trees and mountains on either side were topped off with low-hanging clouds. No human artist could have painted a prettier picture! Driving toward Portland, we turned south to Roseburg, where we spent several days with Nelia's sister and several Walker cousins. The huge sawmill, where they could do everything imaginable to the immense logs, impressed us in an area where timber is a main industry.

As we left Oregon for California, we had a decision to make by majority vote. Would we take the scenic and longer coastline route or "bust" right down the middle of the state on the newly-opened Interstate 5 Highway? Having two more homes of relatives to visit in California and beginning to have land jet lag, we chose the shorter way, Interstate Highway 5.

I was no stranger to southern California, our destination, for I had been there many times. I knew that two things were prevalent - people and traffic jams! Yet we found ourselves traveling along without finding either one. Our first night caught us without our knowing where we would (or could) stay. We used our CB to contact a trucker, gave him our location and asked if he could direct us to a motel. He gave us an exit number, which happened to be near, told us to turn left, after it, over I-5, assuring us that we'd

see a new motel immediately. We followed his instructions, finding a small store and a motel under construction! A lady at the store told us that, in order to find the nearest motel, we had to go back some nine miles to the first exit, cross over I-5 and go another six miles west. As we drove, darkness soon enveloped us, but we finally did find a tiny Mexican Village. The motel accommodations were not too inviting, but we took the room and rested our weary bodies.

Early the next morning, we were back on I-5 heading south. Finally emerging from the desolate area, we rolled into Westlake Village, where a Walker cousin, Carolyn Phillips, and her husband, Olen, lived. It was a swanky addition where we had to stop and have the guard call Carolyn before we could be admitted. Homes on this man-made island were in the $200,000 range. Olen was a pilot for United Airlines and also a builder and seller of homes. They made us feel welcome and I could not help but think of the contrast between our lodging the night before and the wonderfully plush accommodations with the Phillips.

They drove us around the settlement to see the lovely homes, including that of movie-fame, Robert Young and Mickey Rooney. When I mentioned to my cousin, Carolyn, that this was a far cry from the mobile home she and Olen had lived in on my lot, bought from Mrs. Orr in the mid-sixties at Nash, she replied, "Yes, God has really blessed us." I was glad for them. We resumed our journey south to the home of Iva, the sister of Irene and me, and Burl, her hus-

ON THE ROAD AGAIN

band, slightly south of Los Angeles in Huntington Park. They, too, showed us a gala time, taking us to Knott's Berry Farm, Disneyland and many other points of interest in the area.

This was the last stop on our vacation list so leaving Iva and Burl, we took the shortest route possible to Texas. This trip back to my native state was much different, I thought, from the one my family took way back in 1920 in the old Chalmer car! Instead of a dreadful journey of 18 days, we zoomed home in three! Arriving at my house, the luggage and souvenirs were separated, and my two trip companions went to their respective homes. We had enjoyed the experience but were glad to be home. We had been away 20 days and covered 6,200 miles. Each time I went on a trip, my Sunday School Class had to go into some other class, and I was anxious to see them.

I called Loyd to let him know I was soundly and safely back. He let me know that I had been missed and he was eager to see me. I had missed him, too, so we resumed seeing each other pretty regularly. I guess absence does make the heart grow fonder!

Biscuits In A Cold Stove

Fall turned to winter, Loyd and I exchanged gifts at Christmas, continuing our dating. From time to time Loyd would invite me to his house for breakfast. I would always ask, "What are you having?" Usually it was hot biscuits with bacon or sausage and I would accept his invitation. One morning he cooked eggs to

DAUGHTER OF DESTINY

go with the sausage, finished off with hot biscuits and butter. Thinking all was ready, he began setting the food on the table. At the proper time, he opened the oven door for the hot biscuits and there they sat, just as he entered them. He had forgotten to turn the oven on! He was embarrassed, but we didn't have to wait long.

Hawaii

After the trip just described, I didn't think I ever wanted to tackle another one, but Enois, Leon's wife, and I learned of a special tour to Hawaii. It was to be in April and we'd be gone only eight days (and we wouldn't be driving) so we made our plans. I had always wanted to see Hawaii.

We packed the coolest clothes we had and I picked Enois up at their DeKalb home on the appointed day. We arrived at DFW Airport, Dallas, and parked the car in the long-term parking lot. Boarding the little electric car, we were carried to the correct airline and gate. We knew we were early but we had to wait much longer than expected. Our plane was a large chartered one that had picked up a group of 250 salespersons in St. Louis, who had won a trip to the Hawaiian Islands!

We boarded the plane and sat in our seats, grounded, for almost an hour, due to a mechanical failure. Our emotions cooled somewhat when we learned the reason for the delay. We were scheduled to leave Dallas at 12:30 p.m., but it was four o'clock when the

ON THE ROAD AGAIN

huge bird raced down the runway and lifted into the air. The best seats were filled before the plane got to Dallas, so we had to take seats near the back. The flight was to be non-stop to Honolulu so we settled down for a long ride.

About two-thirds of the way, we ran into strong turbulence, which caused our section of the plane to react violently. Poor Enois got sick and was miserable the rest of the way. Thank goodness for air sickness bags! Nuff said! Rain started coming down in sheets, but we finally arrived at our destination.

We accepted our leis and kiss from the greeters; then were escorted to our hotel. Among the events on the itinerary were dinner and a show at a supper club on one evening. When asked as to our choice for drinks, we ordered a Pina Colado without alcohol. "Oh, you want a virgin Pina Colada," said the waiter. It was a delicious drink of pineapple juice and coconut milk. The show was entertaining.

Other trips on the island of Oahu (there are some eight of them I'm told) were a boat trip to Pearl Harbor, where we saw the sunken ship, Arizona, lying on the bottom of the harbor, a bus ride to a monument naming many casualties of World War II, including that of aircraft pilot Oren "Jack" Atchley, from Malta, Texas and a friend of my brother, Leon. We also attended a Polynesian Village show, and visited a cemetery where many American military men are buried. We saw a Dole pineapple cannery, fields of sugar cane, and pineapple.

DAUGHTER OF DESTINY

The eight islands of Hawaii are Nihau, Kauai, Oahu, Molokai, Lanai, Maui, Kahholwe and Hawaii.

We visited Maui by plane for half a day, then back to Honolulu. Rain prevented our seeing all that was planned for us to see there. We next flew to Kona, a city on the southwest side of Hawaii, the big island. Here we saw the black sand beach (black lava mixed with sand), old native thatched huts and other sights of historical interest.

We rode a bus from Kona across the big island to Hilo. We passed large cattle and horse ranches and fields of flowers that were growing wild. There were large ferns, orchids and lantana especially in abundance. In Hilo we stayed at a luxurious hotel. Bougainvillea flowers of almost every color hung from window boxes at the upper floors.

Next day a couple in our group rented a car and invited Enois and me to join them on a sightseeing tour of the countryside. It was Sunday and we passed a Baptist Church just letting the people out of the morning worship service. Farther on we recognized the "Painted Church" seen in movies and on TV programs. We stopped and entered and also visited the adjoining cemetery. After seeing as much as possible, we left the big island (named Hawaii) and flew back to Honolulu on Ohau. Making arrangements to bring home some pineapples and papayas, they were crated and stored in the luggage compartment of the plane. To avoid air sickness for Enois, we were able to get seats up front, which made for a

ON THE ROAD AGAIN

smoother ride, especially in case of turbulence, on the homeward flight. Leaving Honolulu in the afternoon, we landed in Dallas at 6:30 a.m. We retraced our way (luggage, crates and all) back to the car and drove home. By the time I reached Nash and picked up my mail, I was ready for sleep. I truly learned the meaning of jet lag on my trip to Hawaii. After calling Loyd and a few others, and sorting my mail, I slept from 2:00 p.m. till 7:00 the next morning. A wonderful trip but home and sleep felt better!

ROMANS 11:33

"O the depth of the riches both of the wisdom and knowledge of God! how unsearchable are his judgments, and his ways past finding out!"

CHAPTER 19

LIFE WITH LOYD

Home from Hawaii, I gave some of my papaya and pineapple to neighbors and shared the others with Loyd. I decided to see if I could raise a pineapple. I cut the top off of one, taking about an inch of the fruit with the top, and placed it in a dish of water. When roots appeared, I set the plant in a large pot of rich soil. Then I put the pot under a tree in the front yard and let it stay there till fall, watering it regularly.

Loyd and I were seeing each other habitually after I returned home. Our relationship became more serious, and despite our early assertions about not getting married, we found ourselves considering just that!

My mind regressed to the many times Loyd had helped me with personal problems, and when I needed some carpentry work done, he was the one on whom I called. He and wife Cesnia were the first to come to offer help and sympathy when Papa passed away. Cesnia had told me many times how she appreciated my opening my home and help to Brenda (Proctor), who was Cesnia's great niece. She and Loyd had known me all my life, and I looked upon them as among my dearest friends.

DAUGHTER OF DESTINY

All these thoughts of past associations endeared Loyd to me. I wanted, however, to be absolutely sure that marriage to him was the direction I should go, and I prayed earnestly about it. I sometimes doubted my judgment about men since I had gone through a divorce. One night as I prayed for direction, words of the song, "Just As I Am", came to mind. I guess I'd been thinking of some fault or peculiarity on Loyd's part that would bother me, or faults of mine that might annoy him. The song's words kept coming to me over and over and I could not get them out of my mind. Then I remembered how our Heavenly Father takes each of us into his family just as we are individually. The next time we spoke of marriage I felt sure it was in God's design for our lives and I said, "Yes."

"I'm an 'odd ball', Carlene," he said to me as we were beginning to make plans. "There are two things that we won't have. One is fussing and the other is divorce," he continued. "That suits me fine. I've had all of that I can stand," I replied. At our age we didn't have time to waste on those things. The love we had for each other was based on mutual respect and deep caring for the needs of each other. Love and companionship was perhaps the greatest need we had.

Love Deepens And Is Clarified

One morning in early summer while I was working in the garden, Loyd came by to tell me he'd had a little accident. When I asked what happened, he pulled up his pants leg and showed me his shin, which had been

LIFE WITH LOYD

scraped raw from just under his knee almost to the ankle. "How did you do that?" I asked. "A calf stepped on my leg when I was trying to load him in a truck to send him to the auction barn," he answered.

I invited him inside the house, cleansed the wound with antiseptic and bandaged it. His coming to me with his hurt under these circumstances meant two things to me: first, he needed a woman's touch and care; and second, he was dead serious about marrying me! His cows and calves ranked high in his priorities, and he was selling them all! That was an irrevocable decision.

Our plans were to live at my home and he would sell his. Before we set a date for the wedding, we wanted the approval of his four children: Almeda, Anna Loyd, Sue and Dewey and, also, my son Robert. We visited with his daughters and talked with Dewey and Robert by phone. They all gave their approval and blessing. The wedding date was July 28 at my home. We invited no one except his and my families (including his grandchildren and Leon and Enois) and I invited Post and Pauline who still seemed like family. Their daughter, Kim, accompanied them.

Dewey and Polly lived in California so they could not come. I didn't think Robert and Rita would be able to make it from Florida, but they surprised us with their presence. Our pastor was out of town so Brother Van O. Martin, a former pastor, did the honors. When it was time for the ceremony, his wife, Mable, stood with him and held his arm to steady him, for he

was rather feeble and unsteady on his feet. It was the shortest ceremony I ever heard. Words were few other than the "Do you's?", the "I do's" and "I pronounce you husband and wife." Then a great deal of hugging was followed by punch and cake.

It required several weeks for me to get used to having a man around the house twenty-four hours a day because I had been alone and independent for so many years. Before we married, Loyd told me, "I want to apologize to you right now just in case I ever say to you, 'Cesnia did it this way' or if I compare you to her in anyway." To me that was a very considerate thing to say for one who had been married to the same woman for more than fifty years.

After our marriage, we had the task of moving some of his household goods to my house, turning over some to his children and selling his and my leftovers. As he made plans to sell his house, we had to do quite a bit of cleaning and clearing out brush and other growth in his yard. We worked together keeping it up before it sold about fourteen months later. His pecan trees had an abundant crop that fall; enough for all the family.

Not long after the wedding, I learned that Loyd did not believe in insurance. He had no hospital insurance (except Medicare), none on his house and only liability on his car, as the state required. I added him to my hospital coverage and worried a great deal about an empty house with no insurance on it! The winter went fast as we learned once again what it was

like to live in "double harness." I found myself cooking more and enjoying it immensely. With the coming of spring, we started a garden. Loyd got my tiller and started to till the soil. He was accustomed to a horse or mule pulling a plow for garden-making, but the tiller wouldn't respond as an animal did. He tried it several times but it bounced along on top of the ground. I saw his predicament and suggested a plan. "Since I'm used to the tiller, let me use it, and you do the hoeing, planting, raking and other things." He readily agreed and did very little tilling from then on.

Family Get-togethers

I soon learned that the Howell family got together for dinner and visiting quite often. I discovered there was a get-together "at the drop of a hat" and someone was always dropping a hat! They enjoyed reminiscing about things of the past. With just six years between Almeda (the oldest) and Dewey (the youngest), they really had fun as kids. Almeda and Anna Loyd liked to gather cantaloupes from the patch and always got more than they could carry. Dewey always picked the biggest watermelon there was saying, "I can carry it, Daddy," then finding he had to have Loyd's help after a short distance.

They told about cooking dinner with Almeda and Sue, Annie (Anna Loyd) and Dewey paired as partners. I failed to learn what Almeda and Sue had for their menu, but the family always knew there would be fried chicken when it was Annie and Dewey's day!

DAUGHTER OF DESTINY

I soon learned, too, that Annie had the gift of laughter. Whatever subject was being discussed she could always find something funny to say. The Bible says, in Proverbs 17:22, "A merry heart doeth good like a medicine..." and she did us all good! Annie should live to be a hundred! I laughed with them and almost envied the joys of their childhood. I had no siblings near my age when I was a child and had none of the fun they recalled. Besides, I had to assume adult responsibilities early in life.

My Sister's Death

Soon after Loyd's place sold in early fall, Irene developed a large lump under her right arm. The biopsy showed it to be malignant and surgery was performed soon thereafter. The physicians could remove only part of the growth and radiation and chemotherapy followed. She seemed to respond to the treatment and felt she was going to whip it. She even did some plumbing on her house.

The year of 1980 was a prolific one for Loyd's family. Four new great-grandchildren and one step-great-grandchild were added. I crocheted four baby afghans and made a set of quilt, pillow, and burp pads within about six months. It was at this time that a divorce was decided by Robert and Rita, so our joys were mixed with some sadness.

By the end of the year Irene's lymphoma worsened. She had to give up living in her home and moved into the home of Floyd and Rosa, her oldest son and wife.

LIFE WITH LOYD

She continued to take chemo every third week. I took her to the doctor's office each Friday; for tests two Fridays, then chemo the third Friday. She would be so sick after chemotherapy! Irene later moved to her youngest son's home, Dick and Jean. I continued taking her to the doctor, and she continued to weaken. In early '81 Loyd and I had bought a two-door car (an Oldsmobile). Neither of us wanted a two-door automobile, but the color, style or something caused us to buy that car. Now I could see why. The large doors on a two-door car gave room for me to help Irene in and out of the car. God's providence, I believe! In October she had to go into the hospital. We took turns sitting with her - sons, granddaughter, Enois and I - around the clock as long as she lived. Harry, her second son, was with her when she slipped away to be with her Lord on November 1, 1981. She had fought a good fight, had kept the faith, and had finished her course!

Robert Remarries

In February of 1982, Loyd and I drove to Florida for the wedding of Robert and Bettye Lee Crissman, daughter of Sam and Carole Crissman. I was thankful Robert was marrying into a nice Christian family. It was a beautiful wedding in the home of Mark and Irene, Betsy's older brother. Mitch, who was her younger brother, and Wife Kim were in the wedding.

The pineapple I had rooted and set out back in '78 kept growing outside in the warm months and inside at a southern exposure window during the winter. We

DAUGHTER OF DESTINY

(Loyd and I) began to wonder if the sharp pointed blades were all we'd get out of it. One day in August of '82, while it sat out under the magnolia tree, I looked deep into its throat and there was a bright red color! I yelled for Loyd to come see and decided it must be a bloom or whatever pineapples had for blooms. We watched and persevered in watering and feeding it as usual.

Pineapple For Christmas

In a few days that bloom began to grow up out of the throat of the plant. It was on a stem and at the top of it and under the blades around the red bloom was a tiny pineapple. How we did watch that thing grow! As the stem lengthened and the pineapple grew, we moved the pot to the porch. As cold weather came on, we moved it back inside to its southern exposure window. By this time it was getting big, about the size of a softball. When Christmas came, it was turning yellow and the aroma filled the room. We waited for another week or two and cut it from the stem. Loyd kidded me saying we should call Del Monte to see if they would take our surplus pineapple crop! It took four and one-half years to produce, but when we ate it we felt it was worth the long wait.

Before Loyd and I married, I noticed his right hand shook; a sort of tremor. It didn't seem to bother him, but as time went by, it grew worse so he saw a doctor (a neurologist), who examined him but prescribed no medication. He said it was a condition common in older age and called it palsy. This shaking spread to

LIFE WITH LOYD

the other hand, causing us about a year later to go to Scott and White Hospital in Temple, Texas for consultation with another specialist. He too, after testing Loyd in several ways, said it was a type of palsy and prescribed no medicine. We worried that it might be Parkinson's disease since he had some of the same symptoms I had observed in Mama, but the doctor ruled out that possibility. We felt we had done all we could do and that the problem was now in the hands of God.

In marrying Loyd, I became step-grandmother to a host of children, but on October 4, 1983 Robert and Betsy gave me my own grandson and named him Robert Justin! I flew down for a few days and reveled in a brand new experience for me at sixty-seven years of age!

Life has a way of moving along, with its ups and downs. I found that life with Loyd was very good. I learned that he didn't get very excited about anything but was as steady and dependable as the Rock of Gibraltar. He was kind, gentle and affectionate. I did not find him an "odd ball" as he had called himself, any more than each of us is a unique personality. He did not talk much but was patient with me when I prattled on and on about something exciting to me. It was a joy to cook for him and as I learned his tastes in food, I saw to it that they were satisfied. Fish, squirrel and venison to go in the freezer were graciously provided by his grandsons. Loyd loved to put his hoe on his shoulder and go to the garden to chop weeds or grass here and there. Life with Loyd proved

DAUGHTER OF DESTINY

to be one of God's greatest blessings for me. I believed we were both where God wanted us to be, and our love for each other grew stronger with each passing day.

A New Church Sanctuary

On Easter Sunday in 1981 we had our first worship service in our new auditorium at the First Baptist Church in Nash. Under the leadership of Pastor Joe Strebeck, the church had begun raising money for the new edifice two years earlier. I remember it was my task during the money-raising time to visit and get pledges from the widows of our membership. My heart was warmed as I saw sacrificial pledges made by some of them. Their generosity inspired the membership to give liberally. As soon as we reached a certain goal, money was borrowed as work progressed on the new auditorium. On the day of dedication the house overflowed. It hasn't been full since. Where did they go?

A Howell Reunion

Early in '81 Loyd and his cousin Norris Howell of DeKalb began planning a Howell reunion for the fall. We got as many addresses as we could and I sent out cards inviting all to a reunion at the Community Center in New Boston on the first Sunday in the month of October. The group consisted of the descendants of the four Howell brothers who came to Bowie County in the late eighteen nineties or early nineteen hundred's. All but one of the original four-

LIFE WITH LOYD

some were represented at the reunion. The four originals were Fate, "Doc", Richmond and Joe Howell. Joe had moved from New Boston, where he had a general store, to Loraine, Texas (which is west of Sweetwater on Interstate Highway 20) in 1907. None of his family attended. In fact, no one knew of their whereabouts. "Doc" was Loyd's grandfather.

Following our '85 reunion, I talked to Loyd about trying to find the family members of his great uncle Joe, if they could be found. He was very glad to do so, for he had often wondered about them. We got out our map, located Loraine and started west on I-30. The next day we found Loraine and after asking a gas station attendant, we located Uncle Joe's granddaughter in a nursing home. Adine (Howell, who had never married) had recently moved into the nursing home and two of her sisters were visiting her from out of town. Loyd had lots of questions so I hiked out after a composition book to get all the answers down in writing. Such a town! I could see that it must have been a thriving small town once upon a time. There was the remains of an old cotton gin (Uncle Joe and his son had built). Store buildings were boarded up and I had to hunt to find the one Adine told us about. Inside I found everything from washboards and horse collars to coal oil lamps. And, I did find a composition book!

As Adine answered Loyd's questions, I wrote down names, dates and addresses. After a short visit we went on to Colorado City to see Francis Kiker, another sister. Though we missed seeing her, much was

learned from her husband, Doyle Kiker, at his funeral home business. In fact he was able to give Loyd all the answers he wanted. When we arrived home, we shared the information we had gathered with some of the other family members.

Death Strikes Twice

For sometime Hulen, Annie's husband, had been plagued with health problems. He had lost a kidney, then had to be on dialysis for several months. His condition worsened and he was hospitalized. He passed away June 14, 1985. About a year later the husband of Almeda, James, had to be hospitalized, due to heart problems. Some ten years earlier he'd had several by-passes. He went to be with the Lord on July 20, 1986. **Into each life some rain must fall.**

In October of '86 Loyd complained of a pain in his chest and upper stomach. I did all I knew to do with home remedies and then urged him to let me take him to the doctor, but he would not consent to go. On the second day, he said, "Carlene, I think you'd better take me to the doctor. The pain is no better." When we saw the doctor, Kathleen Martin, she sent us straight to the hospital. His heart was beating much too fast. Medication was given for a few days but did not regulate his pulse, so electric paddles (small ones) were used. That did the trick and Loyd was soon feeling better. He never really regained his strength and was on heart medicine from then on; one for regulating his heart and another for giving it

strength. While he was in the hospital, it was suggested by Doctor Martin that he see a nerve specialist because of increased shakiness. He agreed but the medicine that was prescribed was so strong it made him lose perception of time and place; couldn't get back to his room, etc. He refused the medicine and would not see that doctor again. Of course I felt he was right. After Loyd came home, I saw to it that he took his heart medicine, as prescribed, and checked his pulse regularly.

Early in 1987 we learned that Betsy was expecting again. I was glad and anxiously waited for a new grandchild. We thought the pregnancy was going fine but in the latter part of August, she went into labor and Joshua Samuel was born on August 24th, two months premature. I was on my way as soon as I could make arrangements for Loyd to be cared for (he insisted he would be fine alone) and get a flight to Homestead, Florida. Robert and Betsy had moved to Homestead a few months earlier to be house parents to younger boys, about ten to thirteen years of age, who had gotten into trouble with the law.

Such a tiny baby boy! Joshua weighed just over three pounds and would have fit into a small shoe box. I did what I could to help, and Betsy got to come home after a few days, but Joshua had to remain for five weeks. After Betsy got home, I stayed for only a few more days. They had cooking help paid for by the state and Robert's job as a house parent let him be home most of the time so I knew they could do fine without me.

DAUGHTER OF DESTINY

Loyd and Almeda met me at the airport and once more we settled into our usual routine. It was the month of September and time to plant our turnip greens, mustard and radishes. So Loyd got the fertilizer strewed and seeds planted where I tilled the soil. It was good to be home!

JOHN 16:33

"These things have I spoken unto you, that in me ye might have peace. In the world ye shall have tribulation: but be of good cheer; I have overcome the world."

CHAPTER 20

SERENITY

Time moves swiftly when we're happy, especially as we grow older. Loyd and I had many happy hours together working in the yard or garden. The patio was always cool and that's where we shelled peas and beans, and prepared fresh corn for the freezer. When the garden harvest was bountiful, Almeda and Annie gave assistance.

Because of Loyd's great love for gospel singing, anytime singers were available they were always welcome to gather at our house. Two who stand out in my memory were Gussie Kruse and Noble Bates. Loyd and I looked forward to this kind of treat. Reacting to my assertion that surprising me was difficult, Loyd arranged for a singing group to come to our house one evening as one of my birthdays was approaching. He even included my Sunday School Class and when it was all over, I had to admit that I had been completely taken unawares.

After Loyd's hospital stay with heart fibrillation, his health and strength were somewhat diminished. The palsy tremors spread to his arms, shoulders, and head, causing more fatigue. Even though there was additional weight loss, he remained active enough for us to continue family gatherings on special dates.

DAUGHTER OF DESTINY

Our Church's Hundredth Anniversary

In the late fall of 1988, Pastor Roy Canada, who had come to our church in '85, began making plans for the church's hundredth anniversary. He asked me to assist him by getting pictures of as many former pastors as I could. Although our birthday was not until April, 1990, I shortly learned we did not start preparing for the celebration any too soon, as there was so much to be done in order to make the event a worthy and memorable one. The church secretary gave me a list of all former pastors and dates of their serving. I contacted those still living and relatives of those deceased. I was able to obtain pictures of 19 of the 26 who had served at Nash. The first pastor, W. J. Simmons, was also the ninth and had two daughters still living in Texarkana. They were Ouida Wright and Mary Amma Wilson. These two ladies I already knew. Finally when the pictures were framed and hung in the vestibule, I looked back at the months of intensive and extensive work with a great deal of pleasure. The anniversary was a huge success! Many members wore clothing depicting the styles of 1890, and our pastor looked dashing in his frock-tailed coat!

Hospitalized

I had been diagnosed as having osteoarthritis back in the late 60's and had to give up bowling, my favorite sport, because of knee pain and swelling. I was able to stay active by having an occasional shot of cortisone, but by the summer of '89 the shots were having

little effect. The cartilage was gone in my right knee causing bone to rub against bone, and much pain. The only route to relief was a knee replacement, Dr. James Keever, my orthopedist, advised.

My surgery was August 8, 1989 with a hospital stay of about 12 days. After I came home, Annie was with us a few days until I could handle my walker and do a minimum of housework. My general health has always been good and I recovered rapidly. Again, as often before, God was with me!

In the summer of 1990, I began having trouble in my left hip. X-rays revealed general deterioration and a destroyed cartilage, which was (largely) a result of the arthritis that had infected my bodily joints for several years. Again, surgery was my physician's recommendation. While Loyd and other members of his family and mine stood by, Dr. Jeffrey DeHaan did the hip replacement October 19th without any complications.

On the night of my operation, Dewey and Polly were spending the night with Loyd when he broke his hip. He had gone to his bedroom for the night while they remained watching television awhile longer. Suddenly they heard a thud and rushed to find Loyd in the floor, unable to get up. He was rushed to the hospital by ambulance, surgery was performed, and he was placed in the hospital room next to mine, but it was a couple of days, due to my grogginess, before I knew he was there. During the following days I was able to be wheeled into his room for visits and meals togeth-

er. He said he wished they would cut a hole in the wall between us so he could at least reach through and touch me!

I was ready to be moved to another floor for rehabilitation eleven days after my surgery, but Loyd was not doing well. He suffered from a severe pain in his side and could not take a deep breath. It took the doctors three days to agree with Loyd's family and my diagnosis. He had pneumonia. One of the hardest things I ever had to do was to leave that room for a different floor from his, knowing he was in such pain. Naturally, I didn't sleep that night because of my concern for my husband and being in new surroundings with different nurses.

Medication soon conquered Loyd's pneumonia, but he was in a very weakened condition. The diagnosis was delayed as a result of the physicians reading some other patient's x-rays, thinking they were Loyd's. His family and I felt that this mistake slowed his recuperation, which distressed us greatly.

I did well in rehab and could have gone home much sooner, but with Loyd's family sitting with him around the clock, there was no one to help me until I was able to care for myself at home so I remained some extra days to receive the care I required. It also allowed me to visit Loyd in my wheelchair first, and then on my walker. I was dismissed from the hospital on November 12, since by then I could look after myself. I enjoyed being home, but it wasn't the same without Loyd being there.

SERENITY

Loyd's progress seemed so slow! He ate little of the hospital food, so we started taking him home-cooked meals. Almeda was my chauffeur on those daily visits to carry the food we had taken turns preparing. He was moved to special nursing facilities for a week; then to rehab, where he was walked and also put through other exercises. Though we continued to supply him with meals from home, he did not gain any strength. The rehab just seemed too hard for him. A feeding tube to his stomach was suggested by a young speech therapist as not only a means for sustenance, but a safeguard against food going down his windpipe to his lungs and causing pneumonia. Loyd did not want the tube and neither did I. I had fed my mother for years while she had Parkinson's disease, and I felt sure we could handle Loyd's difficulties. He decided against the tube.

On December the sixth, his children and I had plans to eat out together in celebration of two family birthdays in December, Sue's and mine. Before leaving the hospital, I attempted to feed Loyd the food I had brought from home, but he couldn't eat. He was suffering in the lower part of his stomach. We asked for the doctor, who came as soon as possible, but meantime a urological nurse came and made a diagnosis of a bladder blood clot. When the doctor arrived, he had Loyd moved to intensive care immediately. By the next morning he was much improved and after two nights in intensive care, he was moved to a private room. Six days later I was allowed to bring him home, after being instructed in some certain personal care procedures vital to his recovery.

DAUGHTER OF DESTINY

December 14 was our first day home from the hospital and truly, it was a happy one. We had spent almost two months hospitalized - near two months for him and 25 days for me! Christmas found us both improving steadily, for which we gave thanks to our Lord for the privilege and joy of being home!

Normal Life At Home

By springtime, Loyd was eager to help me in the garden. Of course his actions were restricted and he used a cane. As soon as his strength permitted, he enjoyed going to the mailbox for the daily mail. I usually watched to be sure he made it down the hill and up again, but one day I was in the kitchen and failed to see him go. I heard Lillian Brower call my name at our back door and when I answered, she said, "Mr. Howell has fallen down by the mailbox and I can't get him up." We hurried to the site, but upon our arrival learned that a young man driving by had helped him to his feet. Loyd explained that some pieces of mail slid from his hand and when he stooped to recover them, he lost his balance and fell. He insisted that he was unhurt, but I took over the daily mailbox trips, just the same, from then on. I did not want to risk further injury and another period of time in the hospital!

In August of 1991 a cataract was removed from my right eye and I marveled how cataract removal had improved in the past few years. There was no pain and stitches were not required. Thick-lensed glasses were absent and normal duty was not interrupted.

SERENITY

Following Loyd's last time in the hospital, our attendance at gospel singings lessened, but we did invite singers into our home as often as they cared to come, something Loyd greatly enjoyed. I had an electric organ when we married, but because of his wishes, we traded it in on a piano. He loved for me to just sit down at the instrument and play the old familiar church hymns. As long as he was physically able, he would sing along with me. As I now think back, I wish I had done that more often.

We also enjoyed playing forty-two with family and friends. Before Loyd's health confined the playing of the game to our home, we would meet in the home of Gladys Braswell every other Tuesday and Thursday nights, to be joined by Murray Phillips.

The Hiemlich Maneuver

After we were told of the danger of food going down Loyd's windpipe, I cautioned him to take small bites and chew his food thoroughly, especially meat. He liked pork particularly well and I fixed chops, steak or roast often. One day we had pork chops plus the usual side dishes for our noon meal. I happened to glance Loyd's way to see his mouth wide open, but he couldn't breathe. I jumped from my chair, silently praying I could help him. I had never had the training, but had seen people do the Hiemlich maneuver. So, from behind his chair, I wrapped my arms around him, one fist in the other, and gave a sudden jerk with my fists just below his sternum. Nothing happened! Realizing I was running out of time, the same

strategy was repeated and this time a piece of pork popped out of his mouth! He began breathing and I began rejoicing. Although he couldn't speak, his eyes thanked me! Afterward, he told his family, "That piece of meat jumped out like a frog."

Soon thereafter, he got choked again. While he gasped for breath, I jumped to my feet and repeated the same maneuver as before, but in vain. Failing on my third try, I said, "Loyd, keep your mouth open wide and I'll try to dislodge whatever it is with my finger." Reaching my finger as far as I could down one side of his throat, I could barely feel something and pushed it to the other side. That allowed him enough air in his lungs to cough it up. Thank you, Lord! From then on I tried to see that any meat he ate was in small pieces and that he chewed it well. He never choked again!

As Loyd became more disabled, he stopped attending the regular church meetings of the deacons and tried to resign from being chairman of the church trustees. However, our pastor, Brother Roy Canada, asked him to reconsider. "But I'm so shaky I can't write my name where you can read it," Loyd replied. "That's no problem. I'll take your signature from some earlier papers and have it reproduced on a rubber stamp," our pastor answered. Not only was that done, but all trustee business was performed by day so Loyd could still serve. I am compelled from within to say that such a gesture on our pastor's part was very considerate and was deeply appreciated by our family. To this day, Roy Canada has high clout with us.

SERENITY

Fertilized

After the tomato plants in the garden had grown to some twenty inches, it was time to side-dress them. Loyd put the commercial fertilizer in a small plastic bucket and dropped some in the holes I dug by each plant. He always wanted to help all he could. Just before I got to the end of the row, I heard a rustling sound and a slight bump. I looked back to see Loyd on the ground with the little plastic bucket and small white granules of fertilizer scattered from his neck to his knees. He had a cunning smile on his face so I knew he wasn't hurt. The ground was soft from recent tilling. I helped him up, brushed him off and he said, "I stooped to pull up a weed, got overbalanced, and fell backward." "As long as you're not hurt, we won't worry about the weed," I assured him. We finished the task with no more mishaps. The next time Sue saw her dad she said, "Papa, I thought you would have grown some by now. I hear you've been fertilized."

Historical Rockers

As we harvested our garden produce and put it in the freezer, we found ourselves sitting on the patio in two old rockers that I knew Loyd had purchased many years earlier. I also knew they were to be passed on to Dewey at Loyd's death, so I asked him to tell me their history so I could record it for his son. "I bought them in 1923. They and six straight chairs were shipped to Bassett and I picked them up and brought them home in a wagon," he recalled. He

DAUGHTER OF DESTINY

went on to say that the straight chairs wore out, as did the cane bottoms of the two rockers, which he replaced with hide from a steer he butchered. Sure enough, Dewey had no idea of the chairs' history.

Loyd Plans His Funeral

Loyd began to talk seriously about his funeral. We took out a pre-arrangement burial policy for him and he had me to fill in the particulars in a book we were given. I recorded who was to sing what songs, who the ministers were to be and the kind of service he wanted. He was not morbid about it, but rather requested that we rejoice when his time came. He was merely taking care of business and wanted everything concerning this matter made ready. Perhaps he had a premonition that he would not live much longer, but we continued our usual way of life. Not long after, I took out a pre-burial policy on myself.

Visitors From California

In October I had word from my niece, Gloria, that she, Bob (her husband) and Iva (my sister) were coming from California to Texas and spend a few days at the old farm home at Wards Creek. They would do some cleaning by day and even spend some nights there, but we invited them to make our home headquarters while they were here. I was to meet them at the Texarkana airport at nine p.m. on the fourteenth of October. With Almeda staying with Loyd, I took off to meet them, ten miles east and to the south of Interstate Highway 30. Guess what? You

are so right! I missed the airport exit, traveling some two miles beyond. My mind quickly went into high gear. What shall I do? I pulled over on the nice wide concrete shoulder of I-30 to consider my options. I could go on to the next town, but I wasn't sure just how far I would have to drive before I could find an exit and cross over to go back the way I had come. Remembering the same type of experience on another interstate, I had backed up until I could see the overhead sign; then drove on. "Can I dare to back up for two miles?" I thought. That seemed to be the thing I must do. A look at my watch told me it was just about time for the plane to land. Traffic on any interstate highway is usually heavy with big trucks at night and I knew I would be undertaking a dangerous task.

I stayed as far over to the right as I could and began backing up. The backup lights helped as I moved slowly until the traffic thinned, allowing me to speed-up. When the lights of the large trucks approached, I braked and stopped. This went on until I saw I was backing into an entrance ramp. One car entered while I sat still as far right as I could get. I breathed a prayer of thanks as it passed. It seemed to have taken so long! Again, my Lord was with me!

I continued on my way to the airport, worrying about Gloria and her party arriving without my welcome. I could have saved my energy; their plane was late, landing soon after I arrived. I took them to our home, but I was as quiet as a mouse for weeks about some of the particulars of that airport trip.

DAUGHTER OF DESTINY

Loyd's Final Illness And Death

On December 21, 1992 Loyd and I finished lunch later than usual and he was leaning back in his recliner while I finished in the kitchen. When I joined him in the living room, he told me he was in severe pain. Thinking it might be a gas pain from food, I did the customary with antacids and Pepto-Bismol, but relief didn't come. Upon calling his doctor's nurse, I was advised to take him to the hospital's emergency room. Needing assistance in getting him into the car, I called Almeda, but she was not home. Then I phoned Terry Carson, our church's associate pastor, who came to my aid. Before rushing Loyd to the hospital, I left word with Terry's wife to get word to Almeda as soon as she could.

In the emergency room pain killers were given, a few tests were run, but the problem was not diagnosed. Almeda joined us just as soon as she learned what had happened. Loyd was placed in intensive care and the next day we were told what was wrong. His colon and lower part of his intestines could not function because they were getting no blood. With all of Loyd's children with me, we were given our options. We were advised that without surgery he would die soon. Even though we were told that even with surgery his chances of survival were slim, we grasped at a straw and chose operating. It was performed that night while our pastor, church friends and family waited and prayed. He stood the surgery as well as possible for an 88-year-old in his weakened condition, and was placed in intensive care.

SERENITY

Loyd's family and I remained at the hospital through the night; then we made out a schedule so we could take turns being with him. After nine additional days in intensive care, he was given a private room. There were days when we thought we could see improvement; other days his situation was very discouraging. Someone was with him around the clock and to us, the days of Christmas and New Years were just passing ones as our every thought was with Loyd. We were fortunate to have him in a room with an extra bed for us to rest.

With the passing of time, there was no improvement in his condition. On Wednesday, January 13, I begged the doctor to let me take him home, feeling I could take care of him there, but that request was denied. I accepted the physician's decision, feeling she knew better than I what was best.

On Thursday of that week I took sick with diarrhea and thought it best that I swap my scheduled sitting time of Friday night with someone else. On Friday I was still sick and lying around the house when a call came from Almeda at 2:00 p.m., "Carlene, Daddy has gone into a sinking spell." I responded, "I'm coming to the hospital." She replied, "No, he'll be at the funeral home in just a little while." With that, I knew he was gone. A relief that he was free from suffering and in a better place and a sadness at my loss and that I could do no more for him enveloped me. I was told by Almeda that Nell Crumpton, Almeda's neighbor and a member of my Sunday School class, would be there shortly to be with me. Nell arrived soon and

DAUGHTER OF DESTINY

busied herself straightening up the house. What a help and comfort she was! Had I known that Loyd would expire that day, I would have been there sick or not, but God makes no mistakes and I was glad that Almeda, Dewey and Polly were with him in his last earthly moments.

Soon our home was filled with family and sympathizing friends. Food was brought in great abundance and Nell and her sisters served it. How wonderful to have good Christian friends! Loyd's wishes concerning funeral arrangements were carried out as prescribed and I was glad he had the foresight to plan it all out. His body was laid to rest beside that of the children's mother, Cesnia, on Monday, January 18, 1993. Sue and Alvin (Pounds) spent that night with me and the others went their separate ways.

A great deal of money came to the church in Loyd's memory so the family met with our pastor to determine its use. Since Loyd loved singing so much, we thought it fitting to buy hymnals for the church and Brother Canada, our pastor, made sure just that was done.

In February I invited all of Loyd's family for a meal at my home to let them get personal things of Loyd's, e. g., saws, guns, the two rockers, mementoes from his and Cesnia's golden anniversary, pictures, Bibles, and things they had given to us over the years if they wanted them. In April the church held a joint dedication service of hymnals and the hundred and third anniversary of the Nash First Baptist Church.

SERENITY

1993 Not My Best Year

Every person, I suppose, handles grief in his own way. I flew to Florida to be with Robert and family in March and again in July, but I did not find ease from the heartache for which I was looking. The grief I had was so deep that I had to work through it at home where I felt Loyd's presence, which I did feel in the garden, yard, his recliner, and in our usual sixth pew seats at church. God helped me face the reality that he was gone and it was final. How I thanked God for the fourteen and one-half years we'd had together.

I had said to Loyd just the summer before, "In the Bible the number seven is a perfect number. Just think: I'll be 77 December 23 so that gives me two perfect numbers!" Little did I know that not only would my birthday go unnoticed, but that it would be spent with him in the hospital. Then '93 started with my giving up the best thing that ever happened to me - marriage to Loyd. The rest of the year pursued the same course. Sewer problems were followed by having to replace the air conditioning system. After buying a new oven for my stove, the microwave quit! However, one good thing did happen to me that year. Since the spring of 1979, I had been president of the Nash Welfare Association. It, plus my other responsibilities, was beginning to overload me and Loyd had, for sometime, urged me to give it up. My reason for hanging on was the unavailability of someone willing to replace me, but that summer Jimmy Jemenez said he would take over my duties and I resigned.

DAUGHTER OF DESTINY

The 1993 aggravations already mentioned were minor compared with what happened to me in October of that year. On the fourth of October, I put several containers of pears and mixed greens in the freezer. I had just finished watching a program on television when I decided to check as to whether or not I had put dates on the packages. When I looked at the date, I could not reconcile 10-4-93 on the labels with the current date. "Is this October?" I asked myself. It just didn't seem right. I returned to the television show and it made no sense to me. My neighbor next door was Denise Shumake, a pathological technician. When I called and informed her as to what was taking place, she suggested that I see a doctor. I demurred on the basis that the problem lasted only about ten minutes. Also, it was the time of day when the doctors would not be in their offices.

The next day I felt normal and even went out for Chinese food and shopping with a friend. I slept well that night, but the next morning as I walked about the house, my legs were not acting rightly. Hearing Denise mowing next door, I walked out and apprised her of my continuing problem. When she said, "You're calling a doctor right now!" I put up no argument and was able to get an appointment that afternoon.

Following the doctor's examination, I was told to check into the hospital. "When?" I inquired. "Right now," he replied. He gave me my admittance papers and I drove myself to the hospital and was admitted. Almeda took care of collecting and delivering to me

SERENITY

the personal items from home that I needed. Testing at the hospital showed 80 percent blockage of my right carotid artery. Several days later, with family members and the Shumakes standing by, surgery was performed and my problem corrected. My physician agreed to my going home on Monday morning, the 18th of October, but I found getting into the hospital much easier than getting out! I was ready to be dismissed by 9:00 a.m., but it was 9:30 p.m. when I left for home. It's terrible to have to call on someone to take you home. The third person to come to the hospital for my transportation, got me home at 10:00 p.m.!

On December 23, 1993 I celebrated my birthday with my brother (Leon) and wife Enois as they were celebrating their sixtieth wedding anniversary. But remember that 1993 was not my best year, so I had to visit the doctor before I could drive to DeKalb that December day! The eye, from which I had the cataract removed in '91, clouded with a film over the lens, necessitating a laser removal of it by my doctor.

The End

How do I end the story of my life when it isn't over? As I look back over these 79 years, I can truly see the hand of God on me. He has given me health and strength to overcome many obstacles. This year of 1994, so nearly finished, I've made a small garden, kept my yard, taught my Sunday School class and even gone back to singing in the choir. I've had time to reminisce and to write. I've **learned** to make sour-

DAUGHTER OF DESTINY

dough bread and have found shut-ins and other friends who like to eat it! Two trips to Florida during the year have helped me to enjoy my grandsons more. I shall go forward because God is not through with me yet. He has something for me to do. My prayer is that I will be able and willing to be where He wants me to be, doing (always) what He wants me to do.

PHILIPPIANS 3:13B-14

"... forgetting those things which are behind, and reaching forth unto those things which are before, I press toward the mark for the prize of the high calling of God in Christ Jesus."

AN
ABBREVIATED
PICTORIAL DIRECTORY
OF THE
AUTHOR'S LIFE

The Author at age four and Playmate Mary Anna King in Compton, CA.

Mrs. Craig, a neighbor, Roxie Walker (the author's mother) and the author in Compton, CA, 1920.

Luther and Roxie Walker, parents of the author, circa 1944.

From L to R: Papa (Luther Walker), the author, Iva Powell (author's sister) with daughters Darlene and Gloria at the Walker farmhouse.

Carlene and Malcolm Maxwell, who were married in 1940. Malcolm died in 1949.
(top)

Carlene's adopted son, Robert Maxwell, with Old Fellow.
(bottom)

The Robert Maxwell Family: Robert holding Joshua, Betsy and Justin as they were in November of 1989.

Leon Walker (the author's brother) with Wife Enois in front of their home in DeKalb, Texas.

Carlene, as Liberty-Eylau High School Counselor, gives a student guidance.

Loyd and Carlene Howell photographed December 19, 1989.

ORDER FORM

Carlene Howell
131 North Pecan
Nash, TX 75569
(903) 838 6349

I am ordering _____ copy/copies of <u>Daughter Of Destiny</u> at $14.95 each with the correct amount enclosed in check or money order.

Name_____ St. Number or Post

Office Box _____ City _____

_____ State_____ Zip Code_____

Shipping - $3.00. Texans please add $1.16 sales tax per book.

THANK YOU

NOTES

NOTES

NOTES

NOTES

NOTES

T
B H859

Howell, Carlene (Maxwell)
Daughter of destiny :
memoirs of a Bowie County,
Texas farm girl
Central Texas Rm ADU REF
04/06